HISTORIC PHOTOS OF
RONALD REAGAN

TEXT AND CAPTIONS BY JAY STEPHEN WHITNEY

TURNER
PUBLISHING COMPANY

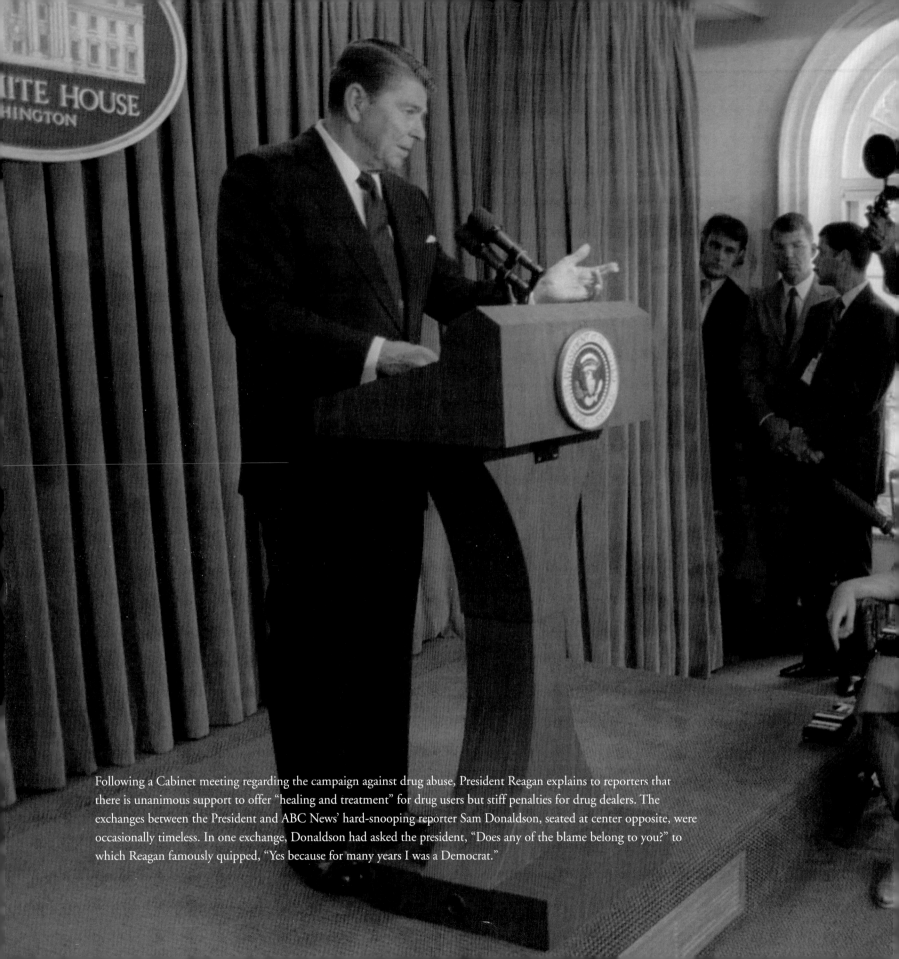

Following a Cabinet meeting regarding the campaign against drug abuse, President Reagan explains to reporters that there is unanimous support to offer "healing and treatment" for drug users but stiff penalties for drug dealers. The exchanges between the President and ABC News' hard-snooping reporter Sam Donaldson, seated at center opposite, were occasionally timeless. In one exchange, Donaldson had asked the president, "Does any of the blame belong to you?" to which Reagan famously quipped, "Yes because for many years I was a Democrat."

HISTORIC PHOTOS OF
RONALD REAGAN

Turner Publishing Company
200 4th Avenue North • Suite 950
Nashville, Tennessee 37219
(615) 255-2665

www.turnerpublishing.com

Historic Photos of Ronald Reagan

Copyright © 2008 Turner Publishing Company

Library of Congress Control Number: 2008901862

ISBN-13: 978-1-59652-436-1

Printed in the United States of America

08 09 10 11 12 13 14 15—0 9 8 7 6 5 4 3 2 1

CONTENTS

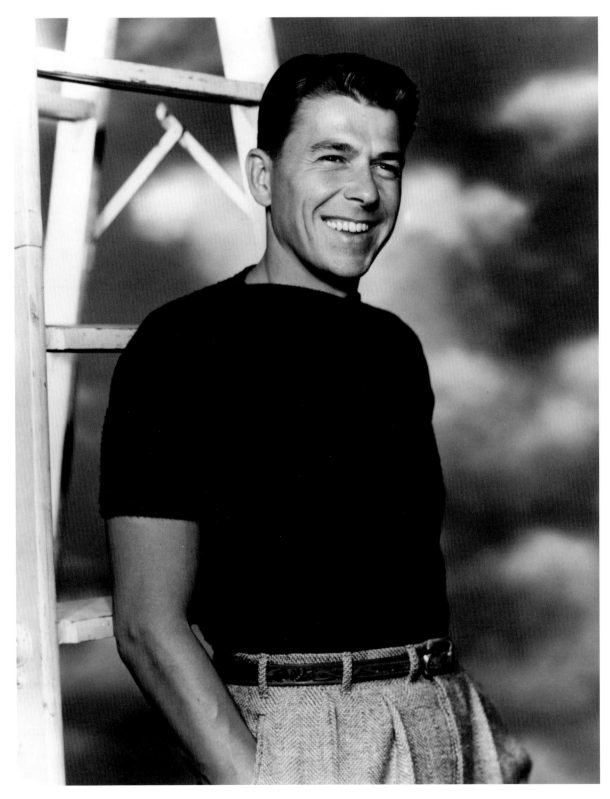

This classic studio head shot, around 1942, was made while Reagan filmed his most important picture. Critics called *Kings Row* the best film of Reagan's acting career, and the actor agreed. He played the rakish cad, Drake McHugh, who suffers a double tragedy: losing his wealth and then both of his legs to a sadistic surgeon whose daughter was spurned by McHugh. When he awakens from surgery, McHugh shouts, "Where's the rest of me?" This iconic title appeared before the subtitle, *The Ronald Reagan Story,* of his 1965 autobiography.

Acknowledgments

This book, *Historic Photos of Ronald Reagan,* is the result of the cooperation and efforts of many individuals, organizations, and corporations. It is with great thanks that we acknowledge the valuable contribution of the following for their generous support: the Acorn Newspapers, Pat Bagley, the Liberace Foundation for the Performing and Creative Arts, the Library of Congress, the National Archives, the Ronald Reagan Foundation, the Ronald Reagan Library, the United States Postal Service, and Don Wright.

Many thanks to the following for adding value to this volume and making it a reality:

The staff of Ronald Reagan Presidential Library and Museum, especially archivist Jenny Mandel, Steve Branch, and Kimberlee Lico; the staff of the Thousand Oaks Library; the staff of Turner Publishing, especially editor Steven Cox, and Michael McCalip, Mike Penticost, and publisher Todd Bottorff.

Individuals who contributed support, research, or photographs and deserve my gratitude are Francois Peloquin, Toby Brooks, Jessica Gordon, Professor Emeritus Bob Scheibel, Cathy J. Okrent, G. Goldberg, Jann Hendry, and Dr. Clifford Phillips, who taught me to appreciate history.

————————

In Memoriam: Tim Russert

To Cathy, Diana, and Lisa for all their love and support

PREFACE

With the approaching centenary of his birth on February 6, 2011, how much do we readily recall of Ronald Wilson Reagan? Before he changed our nation and the world during his presidency, the 40th President was

—Nearly killed twice, first by viral pneumonia in 1947 and then by a bullet in 1981
—Divorced by his academy-award-winning wife in 1948 for "extreme mental cruelty"
—A "New Deal" Democrat who refused to campaign for John F. Kennedy in 1960
—Fired with little notice by his corporate sponsor General Electric in 1962
—Defeated by Richard M. Nixon for the 1968 Republican presidential nomination
—Passed over for vice-president in favor of Governor Nelson Rockefeller in 1974
—Defeated by Gerald R. Ford for the 1976 Republican presidential nomination.

Surprised that anyone could survive such controversy and adversity to win two decisive electoral mandates in 1980 and 1984? Relive or learn about the events that changed America and the world: nuclear arms negotiations with the Soviet Union, the Strategic Defense Initiative (S.D.I. or "Star Wars"), income tax reductions, a massive defense build-up, the PATCO Air Traffic Controllers strike, an assassination attempt, historic Supreme Court nominations, the Grenada invasion, the Iran-Contra affair, and other highlights of Ronald Reagan's presidency. Be amazed with this collection of nearly 200 carefully researched photographs, political cartoons, and other newsworthy images, all captioned with facts not commonly remembered about the roles of Ronald Reagan, whether it be as a lifeguard, student-athlete, sportscaster, Hollywood star, union president, corporate spokesman, father, husband, California governor, or President of the United States of America. From the history buff to the novice reader, all will enjoy this historical reference. Photos abound of 1980s icons who visited the White House—Princess Diana, hockey's Wayne Gretzky, basketball's Kareem Abdul-Jabar, baseball's Roger Clemens,

Don Baylor, and Joe DiMaggio, football's Rick Sanders, and Mother Teresa. Meetings with Pope John Paul II and Queen Elizabeth II appear as well. Ronald and Nancy Reagan brought Hollywood glamour to Washington and the A-listers they knew appear throughout the book. Spot Frank Sinatra, Jane Wyman, Bill Holden, Liberace, Marilyn Monroe, Audrey Hepburn, Sylvester Stallone, Arnold Schwarzenegger, Bob Hope, Ray Charles, Clint Eastwood, and others. Hollywood stills of Reagan movies and television shows are featured. While Ronald Reagan asserts in his autobiography *Where's the Rest of Me?* that American politics is a series of ups and downs, instead of "left and right" forces, the voices of liberals or conservatives resonate in nearly every caption. Pictured are Reagan's friends and adversaries including, among others, Barry Goldwater, Edward Brooke, Tip O'Neill, Ted Kennedy, George H. W. Bush, Bill and Hillary Clinton, Richard Nixon, Colin Powell, Lyn Nofziger, George Schultz, George and Laura Bush, Spiro Agnew, Oliver North, Robert Bork, Jerry Ford, Jimmy Carter, Margaret Thatcher, Caspar Weinberger, Bob Dole, Don Regan, Deng Xiaoping, Mikhail and Raisa Gorbachev, Walter Mondale, William F. Buckley, Jr., James Baker, Howard Baker, John and Cindy McCain, Helen Thomas, Mike Wallace, and Sam Donaldson. Captions echo Reagan's view of the world and how he was viewed by others—placing each event in historical context.

Captions and photos illustrate how Ronald Reagan's actions and decisions made him the most influential president of the last quarter century and one who still influences the current political actors in the twenty-first century. Reagan understood that he had an important legacy and that his presidency was more than two blocks of four-year periods in succession. Ideally this pictorial reference will settle many friendly political arguments with its facts and photos.

—*Jay Whitney*

President Reagan is shown working at his desk in the Oval Office just days into his administration in January 1981.

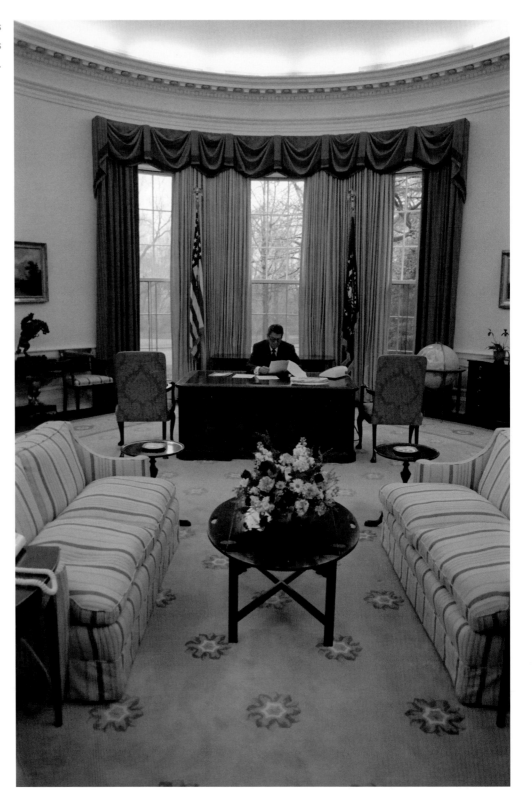

FOREWORD

What is it about the photos of Ronald Reagan? He no doubt was what one would call photogenic. Actors know to make the camera their friend. It's a consciousness of the camera—knowing where it is at all times. Is the light hitting me just right? How's the angle? It's 90 degrees in here under the lights and if I sweat, the shot will be ruined. Yes I can do that take again. It's about poise and control.

It wasn't just that Reagan had an actor's skill; there was something more. He looked like the quintessential American male. When he smiled, he had a squint. It's a squint we see in so many characters in Western movies. His posture was near perfect—upright but never artificial. No one ever had to tell him, "Mr. President, straighten up." For years people would claim Ronald Reagan dyed his hair. There is no evidence of that—he had a distinctive pompadour, which we see in so many of the caricatures of him. His hair conveyed health and well-being.

There was a natural quality to him. People felt it. It wasn't just what he said, it was the way he looked. He could tilt his head in a way that was the perfect visual expression of thought. "Well . . ." he would begin. Where did he get that "oh shucks" gesture? Was it staged in some early film or did it come naturally? Even the early studio publicity photos of Reagan were different. He was the guy from the prairie town, the guy who ran the grocery store, the local loan officer in a small town bank, the former high school football star, the brother who went to war. You can see why they called him Ronnie. What was that look?

Theodore Roosevelt, modern to the core, had the same charismatic look and was master of the photo-op. FDR offered a grin, always a grin, but posed before the camera. Hiding his paralysis made him a bit too guarded and he always looked so tired. For Nixon, the camera was the enemy. What was hiding beneath that five o'clock shadow? Truman, on the cusp of the television era, was great off the cuff but found it nearly impossible to read a speech well, his face buried in the copy. Eisenhower had a great smile but something about him connoted distance.

But Reagan and the camera—what a match!

—Charlie Maday, Vice-President of Programming, History.com

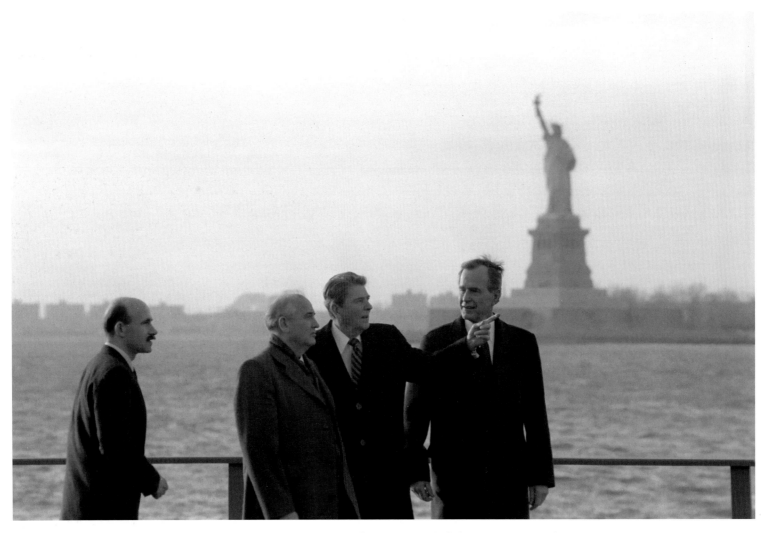

Ending his term triumphant, owing in part to Mikhail Gorbachev's reforms, Reagan laid claim to victory in the Cold War. A new era of peaceful coexistence emerged during the transition to the Bush administration.

Childhood, College, and Radio

(1911–1937)

Ronald Wilson Reagan was born a decade before the formation of the Soviet Union and lived more than a decade after the demise of the Soviet Union. For many of his 93 years he had much to do with the events that caused the communist world to crater. His world began on the 6th of February, 1911, in a cold-water flat at Tampico, Illinois. The family moved throughout his childhood to the small Illinois towns of Monmouth, and Galesburg, as well as the city of Chicago, before landing in Dixon in 1920. His father Jack had "the Irish disease," and eked out his living selling shoes—when he wasn't drinking. His mother Nelle, somewhat of a saint, made good homes for Reagan, his older brother Neil, and their dad despite the hardships caused by low income.

Reagan continued his schooling in Dixon where he attended Dixon High School. His interests were varied and included dramatics, football, and swimming. His first job, lasting for seven summers, was as a lifeguard at a riverside beach near Dixon. Following graduation Reagan moved to Eureka, Illinois, and attended Eureka College where he majored in economics and sociology. In 1932 he received his degree and started his career as a radio announcer at WOC in Davenport, Iowa. Later Reagan moved to Des Moines radio station WHO where he worked as a sportscaster.

On a trip to California in 1937, Reagan was invited to take screen tests at Paramount and Warner Bros. studios in Hollywood. Reagan, who was covering the Chicago Cubs at spring training on Catalina Island, had time only for the test at Warner. Back in Des Moines Reagan received a call from his agent offering a seven-year, $200-a-week contract. "Tell them 'yes' before they change their minds," Reagan laughed.

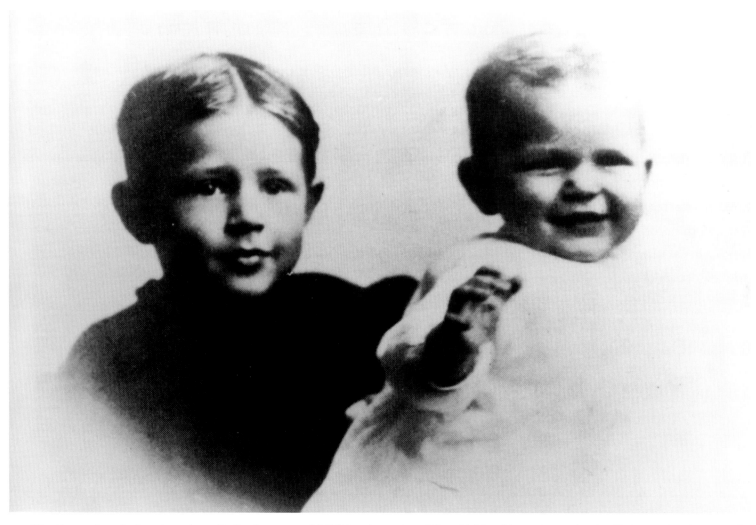

The Reagan boys had a grin and a smile for the camera: Neil (Moon), age 4, and Ronald (Dutch), age 9 months. At Christmas time in 1911, the Reagan family lived above a Tampico, Illinois, bank in a flat of rooms that lacked central heat, an indoor toilet, and water or electrical utilities. The origination of "Dutch" as Ronald's nickname resulted from an exclamation Jack Reagan made about his infant son: "For such a little bit of a fat Dutchman, he makes a hell of a lot of noise!"

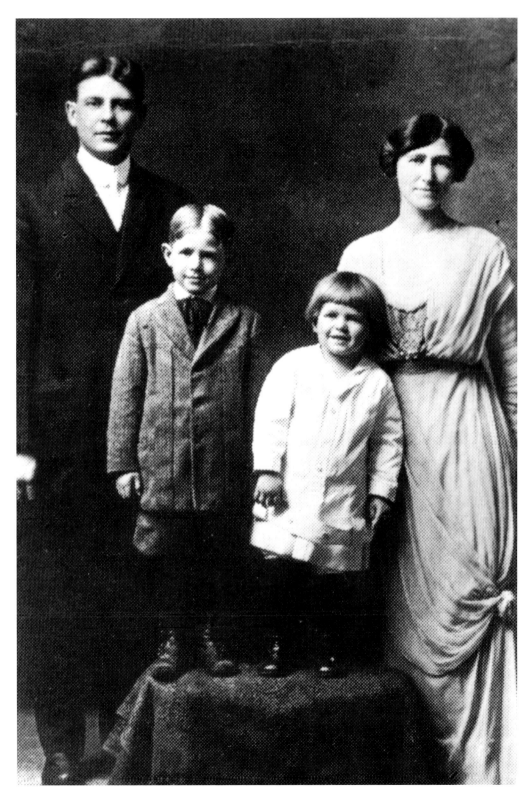

The family photograph in 1913 Tampico, Illinois: John "Jack" Reagan, Neil, Ronald, and Nelle (Wilson) Reagan.

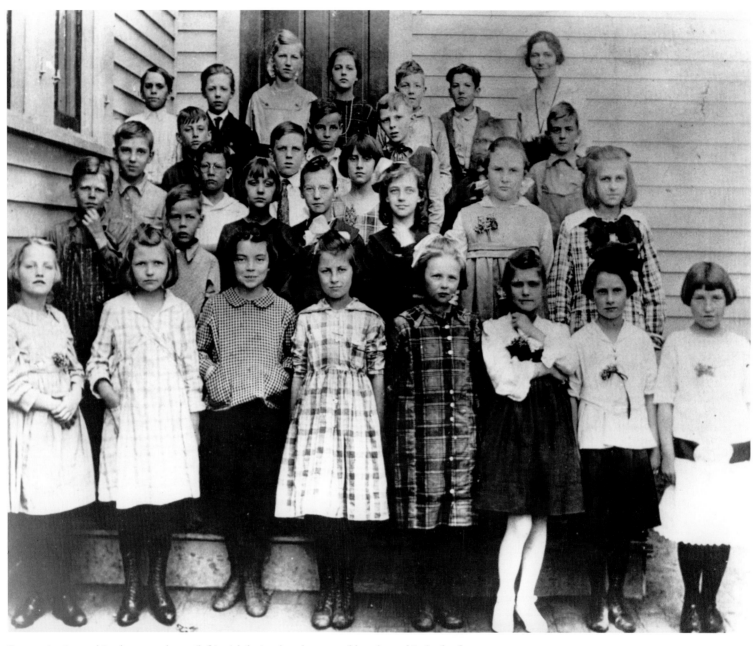

Reagan is pictured in the second row (left) with knitted eyebrows and hand-on-chin look of concern. Nearsightedness may have accounted for the studied look on his face as the photographer focused the camera lens to capture this Tampico, Illinois, third grade class picture on May 12, 1920.

Reagan's extended family included Aunt Vina, Mother Nelle, Aunt Emily, Aunt Jennie (back row), Father Jack (center row left), and Ronald (front left), Neil (front, second from right), and unidentified cousins.

A few days after reading Harold Bell Wright's *That Printer of Udell's* in 1922, Reagan, as a preteen pictured here, asked to be baptized in the church of his mother's faith—the Disciples of Christ. Reagan professed a heartfelt spirituality throughout his life.

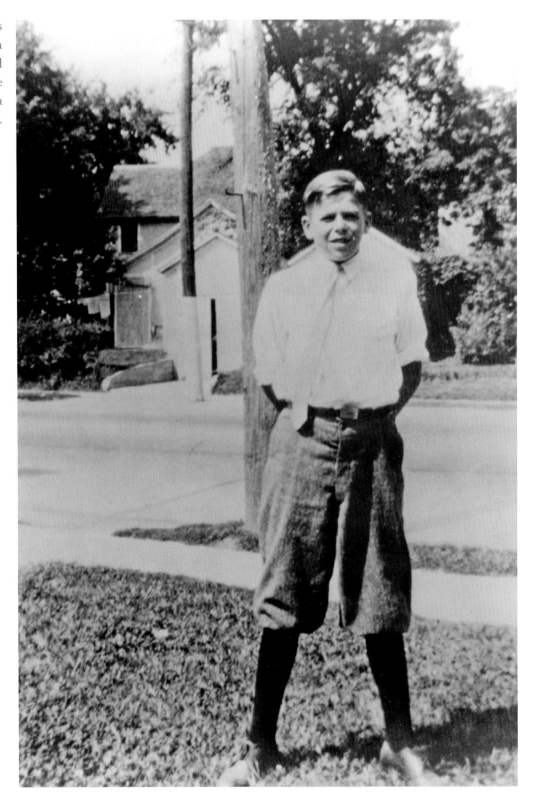

The Lincoln Highway Ladies Golf Tournament in DeKalb, Illinois, was the scene of a women's golf tournament around 1922. Ronald appears (left) in the first row with hand raised, and his brother Neil is in the second row (left).

Lifeguard Ronald Reagan, age 18, worked at Lowell Park on the Rock River near the town of Dixon, Illinois, where the Reagans had moved. During seven summers Reagan saved 77 lives, according to the *Dixon Telegraph* newspaper. The *Telegraph* republished this photo in 1937 to announce that Ronald Reagan had signed a movie contract with Warner Brothers Studio in Hollywood.

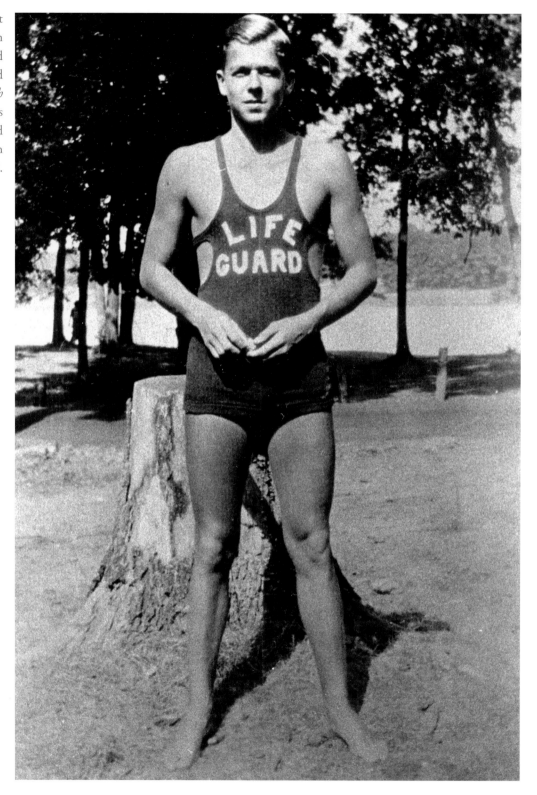

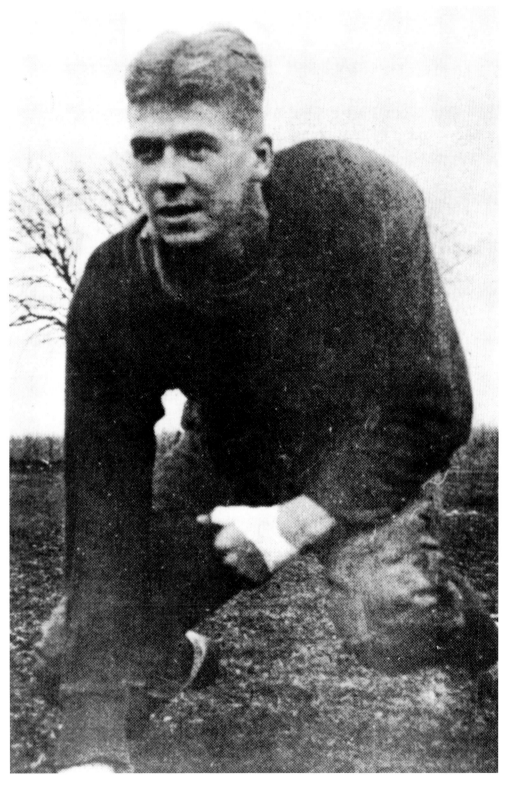

This 1929 photograph of Reagan predated his junior year at Eureka College, where he was an offensive guard with the Golden Tornadoes football team in the 1931 season. Reagan stood six feet and one inch tall.

Although Reagan was not a college football star at Eureka, he starred in the key supporting role of George "the Gipper" Gipp in the popular 1940 film *Knute Rockne—All American.* Critics praised Reagan's performance as the doomed Notre Dame halfback who spurred his team on to victory. But Reagan almost failed to get the part because the studio did not believe he looked like a football player—until he produced this photograph of himself on the gridiron at Eureka College.

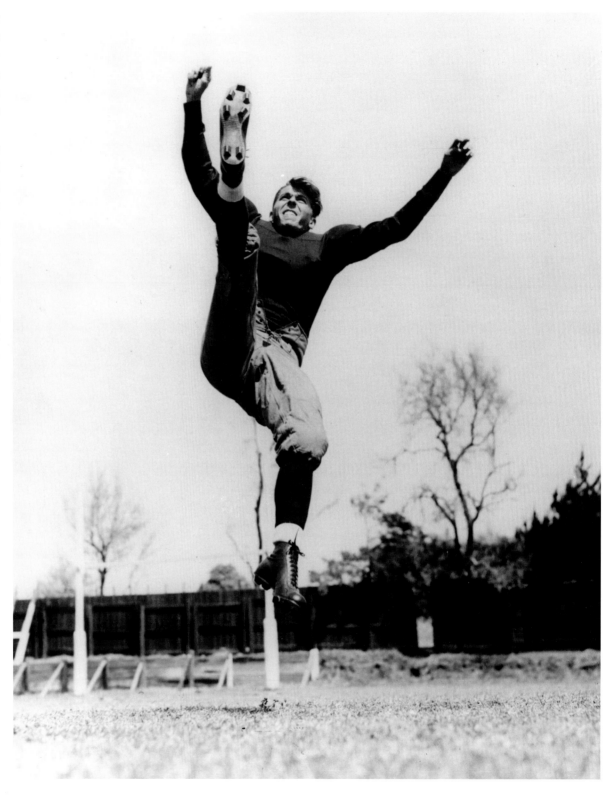

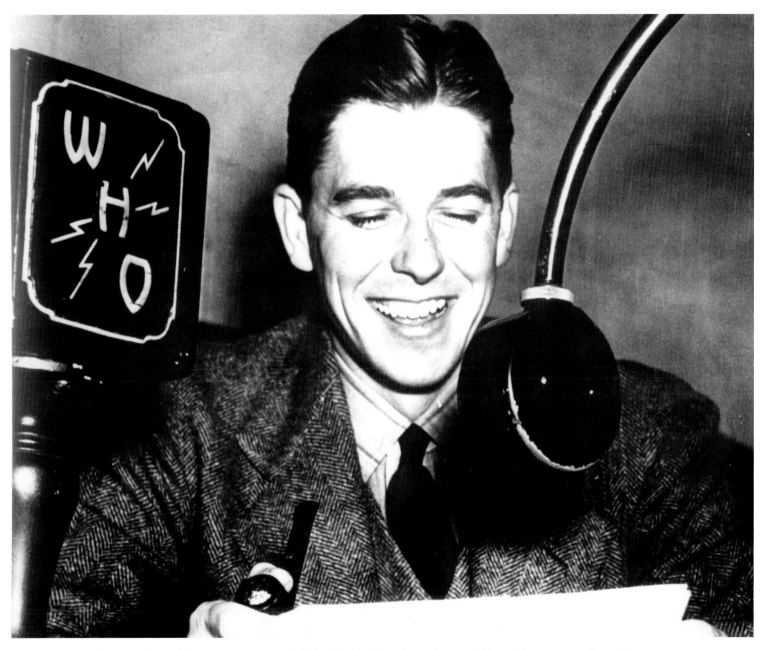

After graduation from Eureka College in 1932, Reagan failed to land a job in depression-era Chicago. Davenport radio station WOC offered him a job, and he later transferred to sister-station WHO in Des Moines, Iowa. "Dutch" Reagan spent the next four years developing an on-air presence and voice that would serve him well.

"Dutch," his radio name borrowed from boyhood, was WHO's voice of the Chicago Cubs. He provided play-by-play coverage reading newswire reports of the baseball games from the Des Moines studio, adding color commentary of his own as he went along. In the fall he switched to football games, often broadcasting the playing field exploits of the University of Michigan's star Jerry Ford. In 1937, while covering the Cubs during spring training in California, Reagan arranged to take a screen test at Warner Bros. Studios. He was quickly offered a seven-year contract at $200 a week for his all-American good looks and trained broadcaster's voice.

MOTION PICTURES AND TELEVISION

(1937–1965)

The complete filmography of Ronald Reagan comprises the following list of titles. Between 1937 and 1964, Ronald Reagan's image or voice appeared in 55 feature films from Hollywood and, to support the war effort, more than 400 training films made for the military during World War II.

Elected to the Screen Actors Guild (SAG) Board of Directors in 1941, Reagan was president of the union from 1947 to 1952 and in 1959. During the 1940s and 1950s, labor and management strife plagued the motion picture industry, a blacklist emerged that prevented suspected Communists from working in Hollywood, and the House Un-American Activities Committee (HUAC) hearings paralleled Reagan's tenure at SAG.

Switching to the new medium of television in 1954, Reagan was the host of GE Theater until 1962. From 1964 to 1965 he was the host of the hugely successful syndicated series *Death Valley Days.* Reagan also enjoyed frequent starring roles in both series.

1937: *Love Is On the Air* and *Hollywood Hotel* (Warner Bros./First National)

1938: *Swing Your Lady, Sergeant Murphy, Accidents Will Happen, Cowboy from Brooklyn, The Amazing Dr. Clitterhouse* (including Reagan's voice on the radio only), *Boy Meets Girl, Girls on Probation, Going Places,* and *Brother Rat* (Warner Bros.)

1939: *Secret Service of the Air, Dark Victory, Code of the Secret Service, Naughty but Nice, Hell's Kitchen, Angels Wash Their Faces,* and *Smashing the Money Ring* (Warner Bros.)

1940: *Brother Rat and a Baby, An Angel from Texas, Murder in the Air, Knute Rockne—All American, Tugboat Annie Sails Again,* and *Sante Fe Trail* (Warner Bros.)

1941: *The Bad Man* (MGM); *Million Dollar Baby, Nine Lives Are Not Enough,* and *International Squadron* (Warner Bros.)

1942: *Kings Row, Juke Girl,* and *Desperate Journey* (Warner Bros.)

1943: *This Is the Army* (Warner Bros.)

1947: *Stallion Road, That Hagen Girl,* and *The Voice of the Turtle* (Warner Bros.)

1949: *John Loves Mary, Night unto Night, The Girl from Jones Beach,* and *It's a Great Feeling* (Warner Bros.)

1950: *The Hasty Heart* (Warner Bros.); *Louisa* (Universal)

1951: *Storm Warning* (Warner Bros.); *Bedtime for Bonzo* (Universal); *The Last Outpost* (Paramount)

1952: *Hong Kong* (Paramount); *She's Working Her Way Through College* and *The Winning Team* (Warner Bros.)

1953: *Tropic Zone* (Paramount); *Law and Order* (Universal)

1954: *Prisoner of War* (MGM); *Cattle Queen of Montana* (RKO)

1955: *Tennessee's Partner* (RKO)

1957: *Hellcats of the Navy* (Columbia)

1961: *The Young Doctors* (Reagan as an off-camera narrator) (United Artists)

1964: *The Killers* (Universal).

Reagan played pilot-turned-secret-service-agent "Brass" Bancroft in four movies. In *Murder in the Air,* Bancroft fights to protect a machine called the inertia projector, which downs enemy bombers with a ray before the aircraft can reach their targets. Ironically, the "inertia projector" sounds eerily like an early precursor to Reagan's Strategic Defense Initiative, which he championed during his presidency. He also "piloted" planes in two other motion pictures with varying circumstances: In the "A" film *International Squadron,* Reagan received top billing playing a stunt pilot, and with star Errol Flynn he played an American pilot in the Royal Air Force in *Desperate Journey.*

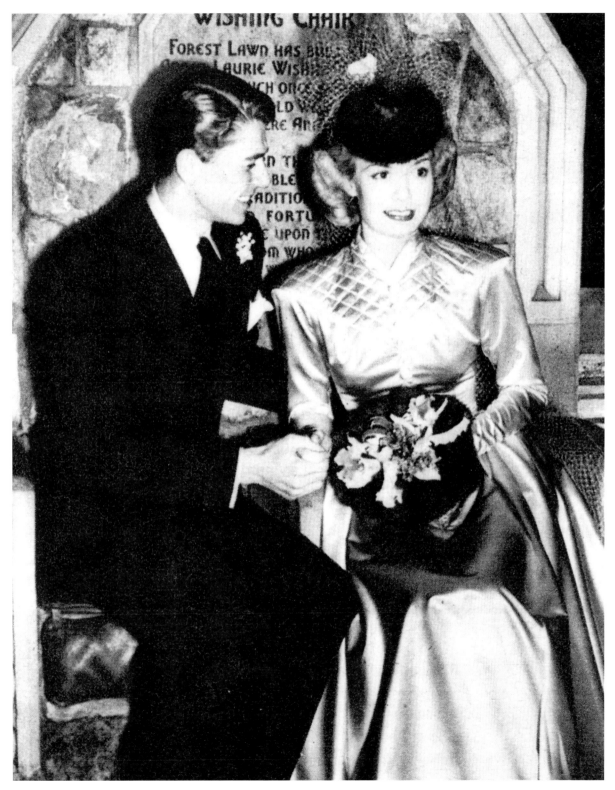

Ronald Reagan and Jane Wyman were wed at Forest Lawn's Wee Kirk o' the Heather Chapel in Glendale, California, on January 26, 1940. Hollywood reporter Louella Parsons, another native of Dixon, Illinois, opened her Beverly Hills home for the newlyweds' reception and dished about the two "stars of tomorrow" in her newspaper columns. They honeymooned in rainy Palm Springs where Reagan had hoped to teach Jane to swim.

Maureen Elizabeth Reagan was born January 4, 1941. Reagan became a father and, less than five months later, lost his father when Jack Reagan died on May 18, 1941. Nicknamed "Mermie," Maureen was a toddler in her father's arms in this photograph and was the only child born to Reagan and Wyman who survived infancy.

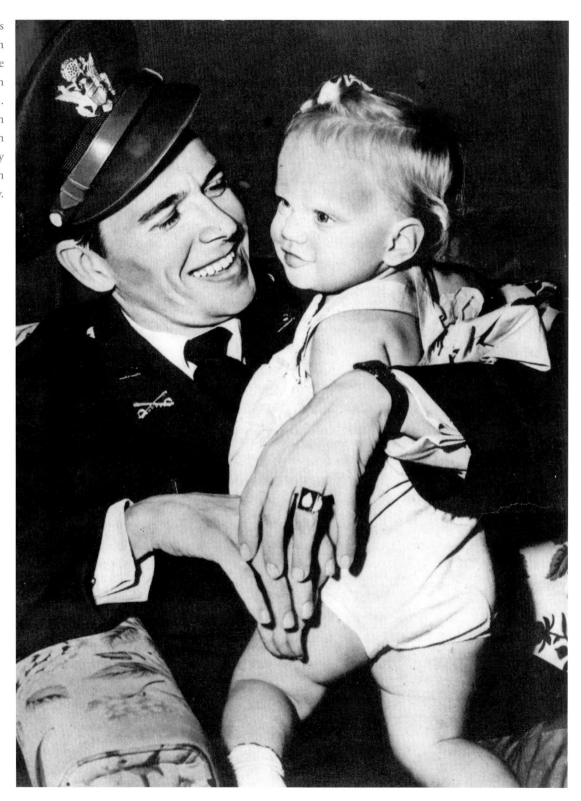

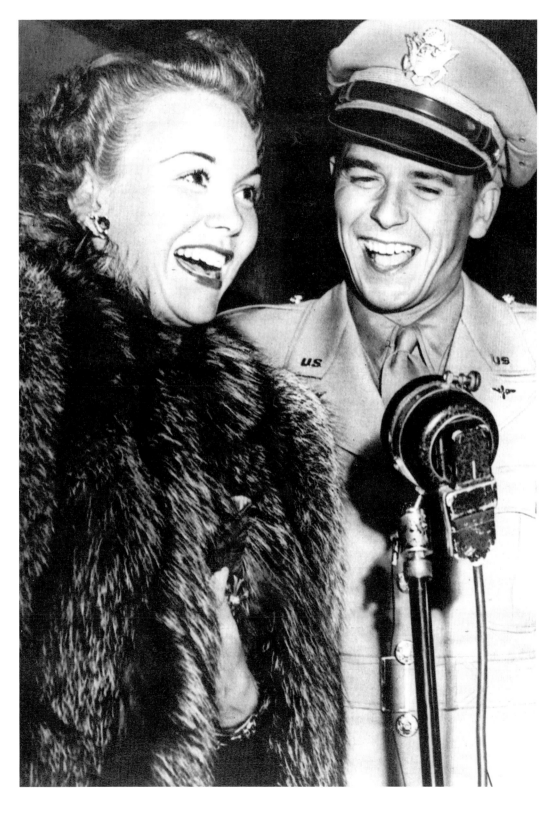

In April 1943 the glamorous Jane Wyman and dashing Lieutenant Ronald Reagan appeared in this World War II–era photograph. They were planning to adopt a child, and after his birth on March 18, 1945, Michael Edward Reagan joined the family.

In September 1943, Lieutenant Reagan's mother visited her son at "Fort Roach," also known as Hal Roach Studios in Los Angeles. Although most famous as the studio that produced *The Little Rascals* short films of the 1930s, it was transformed in World War II for the production of military training films and other "shorts" supporting the war effort. Reagan worked on the production of such films.

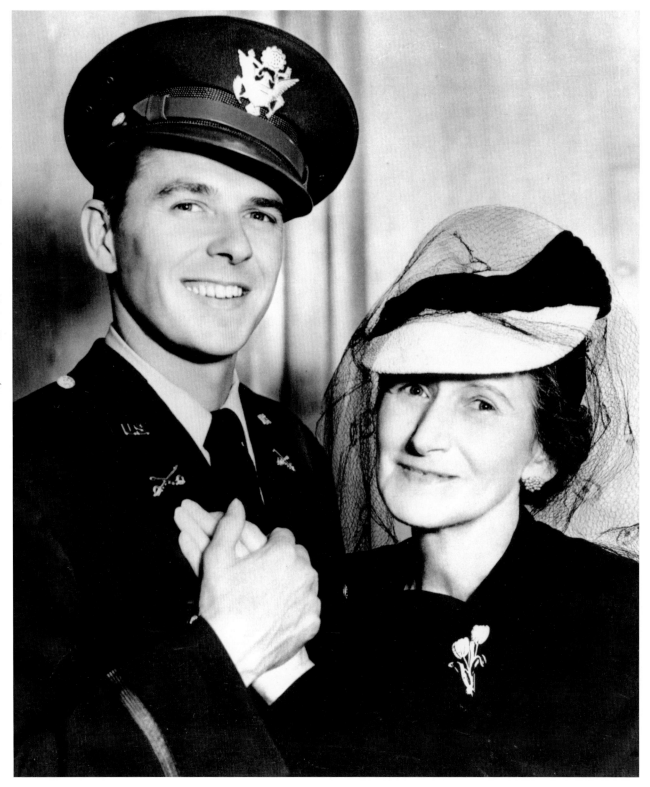

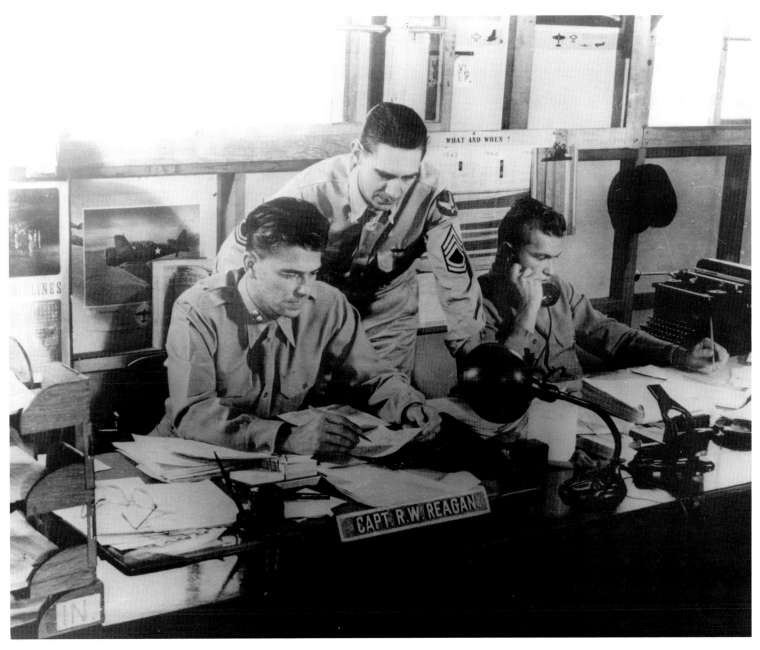

Promoted to Captain R. W. Reagan (note his nameplate on the desk), he earned a mere $250 a month. Reagan's lucrative studio salary was suspended while he served in World War II, making Jane Wyman the primary breadwinner of the family.

As president of the Screen Actor's Guild (SAG), Reagan testified as a "friendly witness" before the House Un-American Activities Committee (HUAC) on October 23, 1947. Although he never "named names," Reagan did imply that others suspected that the president of the Hollywood unions CSU (Conference of Studio Unions) and IATSE (International Alliance of Theatrical Stage Employees) was a communist: the pugnacious and petulant Herbert Knott Sorrell. Archives released after the fall of the Soviet Union in 1991 revealed that Sorrell was a communist spy and that strikes he led were funded by communists.

This movie still from *Brother Rat* shows engaged co-stars Reagan and Wyman happily bowling, but this Mr. and Mrs. Ronald Reagan rolled a gutter ball in real life. During much of their marriage Reagan's film career was in decline while he devoted more time to SAG politics. In 1947, Wyman starred in the film *Johnny Belinda* (for which she won a 1948 Oscar) and gave birth to a daughter Christine, who lived but one day. At the same time Reagan almost died of viral pneumonia in another hospital. Whatever the reasons for it, the couple divorced in 1948. In his autobiography *Where's the Rest of Me* Reagan wrote, "I have never discussed what happened, and I have no intention of doing so now."

Upon his death in 2004, Wyman said of Reagan: "America has lost a great president and a great, kind and gentle man." When she died in 2007, their son Michael Reagan said, "Hollywood has lost the classiest lady to ever grace the silver screen."

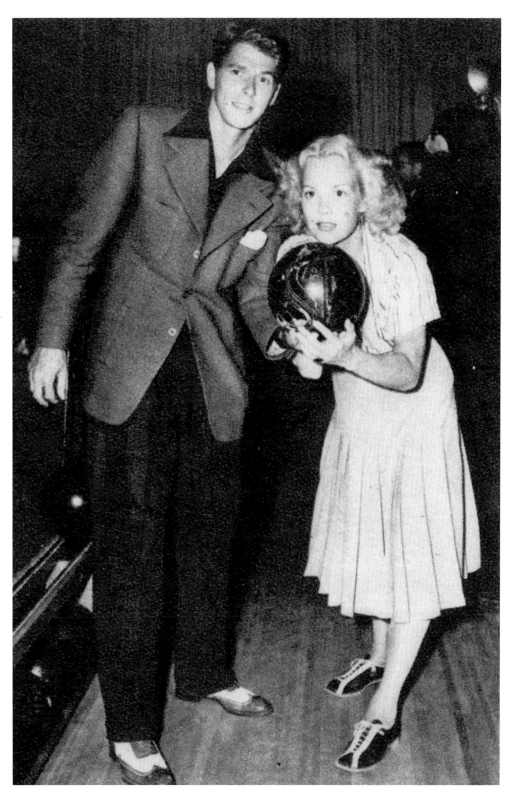

In 1949, SAG president Ronald Reagan received a telephone call from movie director Marvyn Le Roy. He was calling as a favor to a young MGM starlet who was working on his latest picture. Nancy Davis, born Anne Frances Robbins on July 6, 1921, was receiving unsolicited mailings from leftist front organizations and had recently learned her name was on communist party rosters. Reagan quickly determined that there was another Nancy Davis and made assurances to Le Roy that SAG stood ready to defend her if necessary.

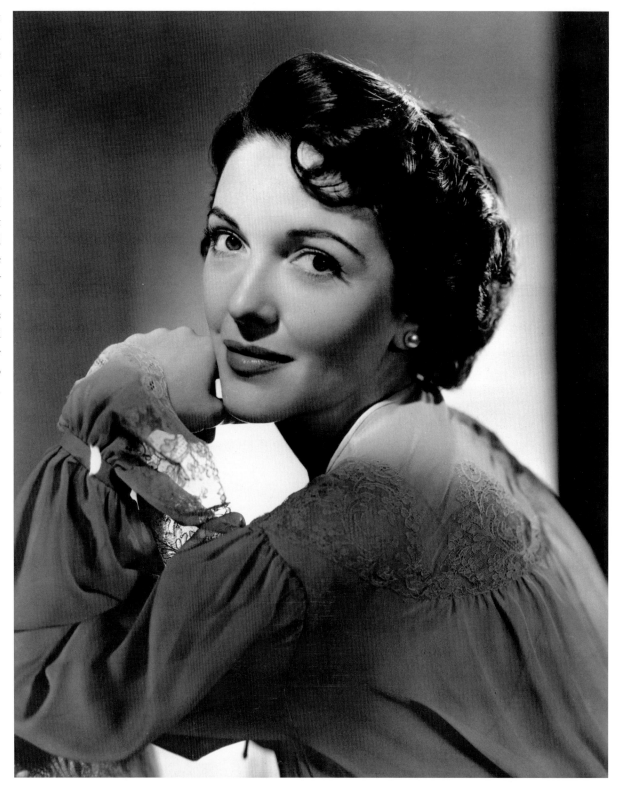

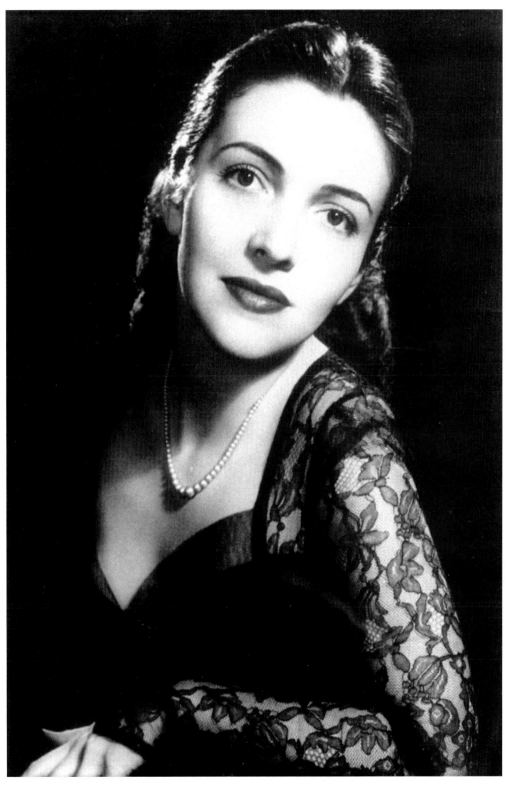

Nancy Davis, as she appeared during filming of *Night into Morning,* was still fearful for her career because of the red scare mentality in the postwar era. Davis wanted Reagan himself to reassure her. Between an early dinner at La Rue's and clubbing at Ciro's, where they watched Sophie Tucker's two opening night shows, their first date lasted until three-thirty the next morning.

In Paramount's *The Last Outpost* (1951), Reagan enjoyed making a real western where he could demonstrate his riding skills. Reagan played Vance Britten, a Confederate cavalry officer trying to intercept a Union gold shipment during the Civil War. The beautiful Rhonda Fleming was his co-star. Reagan was a quick-study in Hollywood, always on set with lines memorized. It has been stated that his memory was photographic.

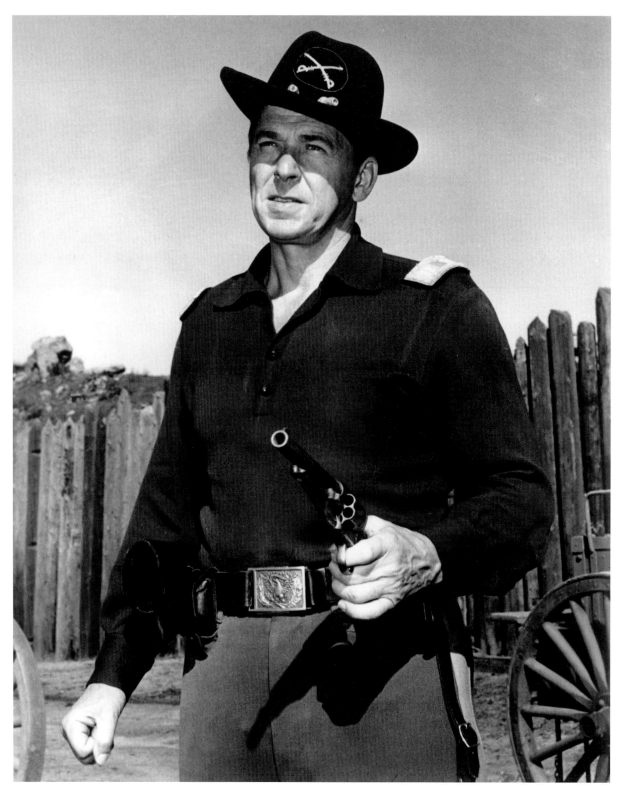

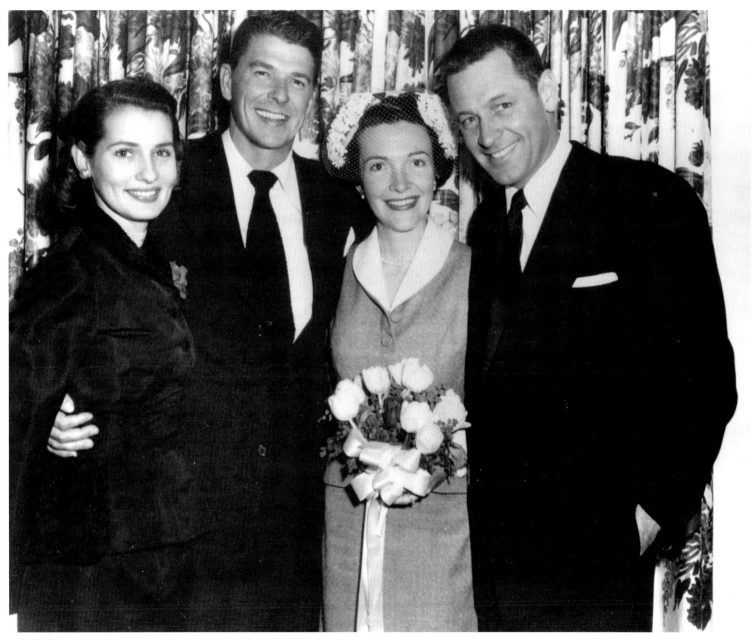

During 1950 and 1951, Reagan and Davis dated intermittently and she became acquainted with his children Maureen and Michael, who lived at boarding school near Los Angeles. On March 4, 1952, the couple married at the Little Brown Church in the San Fernando Valley with Ardis and Bill Holden serving as matron of honor and best man.

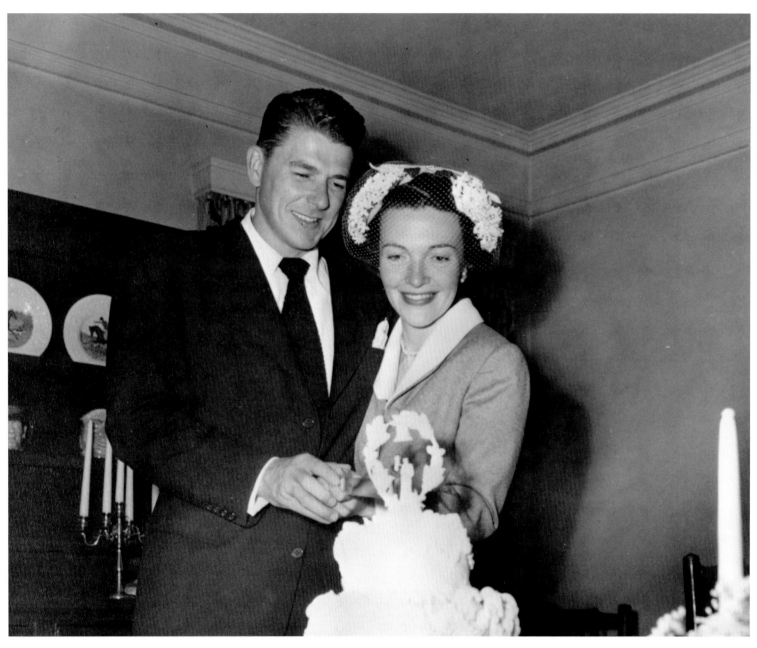

Had Ardis Holden not arranged for a wedding cake and photographer to be at the Holdens' Toluca Lake, California home, the Reagans' wedding photographs would not exist today. The newlyweds spent their first night at the historic Mission Inn at Riverside, California, before traveling to Arizona on a wedding trip. In Phoenix, Reagan met Nancy's parents for the first time.

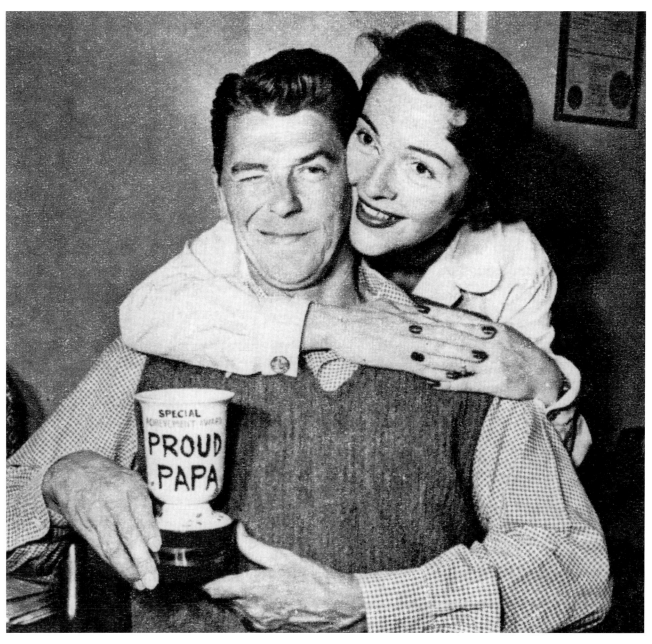

On Tuesday, October 21, 1952, Patricia Ann Reagan joined her parents after a difficult labor and now they were fast a family. Nancy congratulated Reagan in his dressing room with a "Proud Papa Award."

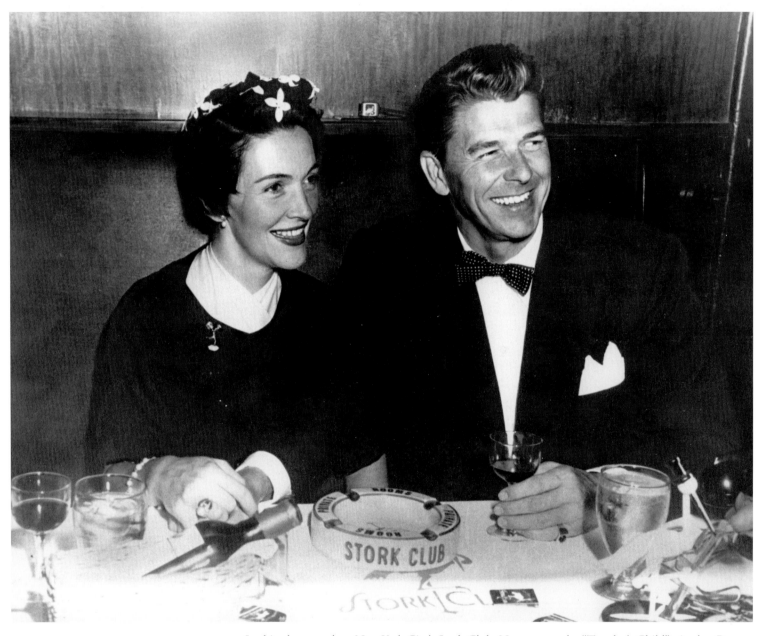

In this photo made at New York City's Stork Club, Nancy wore the "Tuesday's Child" pin that Reagan gave her following the birth of their daughter.

Ronald Reagan visited Nancy on the set of *Donovan's Brain,* a 1953 science fiction horror film, where she was the wife of a Dr. Corey played by veteran actor Lew Ayres. Ayres received an academy award nomination in 1948 for *Johnny Belinda,* the same year Reagan's ex-wife Jane Wyman won an Oscar as his leading lady in the film.

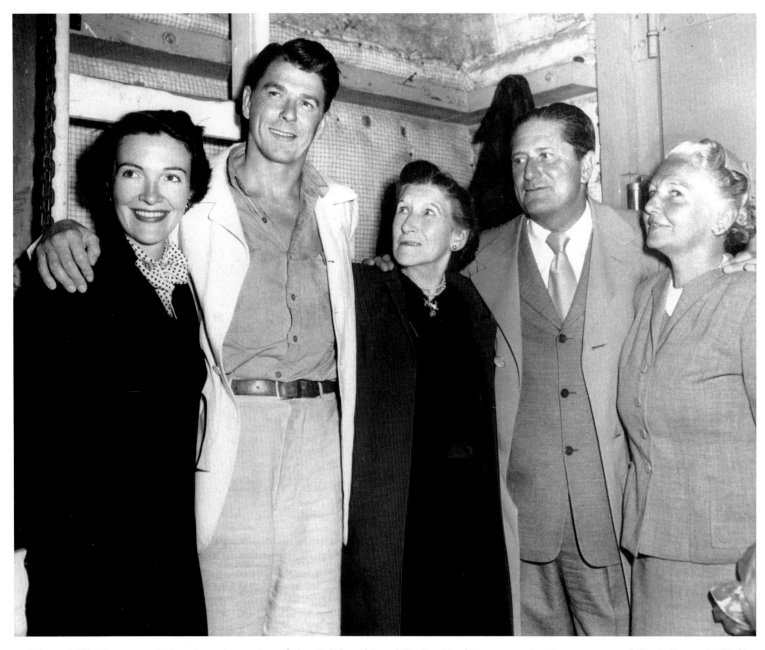

Nancy, Nelle Reagan, and Nancy's mother and stepfather, Edith and Loyal Davis, visited Reagan on the Paramount set of *Tropic Zone*, a 1953 film where Reagan played a plantation foreman. Edith Davis was a former Broadway actress and a character in her own right who was married to the internationally renowned surgeon. Nancy was devoted to Dr. Davis and never knew her biological father, Kenneth Seymour Robbins, who was the estranged husband of Edith when Nancy was born. Nelle Reagan died in 1962 of Alzheimer's disease, a fate that would befall Reagan as well.

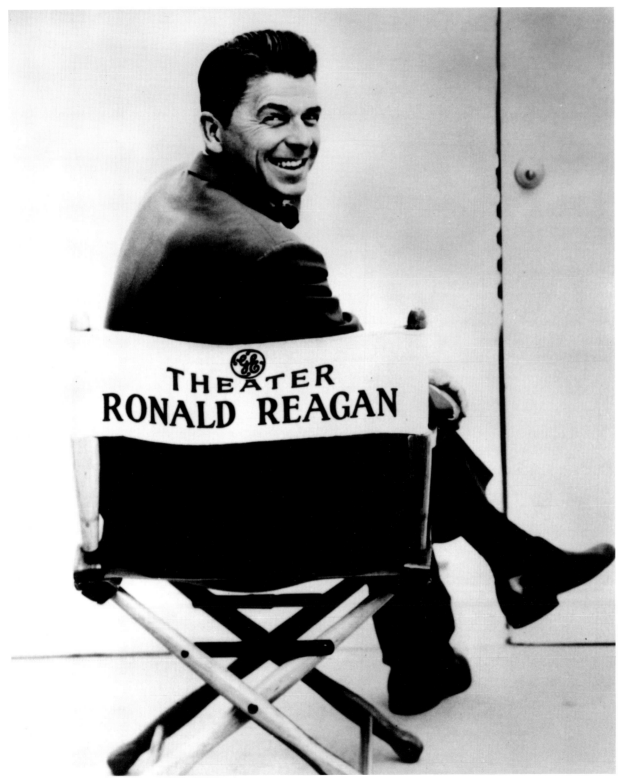

In 1954, Revue Television Productions, a division of MCA, hired Reagan to host a weekly dramatic television series sponsored by General Electric and named GE Theater. For a salary of $125,000 a year, Reagan hosted, acted in six episodes per season, and was a traveling "goodwill" ambassador for GE.

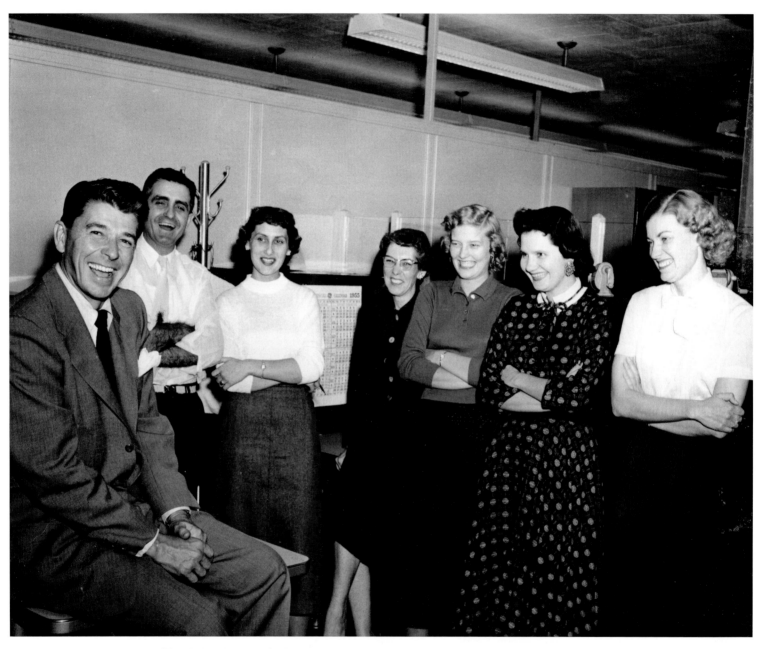

Part of his deal with General Electric required Reagan to visit 135 GE plants and offices throughout the nation. During eight years, he promoted GE Theater, improved employee morale, and made crowd-pleasing speeches of his vision for the country to 250,000 people. Reagan, pictured here at a 1955 "meet and greet" with GE employees, is touring the General Electric facility in Danville, Illinois. Once, following a two-month separation, Nancy asked him to limit his trips to a maximum of two weeks each. His contract was amended to accommodate the Reagans.

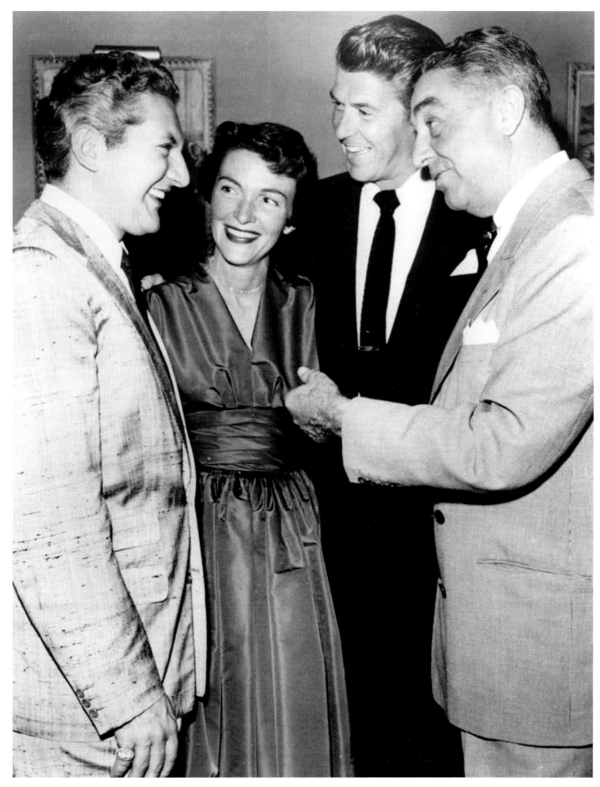

Sharing Midwestern values and conservative politics, the Reagans laugh with Liberace around 1955 in Los Angeles. When Liberace died three decades later, President Reagan's telegram read: "Lee was a gifted musician, a man who truly earned the title 'superstar' and a caring individual who time and again responded generously when called upon. He will be remembered in many ways, but most importantly as a kind man who lived his life with great joy. We are grateful that he has left us such a rich legacy of memories, and they will be our joy." The Reagan administration received criticism for perceived inaction to the AIDS epidemic spreading through the 1980s gay community. Reagan contemporaries Rock Hudson and Liberace were the first celebrity victims of HIV/AIDS upon their deaths in 1985 and 1987.

Reagan and Nancy shot this scene in their first and only film together, *Hellcats of the Navy*, made in 1957 by Columbia Studios. The script was by a blacklisted writer and former communist Bernard Gordon, who used the pen name Raymond T. Markus. This movie set drips with irony: Mr. and Mrs. Ronald Reagan met because of her fear of being blacklisted, the stars of the movie were following a blacklisted writer's script, and while running for president in 1980, Reagan denied the existence of a Hollywood blacklist to conservative writer Joseph Alsop.

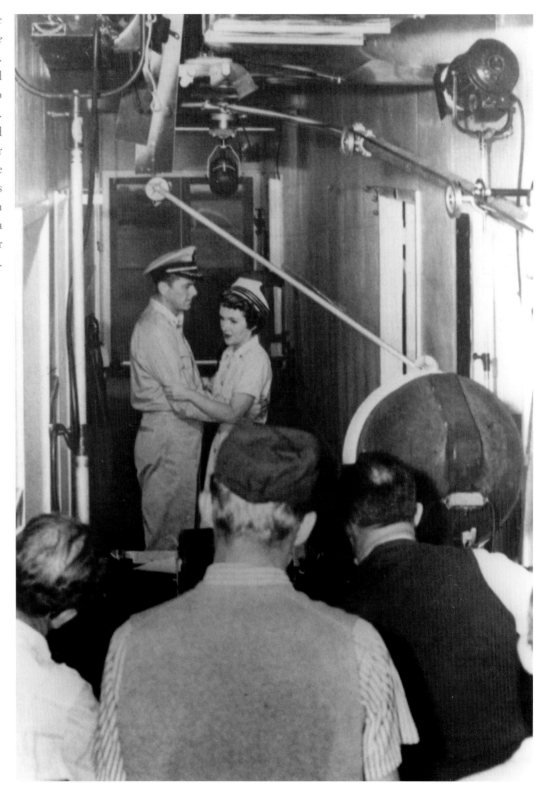

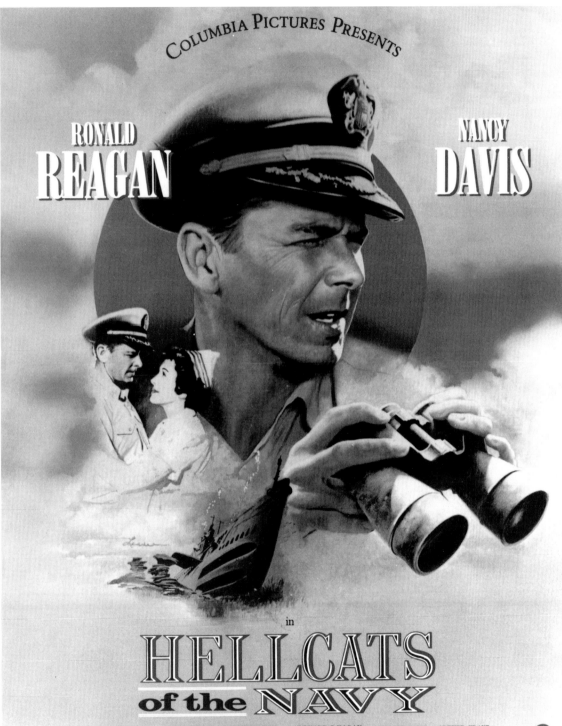

Movie poster for Columbia Pictures *Hellcats of the Navy.*

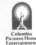

This Columbia Studios publicity shot of Ronald Reagan and Nancy Davis starring in *Hellcats of the Navy* was a capstone of their major film careers. "Nurse" Nancy and Reagan as Commander Casey Abbott "had a moonlight farewell scene on the eve of my departure for the dangerous mission which was the climax of the story," Reagan recalled in his autobiography. The scene was prophetic because it virtually ended Reagan's two-decade film career. Although they both continued acting in television, the last movie he made was *The Killers* in 1964. Per the script based on a Hemingway story, Reagan played a villain and surprised all when he slapped co-star Angie Dickinson. NBC executives deemed the film, originally planned for broadcast, too nasty for network television and released it through Universal where it screened in second-run movie houses.

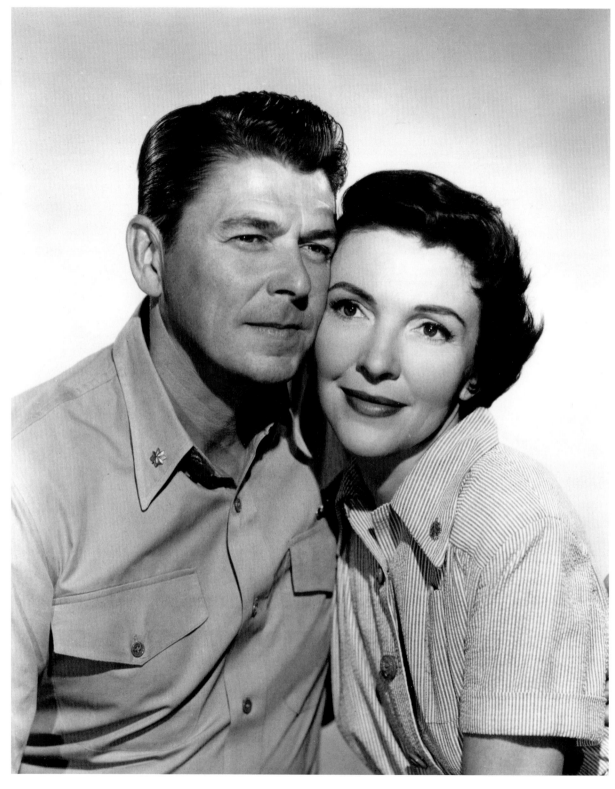

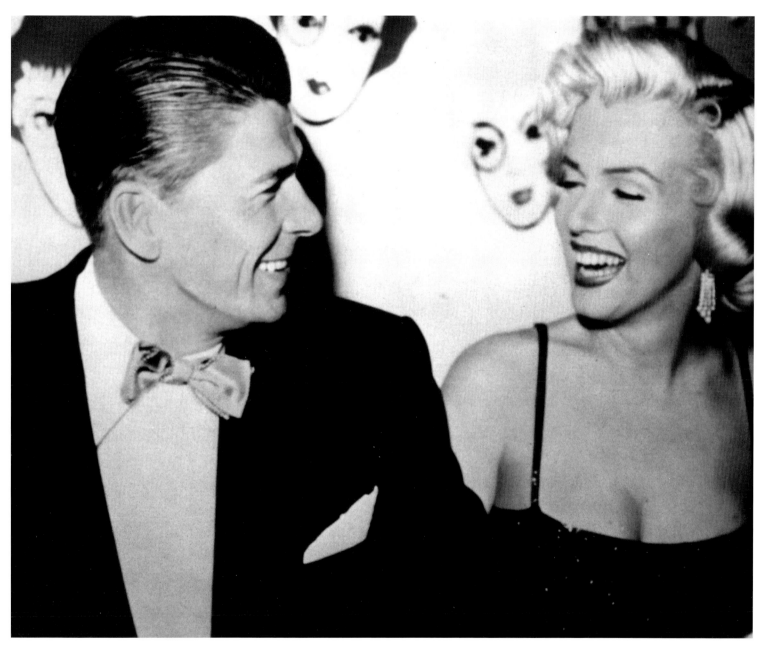

SAG board member Reagan chats with Hollywood actress Marilyn Monroe in 1958, the year her husband's conviction for contempt of Congress was overturned by the Court of Appeals. Before his appeal, playwright Arthur Miller's passport was revoked and he was subpoenaed to testify before the House Un-American Activities Committee in 1957. With Monroe by his side, Miller testified about his activities. Like Reagan ten years earlier, Miller refused to "name names" per his prearrangement with the committee—but the chairman reneged on his promise. HUAC first became interested in Miller after his production of *The Crucible* opened on Broadway in January 1953, and especially after his 1956 marriage to the sexy Hollywood actress Monroe. His allegorical play invited comparisons of the HUAC hearings with the witch-hunt and trials in 1690s Salem, Massachusetts. Monroe and Miller were divorced in 1961.

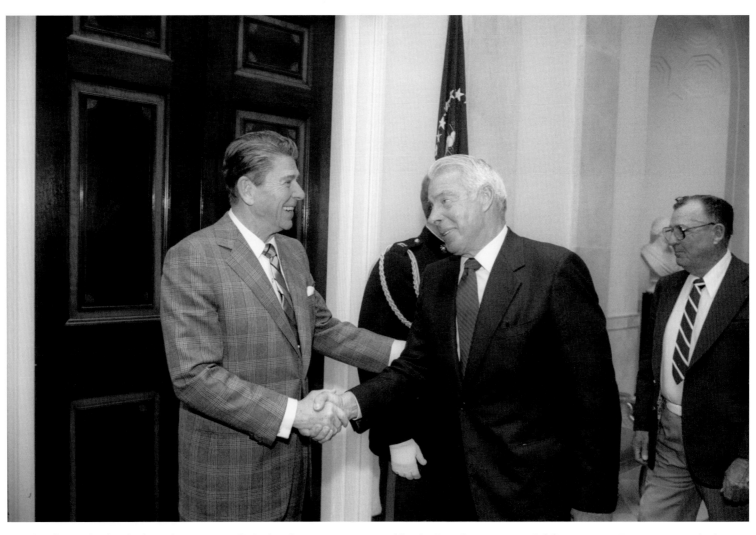

Another former husband of Marilyn Monroe, "Joltin' Joe" DiMaggio is greeted by the President in 1981. California native DiMaggio was also known as the "Yankee Clipper" for playing his entire stellar career (he played in nine World Series) with the New York Yankees, from 1936 to 1951. Like Reagan and other celebrities of the day, DiMaggio served in World War II but remained stateside.

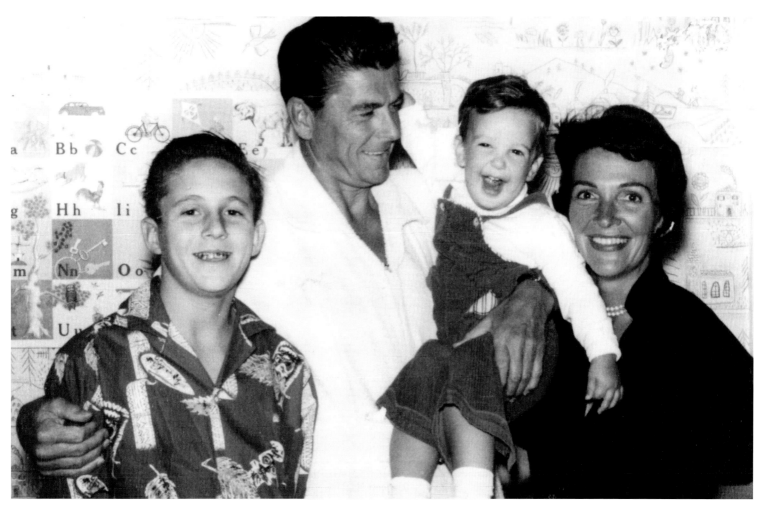

Pictured in 1959 with sons Mike, age 14, and Ron (a.k.a. "Happy Jack"), age 2, the Reagans lived at 1669 San Onofre Drive, Pacific Palisades, California. Designed by architect Bill Stephenson for the Reagans, the home showcased General Electric appliances and state-of-the-art lighting. Mike came to stay with his father and stepmother after living with his mother Jane Wyman and later at Chadwick School. Ronald Prescott Reagan was born May 20, 1958. Except for Maureen, the Reagan children had an uneasy relationship with their parents as adolescents and young adults.

The Reagans starred with Charlotte Armstrong in "Money and the Minister," a production for GE Theater on November 26, 1961. In 1962, after eight seasons with usually high ratings, the series was ended suddenly by sponsor General Electric.

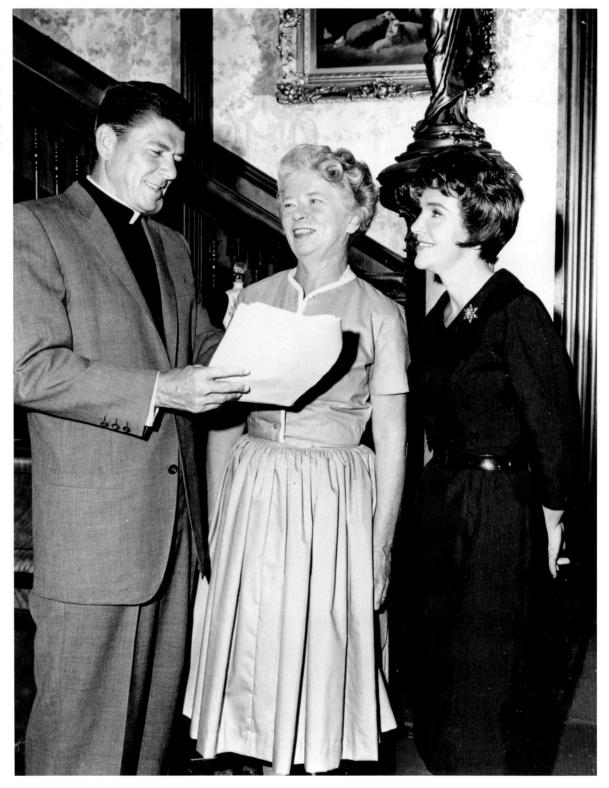

The highlight of the Goldwater campaign was Ronald Reagan's "Time for Choosing" speech. It was broadcast on national television in support of the Arizona Republican's candidacy one week before the election. Honed during his tenure with General Electric on the "mashed potatoes circuit," Reagan made a compelling pitch for conservative political values: "This idea that government was beholden to the people, that it had no other source of power is still the newest, most unique idea in all the long history of man's relation to man. This is the issue of this election: Whether we believe in our capacity for self-government or whether we abandon the American Revolution and confess that a little intellectual elite in a far-distant capital can plan our lives for us better than we can plan them ourselves." Goldwater lost to Lyndon Johnson in a landslide, but Reagan was launched on a career that would land him in Sacramento two years later.

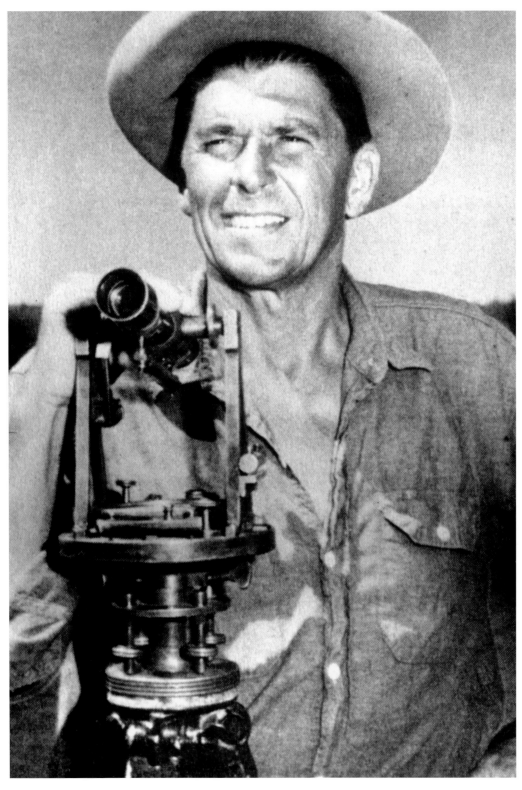

In 1965, Reagan assumed the role of host of *Death Valley Days,* the most successful syndicated television show in American history. The stories used in the programs, some of which Reagan appeared in as an actor, were true and based on the old American West. Robert Taylor replaced Reagan as host when he ran for California Governor in 1966.

THE CALIFORNIA GOVERNORSHIP

(1966–1975)

Jack Warner was quoted, upon learning of his former star's quest for the California Governorship, "Not Reagan: Jimmy Stewart for governor and Ronald Reagan as best friend!" Reagan, a lifelong Democrat, had switched to the Republican Party in 1962 and often stated, "I didn't leave the Democratic Party. The party left me." That same year, "Pat" Brown defeated former Vice-president Richard Nixon in the gubernatorial race. In 1966 Reagan defeated Brown, campaigning "to send the welfare bums back to work" and "to clean up the mess at Berkeley." Some highlights of Reagan's work as a two-term governor:

1967

January: Reagan was inaugurated as the 33rd governor of California and ordered all state agencies to cut budgets by 10 percent.

February: State employees were requested to cut salaries by working on holidays. After 2 percent reported for work, the proposal was abandoned.

March: Reagan's order to cut 10 percent of the budget of all state agencies was abandoned in favor of a legislative tax increase of $1 billion, the largest tax increase ever signed by a U.S. governor.

May: Reagan signed the Therapeutic Abortion Act, allowing abortions for the well-being of the mother, later regretting his decision to do so.

June: Reagan signed his first budget, which was 10 percent higher than the year before under Governor Brown.

1968

August: After an "on again, off again" non-campaign for the GOP nomination, Reagan failed to block the Republican presidential nomination of former Vice-president Nixon.

September: Speaker Jesse Unruh's Assembly passed a $261 million property tax plan with a $750 annual homeowner's exemption. Reagan agreed with Unruh that local governments were too reliant on rising property taxes.

1969

August: The legislature passed and Reagan signed a one-time income tax rebate of $100 million.

October: Reagan declared "no new taxes."

1970

August: Reagan's plan to lower local property taxes by increasing state revenues was defeated.

November: Reagan was re-elected to a second term, defeating Jesse "Big Daddy" Unruh by half a million votes.

1971

August: Almost eight months of negotiations ended in Reagan's signing the welfare reform bill, a compromise between the legislature and the governor.

December: Reagan signed a $500 million tax increase, including payroll withholding of state income taxes.

1972

December: Property tax relief and state aid to local school districts was signed into law, funded by $1.1 billion in state tax increases.

1973

February: Reagan proposed to limit state taxes by linkage to a declining annual percentage of statewide personal income.

March: When the legislature refused his tax limitation plan, Reagan sought a statewide initiative on the ballot.

August: Reagan signed an $800 million one-time tax cut and delayed an increase in the sales tax.

December: Over eight years, Reagan delivered a balanced budget, a state surplus, and billions of dollars in tax rebates and reductions to the people of California.

In this photograph, Lyn Nofziger literally watches Reagan's back, the job he performed figuratively during Reagan's political career. In 1966 Nofziger, a seasoned journalist, was named press secretary for Reagan's successful gubernatorial campaign and, upon his election, director of communications. He worked for subsequent Reagan campaigns and was named Assistant to the President for Political Affairs in 1981. He refused the job of presidential press secretary because he said it was "a young man's job."

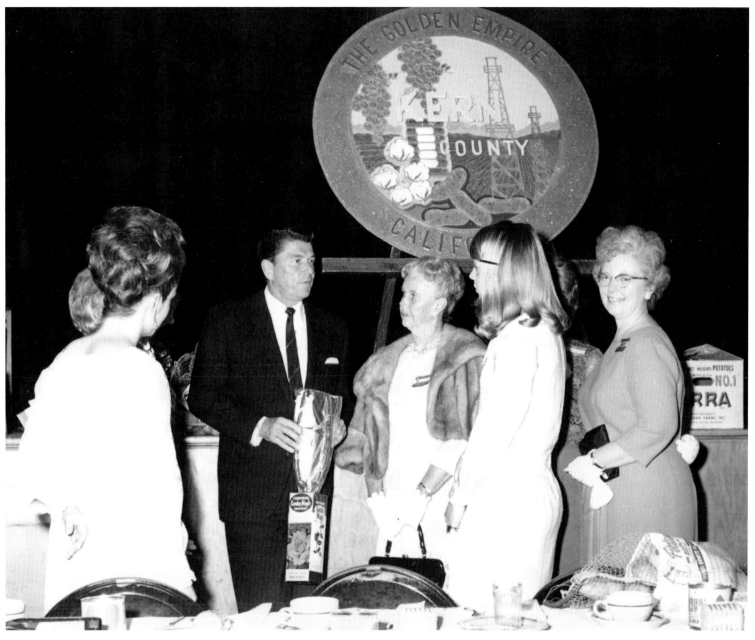

The original "Reagan Country" was in Kern County where Reagan campaigned in 1966. Planted in California's agricultural central valley, Kern County enjoyed a population rise of almost 65 percent between 1935 and 1940, largely composed of migrants fleeing the "dust bowl" states. By the time of this photograph, being an "Okie" was a source of pride. According to author Rick Wartzman, "Kern began to swing further to the right, solidly backing Reagan for governor and voting more conservatively than the rest of the state on a range of issues: the death penalty, marijuana legislation, school busing, and gay rights."

The Reagans celebrate his election over Democratic governor Edmund "Pat" Brown by almost 1 million votes at the Biltmore Hotel in downtown Los Angeles on November 8, 1966.

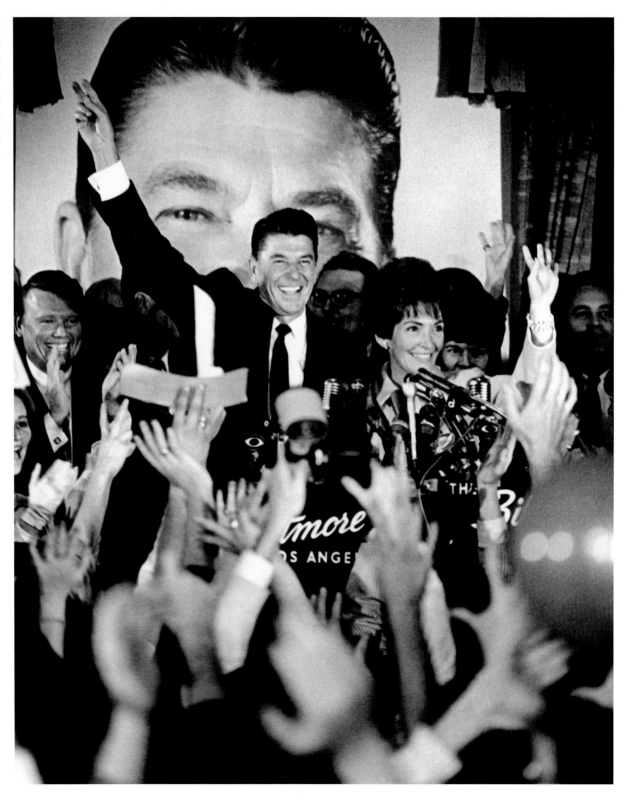

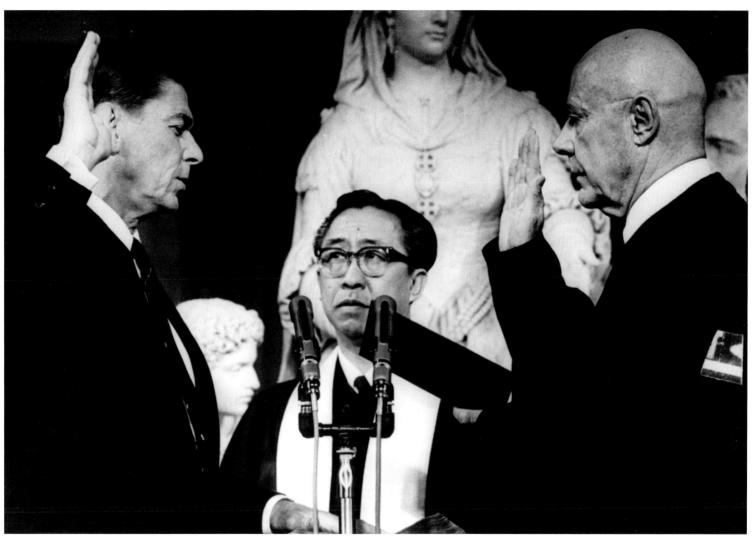

Reagan is sworn in as governor on January 2, 1967, by California Supreme Court Justice Marshall McComb while Wilbur Choy observes the ceremony. Reagan was already officially governor, having been sworn in immediately after midnight on January 1, stating that he aimed to preclude last-minute appointments by outgoing Governor Brown.

Nancy fixes her famous "gaze" on him while Reagan speaks at the Governor's Inaugural Ball on January 5, 1967. The former actress added glamour to the Reagans with her haute couture. At this event she wore a Galanos-designed ivory one-shoulder wool crepe evening gown trimmed with diamond daisies. She later donated the gown to a Los Angeles museum. In 2007, the Reagan Library and Museum opened an exhibit of Nancy's apparel worn during Reagan's political career.

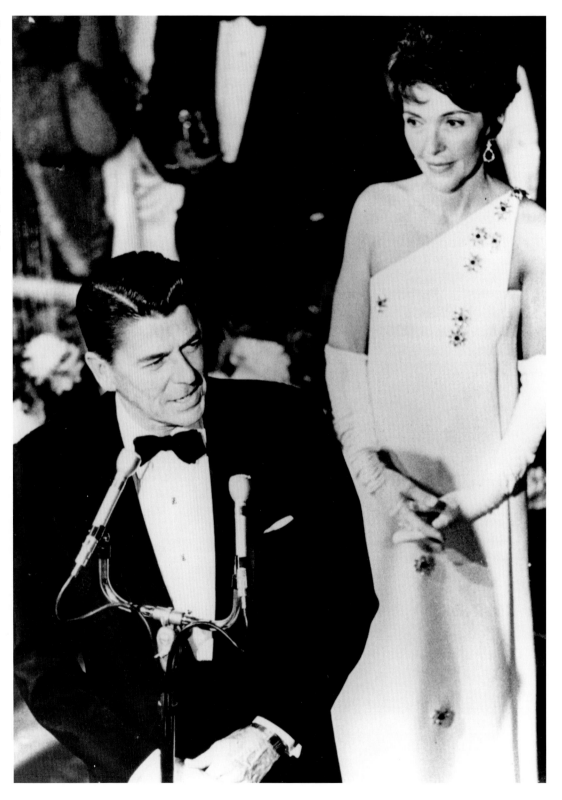

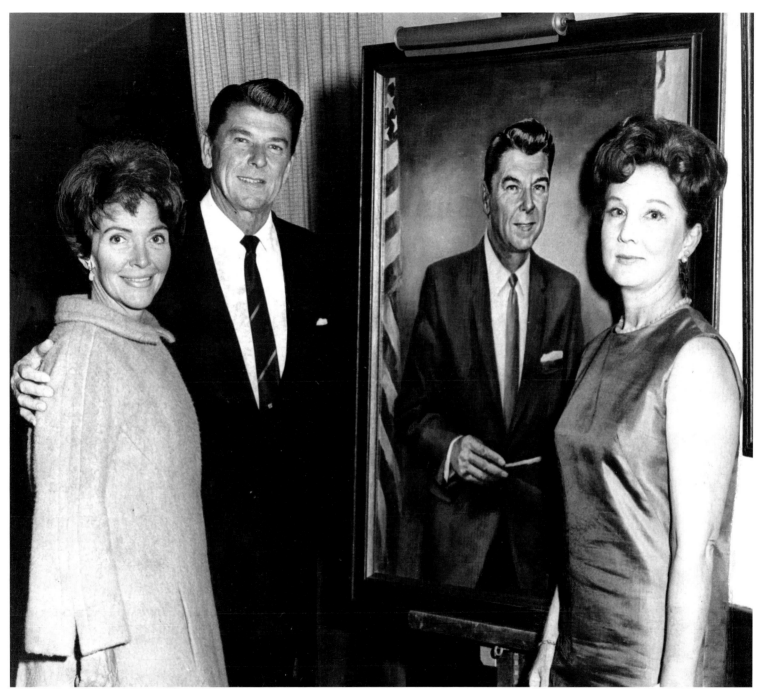

Reagan was very photogenic as evidenced by his motion picture career, and his governorship was now memorialized by portrait paintings like the one unveiled at a Republican dinner in the Balboa Bay Club on April 15, 1967.

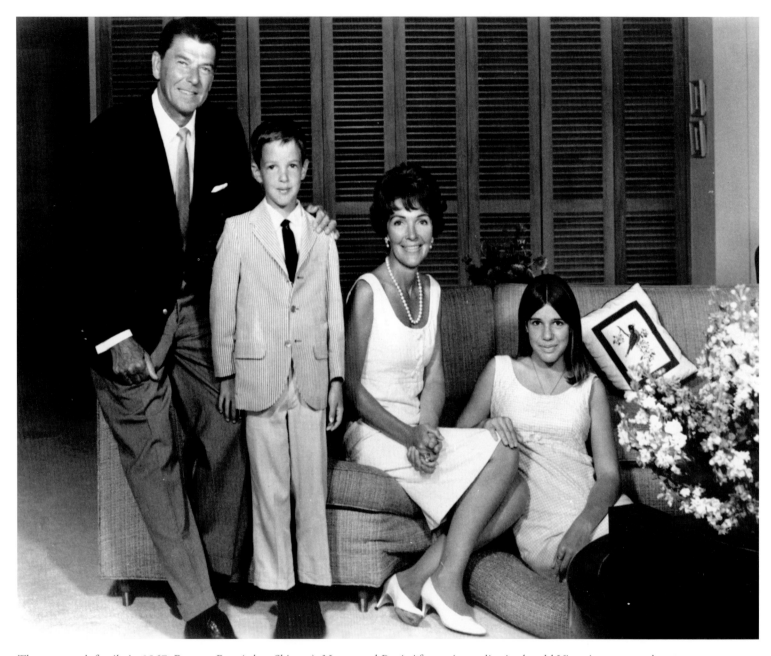

The governor's family in 1967: Reagan, Ron (a.k.a. Skipper), Nancy, and Patti. After trying to live in the old Victorian governor's mansion, the Reagans moved to newer digs in an exclusive part of Sacramento. Declared a "firetrap" as a residence, the governor's mansion in downtown Sacramento became a museum.

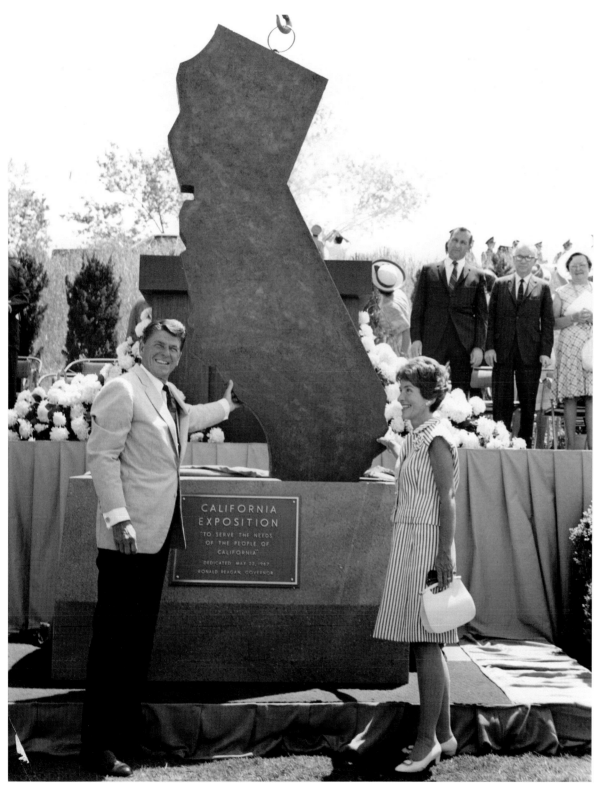

The Governor and First Lady preside at the dedication of the California Exposition on May 22, 1967. Inscribed are the words "To Serve the Needs of the People of California," a motto Reagan internalized while serving two terms in Sacramento.

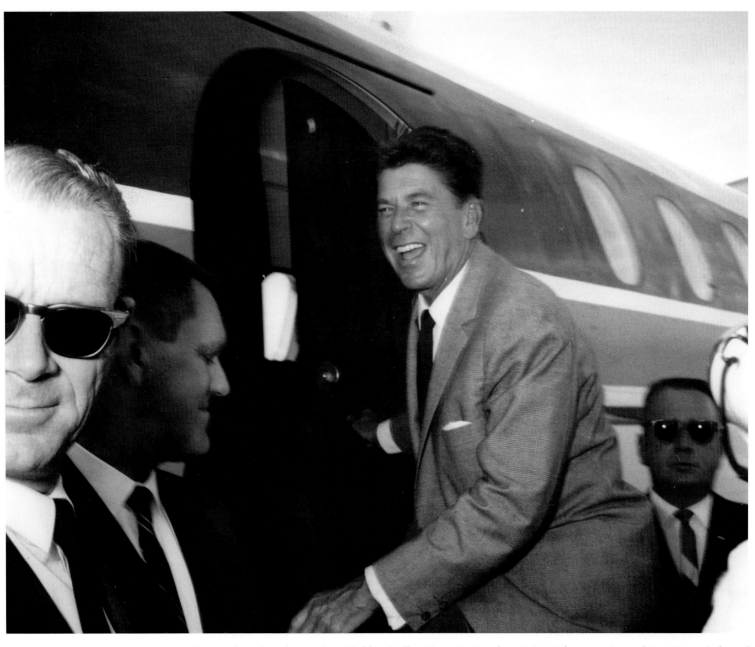

Reagan boards a plane at Love Field in Dallas, Texas, in October 1967. Before entering politics, Reagan's fear of flying kept him riding trains during his employment with General Electric.

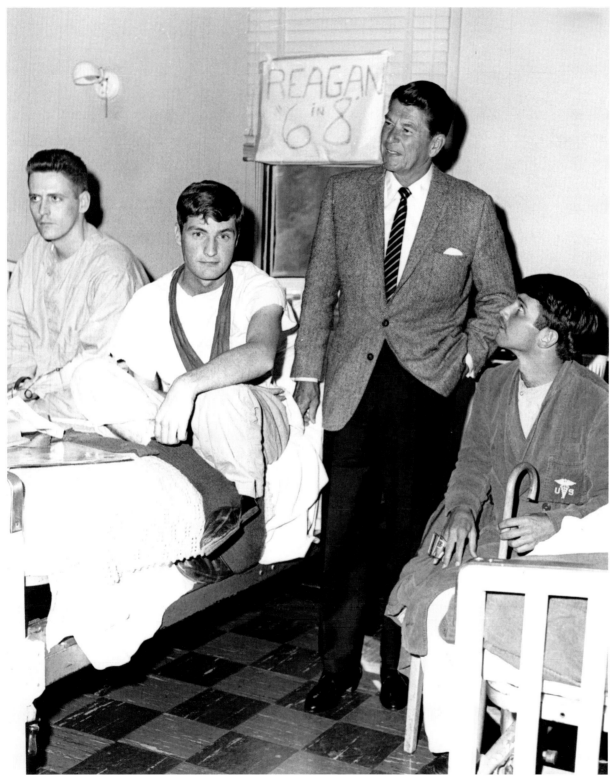

Reagan met with wounded sailors convalescing from war injuries sustained in Vietnam at Oak Knoll Naval Hospital, Oakland, California, in 1968. On the window behind him, a handmade sign supports Reagan's first presidential campaign that year.

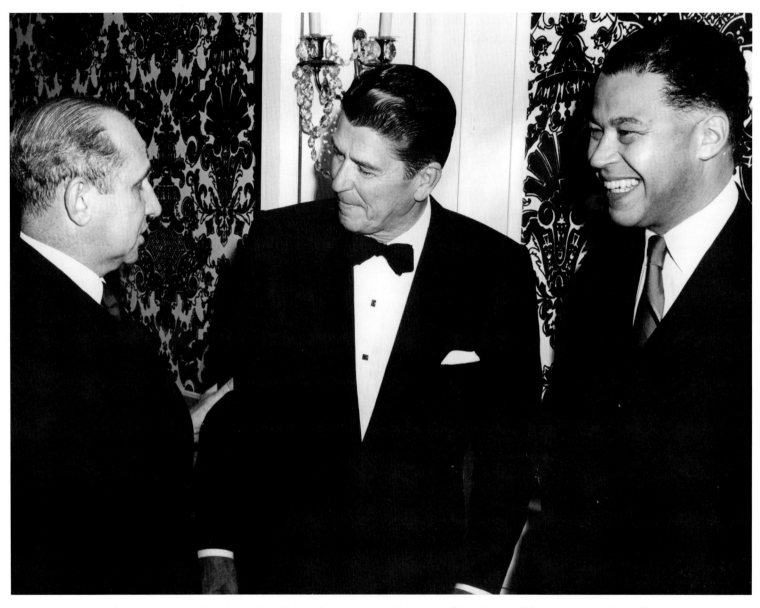

Governor Reagan welcomes Senator Edward Brooke of Massachusetts to the University of Southern California, Los Angeles. A liberal Republican, Brooke supported the candidacy of Governor Nelson Rockefeller in his bid for the Republican presidential nomination in 1968, over Nixon or Reagan. Nixon won the nomination and the general election. Brooke, a senator from 1967 to 1979, was the first popularly elected African-American in the U.S. Senate and one of the first senators to call for Nixon's resignation after the Watergate scandal.

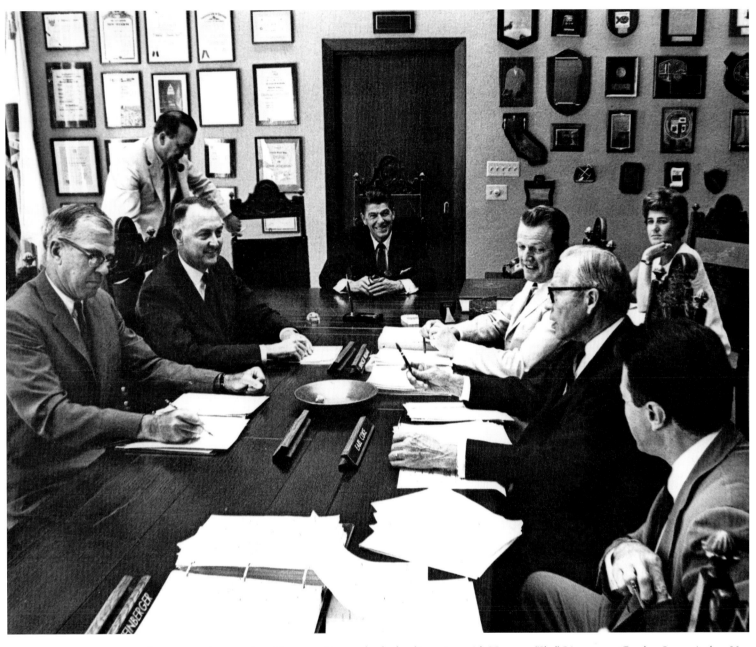

In an executive meeting, Governor Reagan leads the discussion with Norman "Ike" Livermore, Gordon Luce, Arthur Van Court, Stuart Spencer, and Caspar Weinberger. Lyn Nofziger is standing; the woman at right is unidentified.

Republican governor James A. Rhodes of Ohio (1963-1971 and 1975-1983) meets with Governor Reagan. Like Reagan, Rhodes used humor to attract voters to his political positions. Unlike Reagan with his self-described "mess at Berkeley," Rhodes' second term came to a tragic end when he ordered National Guardsmen onto the campus of Kent State University to quell anti-war protests, a clash that left four students dead and nine injured. At the University of California–Berkeley, Reagan's hard-line rhetoric and actions against the People's Park student uprising on May 15, 1969, put down the disturbance, with one fatality and scores injured.

At Reagan's second inaugural, the First Couple excitedly receive warm congratulatory applause.

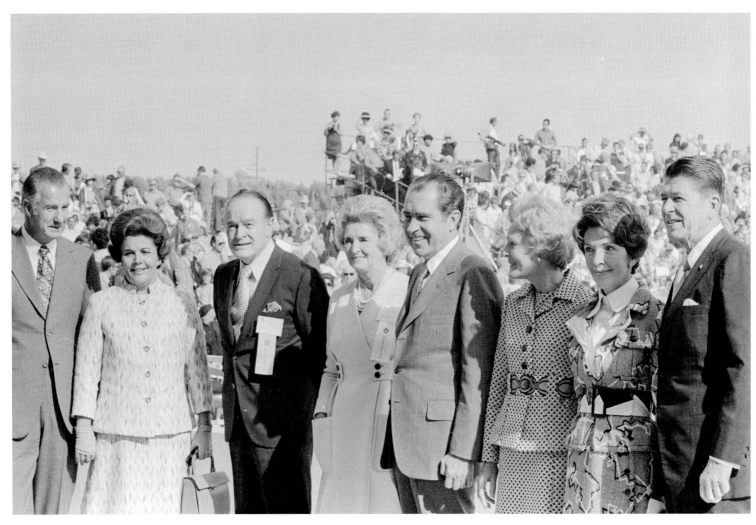

Vice-president Spiro Agnew and wife Judy, Bob and Dolores Hope, President Richard M. Nixon and First Lady Pat Nixon, and Nancy and Governor Reagan met on November 27, 1971. The next year, the Watergate burglary of the Democratic National Headquarters preceded Nixon's landslide victory over George McGovern. In 1973, Agnew resigned over corruption charges and Nixon resigned in 1974 in the aftermath of the Watergate scandal.

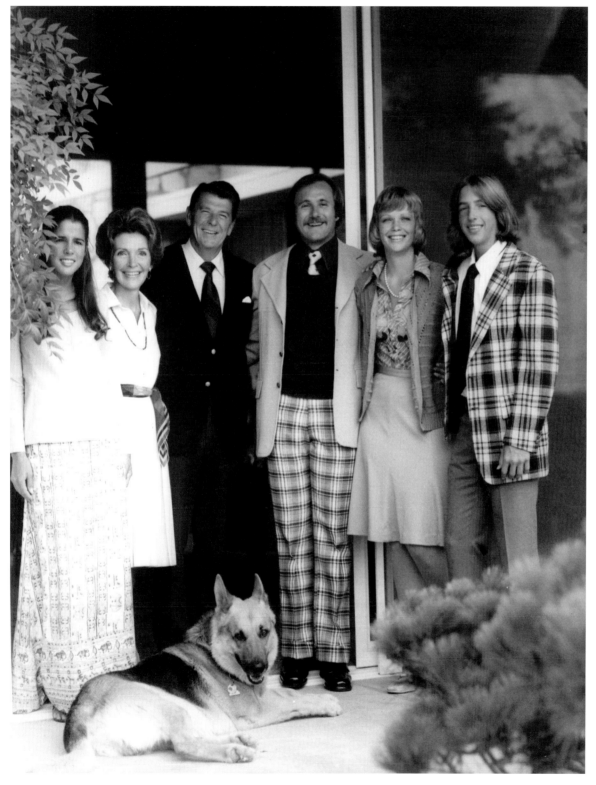

In 1976, the Reagans pose at home with the family German shepherd: (left to right) Patti Davis (the screen name she assumed as an actress), Nancy, Reagan, Mike, Maureen, and Ron. Maureen, a registered Republican before her father, died in 2001.

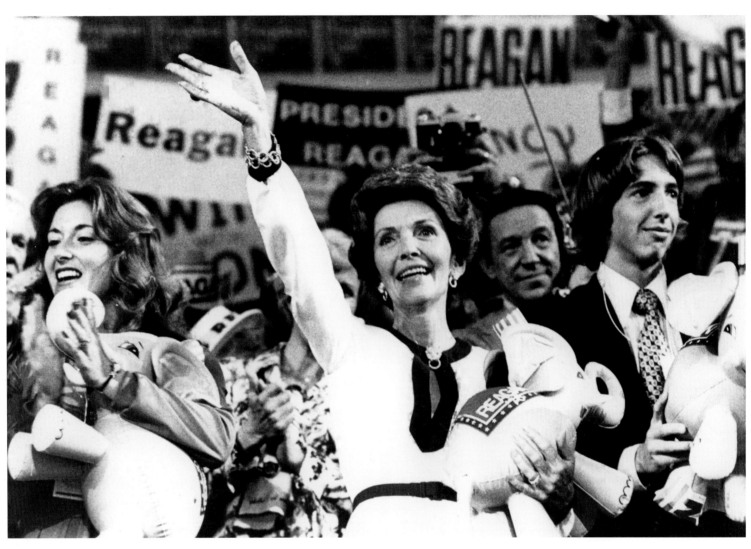

Nancy and son Ron are observed by correspondent Mike Wallace of CBS while they enjoy the adulation of the delegates at the 1976 Republican National Convention.

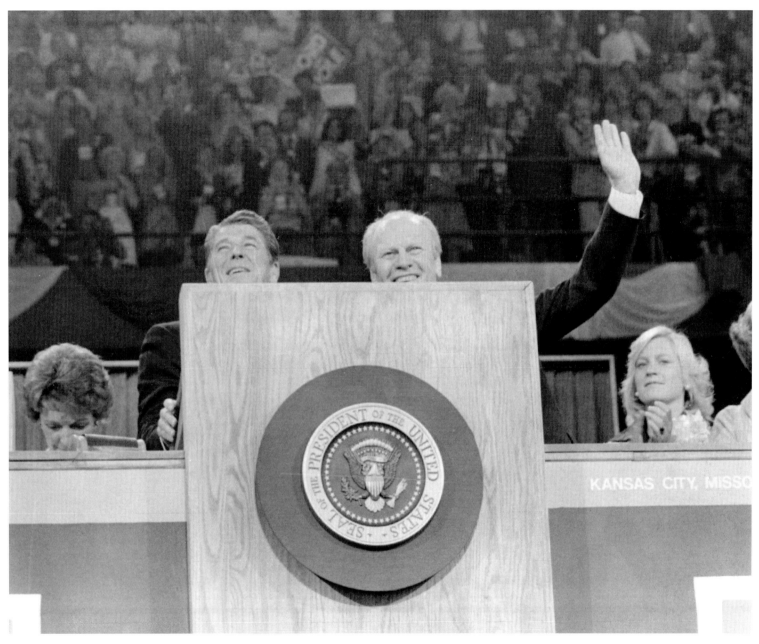

After he endorsed the president's nomination, Reagan and President Gerald R. Ford posed together at the 1976 Republican Convention. Ford had narrowly won the nomination and always blamed Reagan for his loss to Jimmy Carter in November. Advisors had warned Ford that Reagan would present a difficult challenge, especially after picking Governor Nelson Rockefeller, not Governor Reagan, as his vice-president in 1974. Thus the die was cast for Reagan's challenge to the unelected appointee to the presidency. An aide to Ford, Gerald T. Hartman said, "Ford thought Reagan was a phony, and Reagan thought Ford was a lightweight, and neither one felt the other was fit to be president."

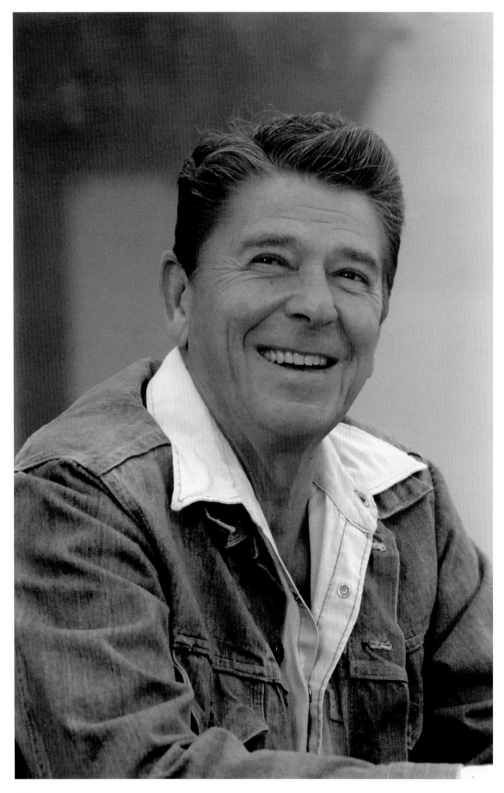

Reagan relaxed in relative retirement at his beloved Rancho del Cielo (Ranch of the Sky) when he wasn't traveling to make lucrative speeches or recording his radio commentaries. The CBS television network had offered him a regular spot commenting on current political events, but he chose radio instead. Reagan thought people would tire of watching him on television.

CAMPAIGNING AND THE PRESIDENCY

(1976–1989)

Ronald Reagan burst onto the national political scene in the waning days of Senator Barry Goldwater's 1964 Republican campaign for president. In his "Time for Choosing" speech, Reagan championed the conservative movement on the night of October 27, 1964, broadcast in support of the campaign: The Founding Fathers knew that "government can't control the economy without controlling people. And they knew when a government sets out to do that, it must use force and coercion to achieve its purpose. . . . You and I have a rendezvous with destiny. We will preserve for our children this, the last best hope of man on Earth, or we will sentence them to take the last step into a thousand years of darkness." In the sixteen years that followed, including two failed attempts at the Republican nomination in 1968 and 1976, Reagan mounted a campaign for president based on his conservative ideology. Upon his election in 1980, Reagan began a drive to end decades of liberal Democratic control of government in the United States of America.

For good and bad Iran provided two bookends at the beginning and end of Reagan's presidency. In 1981, Iran waited until Carter left office to release the American hostages, adding to the euphoria of Reagan's inaugural. In 1988, 14 administration officials were indicted in what was dubbed the Iran-Contra scandal. It was determined that the United States had supplied weapons to Iranian moderates to effect the release of six American hostages held by Hezbollah, an apparent "arms-for-hostages" deal not sanctioned by Congress. Lieutenant Colonel Oliver North of the National Security Council then used some of the proceeds from weapon sales to fund anti-communist rebels (the Contras) fighting Nicaragua's Sandinista government. Eleven U.S. officials were convicted, including longtime Reaganite Caspar Weinberger. The Tower Commission, headed by Senator John Tower, absolved President Reagan of liability in the matter. Reagan took to the airwaves, however, assuming responsibility. The convicted were subsequently pardoned by President George H. W. Bush.

Some of the highlights of President Reagan's two terms as President follow.

1980

November: Elected president in a landslide, Reagan's coattails win him the first Republican Senate in decades. Democrats retain control of the House of Representatives.

1981

January: Reagan assumes the office of President of the United States. Within minutes, the 52 Americans held hostage by Iran for 444 days are set free.

March: An attempt on President Reagan's life is unsuccessful.

July: Congress passes the president's tax reduction legislation and a budget that cuts spending, ushering in the era of "Reaganomics."

August: Reagan fires PATCO air traffic controllers.

1982

May: Reagan announces his nuclear weapons reduction initiative START.

June: The president addresses Parliament and consigns the U.S.S.R. to the "ash heap of history." He meets with Pope John Paul II.

1983

March: President Reagan announces his Strategic Defense Initiative or SDI.

April: The president signs the Social Security Bill, passed with bipartisan support.

October: United States Marines are killed in a suicide bombing in Beirut, Lebanon. Grenada is invaded to free the island of Cuban domination.

1984

April: President Reagan and the First Lady visit China.

June: Ireland and France play host to America's First Couple.

August: Reagan is nominated for a second term by the Republican Party.

November: President Reagan wins 49 states in a re-election landslide.

1985

January: President Reagan is inaugurated for his next term. Saudi Arabia increases production and oil prices plunge, pressuring the U.S.S.R.

June: The hijacking of a TWA jet in Lebanon is resolved with the release of American hostages.

July: President Reagan undergoes surgery for removal of cancerous polyps.

November: A first summit is held between Soviet leader Mikhail Gorbachev and President Reagan.

1986

January: The Space Shuttle *Challenger* explodes after launch, ending in the deaths of seven crew members. The president addresses the nation.

April: With hard evidence of its ties to terrorism, Reagan orders air strikes against Libya. France and Spain deny the U.S. overflight rights to carry out the operation, which succeeds in deflating the ambitions of dictator Muammar Khaddafi.

October: Reagan signs a drug enforcement bill signaling the "war on drugs," with Nancy serving as spokesperson. In Iceland, Gorbachev insists that Reagan stop SDI development and Reagan refuses.

November: The Immigration Reform and Control Act offers amnesty to three million illegal aliens and criminalizes the hiring of undocumented workers, in a bid to enforce immigration laws.

1987

January: President Reagan is treated for prostate cancer. Senator John Tower's commission questions the president about Iran-Contra.

June: The president demands that Gorbachev tear down the Berlin Wall.

December: Gorbachev agrees to the terms of the INF Treaty in a White House ceremony.

1988

February: The Supreme Court is reconfigured with the third Reagan appointee to the court.

March: Indictments are handed down in the Iran-Contra affair.

June: INF treaty ratifications are signed by President Reagan and Soviet leader Gorbachev.

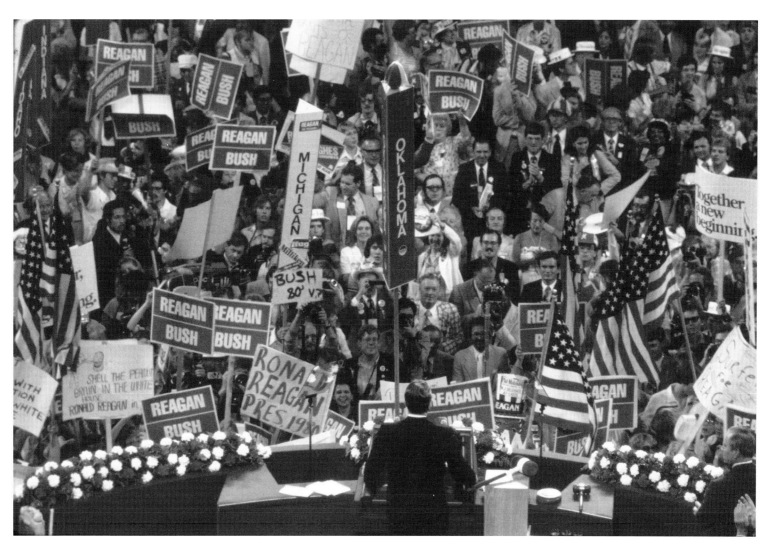

Reagan appears before the 1980 Republican Convention to accept the nomination for president. In a surprise move, Reagan offered the vice-presidency to former President Gerald R. Ford. Ford refused after Reagan could not agree to Ford's demand for a greatly enhanced role. Both were said to be relieved and Ford's preferred candidate George H. W. Bush was chosen instead. Reagan won the election with 489 electoral votes from 44 states and almost 51 percent of the popular vote.

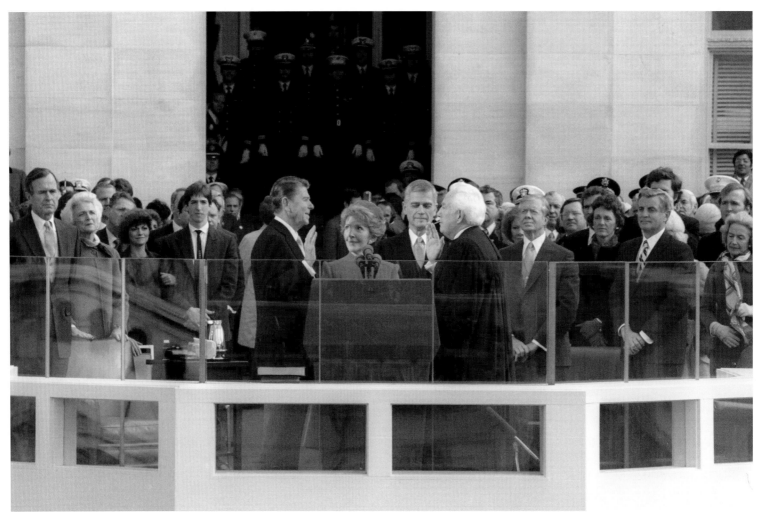

During the swearing-in ceremony on January 20, 1981, at the Capitol are (left to right) Vice-president George H. W. Bush and Barbara Bush, Doria Reagan and Ron Reagan, President Ronald Reagan, First Lady Nancy Reagan, Supreme Court Chief Justice Warren Burger, President Jimmy Carter, Eleanor Mondale and Vice-president Walter Mondale, and former first lady Lady Bird Johnson.

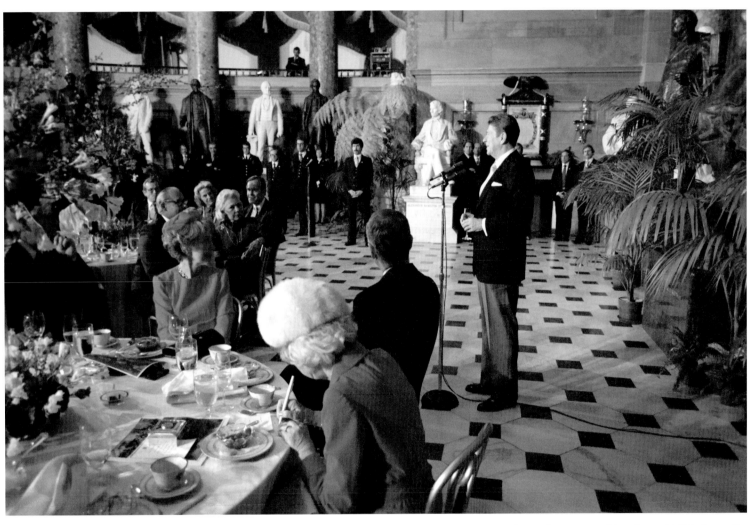

President Reagan announces the release of 52 U.S. diplomats, held hostage in Iran, during his inaugural luncheon. Political pundits factored the hostages' 444 days of captivity as contributing to Carter's defeat by Reagan.

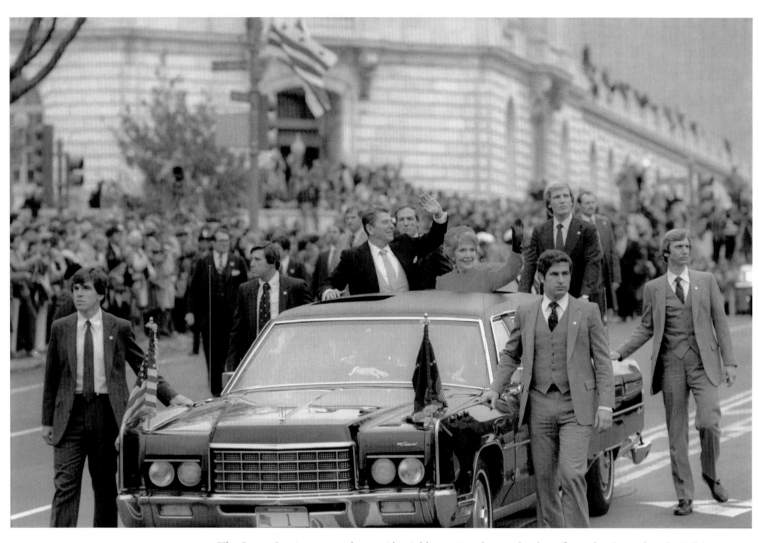

The Secret Service escorts the presidential limousine during the drive from the Capitol to the White House.

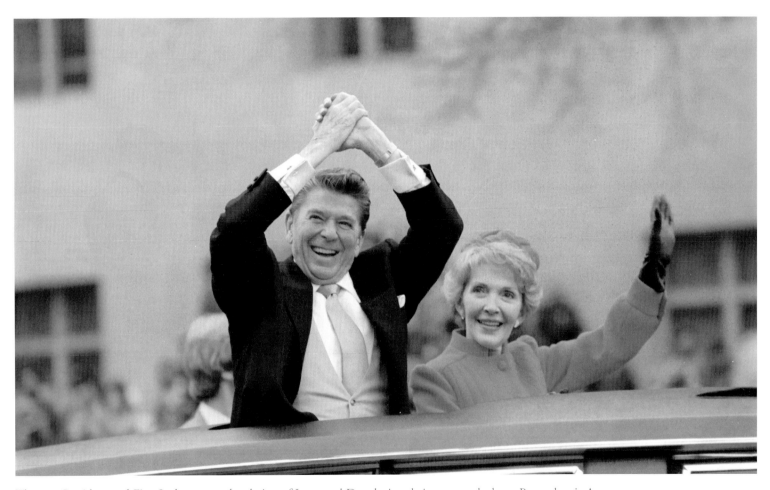

The new President and First Lady express the elation of Inaugural Day during their motorcade down Pennsylvania Avenue.

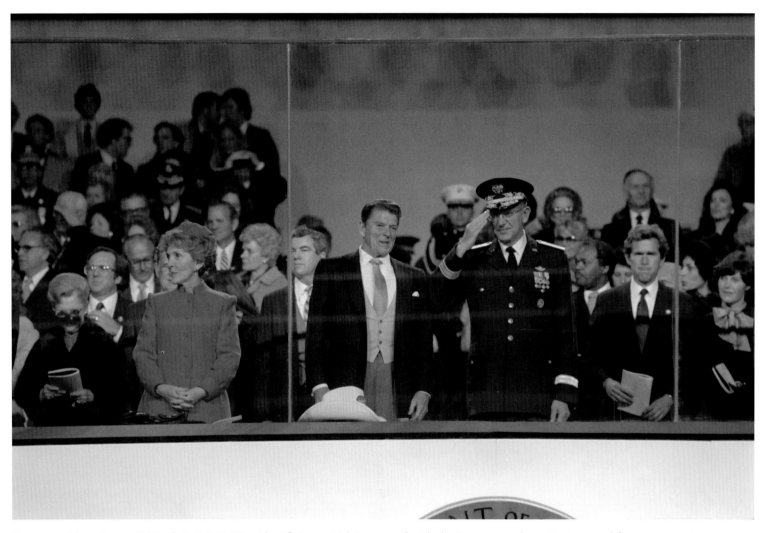

Future president George W. Bush (2001-2009) with wife Laura (right) appeared with the Reagans on the reviewing stand for the 1981 Inaugural Parade down Pennsylvania Avenue.

Ronald Reagan and Nancy Reagan pose for the camera in formal evening attire at the White House before attending the Inaugural balls.

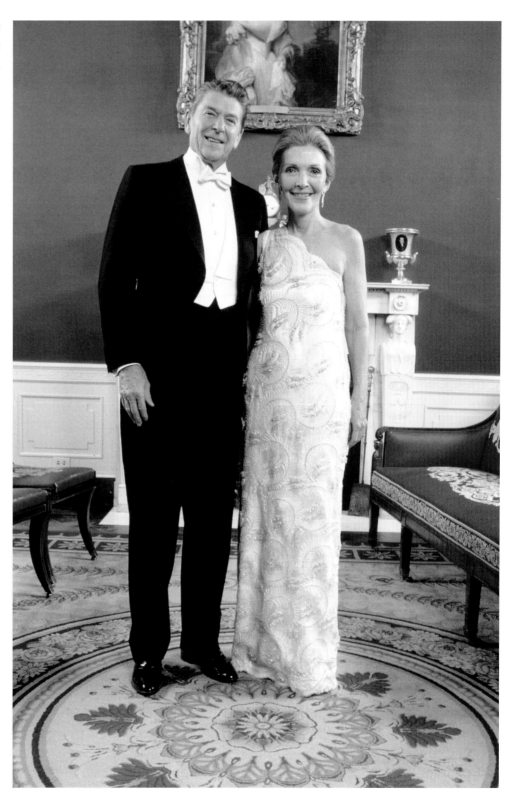

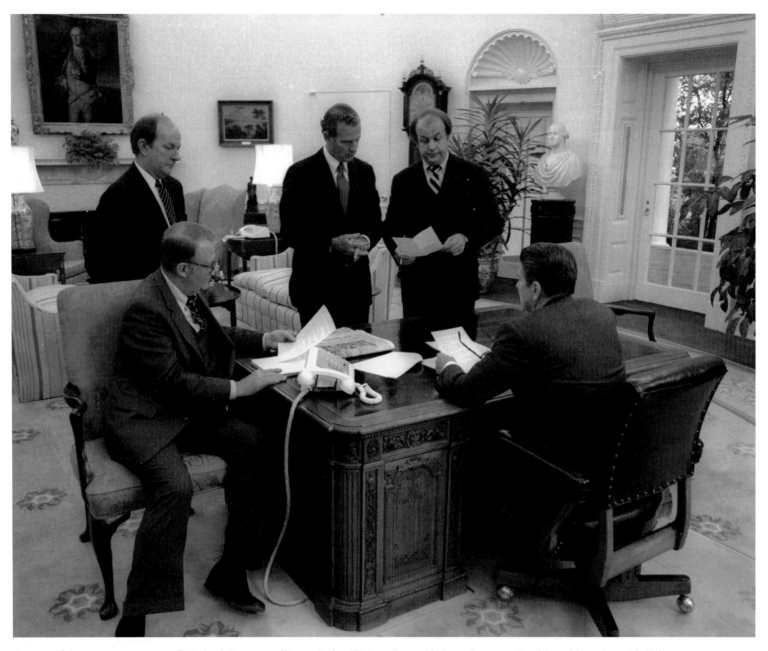

A successful management team of Michael Deaver and James Baker III (standing with Press Secretary Brady) and longtime aide Ed Meese III (sitting) with President Reagan. Charged by critics with being merely an actor, dependent on the words and ideas of his handlers, Reagan to the contrary delegated management of the White House to platoons of assistants. "He treats us all the same, as hired help," Baker observed. Treasury Secretary Donald Regan would swap jobs with Baker in 1985, later resigning as a result of clashes with the First Lady and for mismanaging the White House response to the Iran-Contra affair.

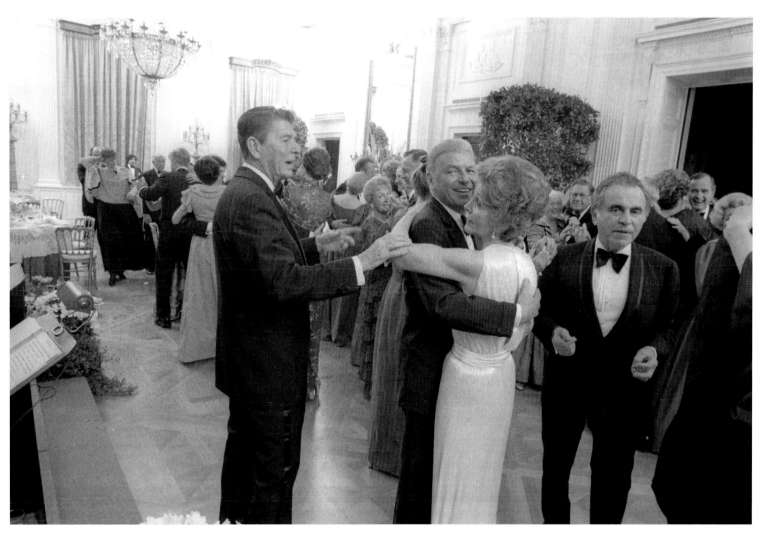

President Reagan cuts in on Frank Sinatra and Nancy while dancing at Reagan's 70th birthday party on February 6, 1981. Though longtime friends, rumors of Sinatra's mafia ties created questions that the President and First Lady publicly hoped were untrue.

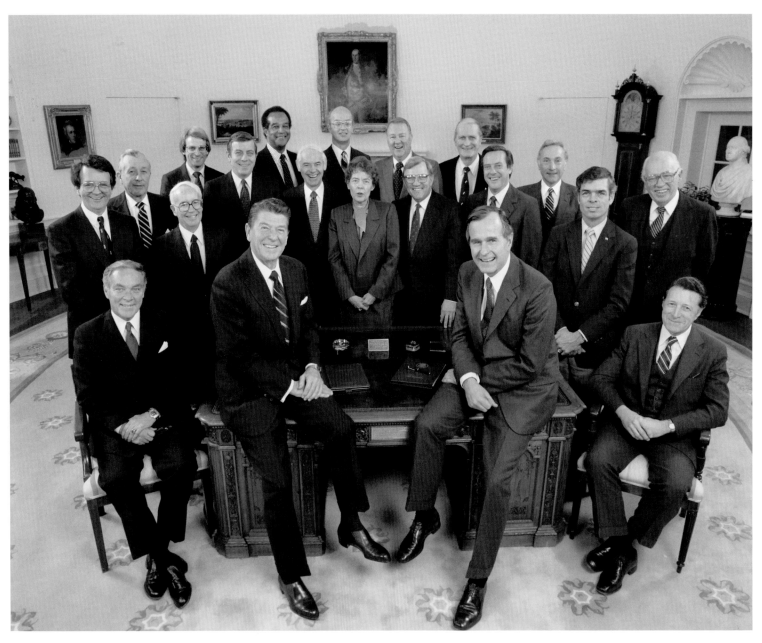

The President and Vice-president are flanked and backed by the cabinet secretaries and cabinet-level appointees, including Ambassador to the United Nations Jeane Kirkpatrick, the first woman to hold the post. (First row:) Alexander Haig, Secretary of State; President Reagan; Vice-president Bush; and Caspar Weinberger, Secretary of Defense. (Second row:) Raymond Donovan, Secretary of Labor; Donald Regan, Secretary of the Treasury; Terrel H. Bell, Secretary of Education; David Stockman, Director, Office of Management and Budget; Andrew Lewis, Secretary of Transportation; Samuel Pierce, Secretary of Housing and Urban Development; William French Smith, Attorney General; James Watt, Secretary of the Interior; Jeane Kirkpatrick; Edwin Meese III, Counselor to the President; James Edwards, Secretary of Energy; Malcolm Baldrige, Secretary of Commerce; William E. Brock, United States Trade Representative; Richard Schweiker, Secretary of Health and Human Services; John Block, Secretary of Agriculture; and William Casey, Director, Central Intelligence Agency.

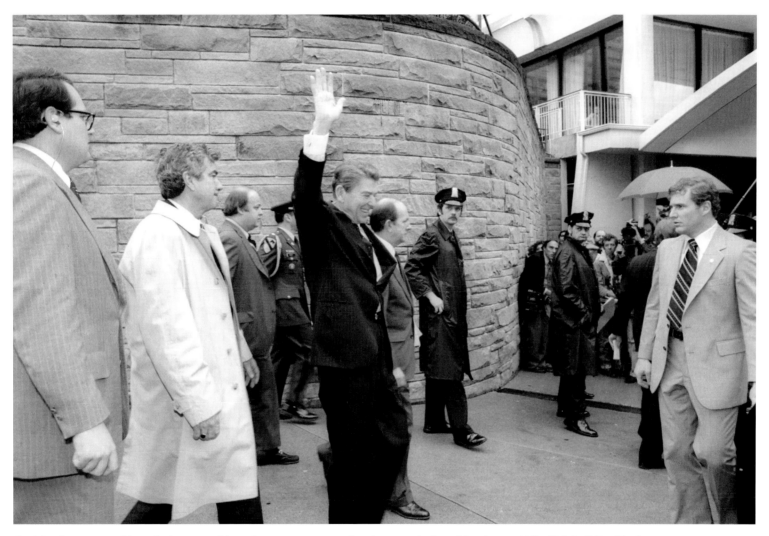

On March 30, 1981, his 70th day as president, Reagan waves to a cheering crowd after addressing an AFL-CIO Building Trades Council meeting at the Washington Hilton Hotel. The shooting of President Reagan followed. In the melee would be Secret Service agent Jerry Parr, Press Secretary James Brady (victim), Michael Deaver, Washington D.C. police officer Thomas K. Delahanty (victim), Secret Service agent Timothy McCarthy (victim), and would-be assassin John Hinckley, Jr.

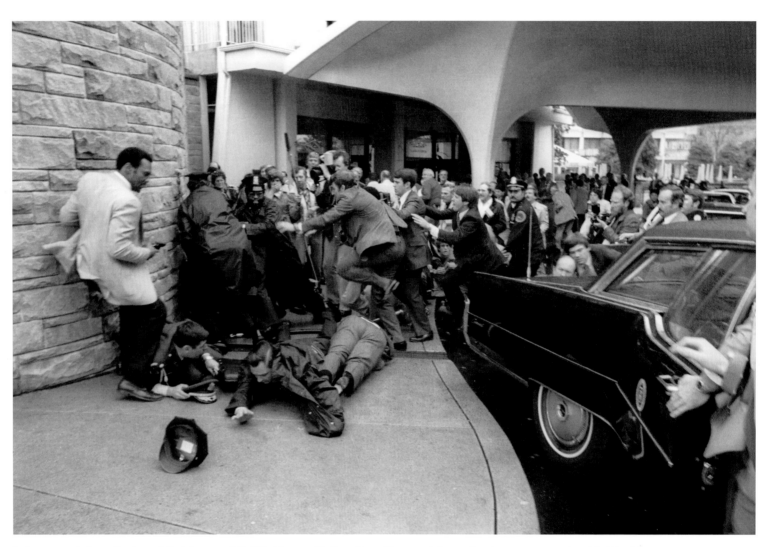

Lying wounded are Brady and Delahanty, while Washington D.C. police officers and Secret Service agents wrestle with Hinckley following the attempt on Reagan's life. The Secret Service agent closed the limo door while the speeding limousine transported the President to the hospital.

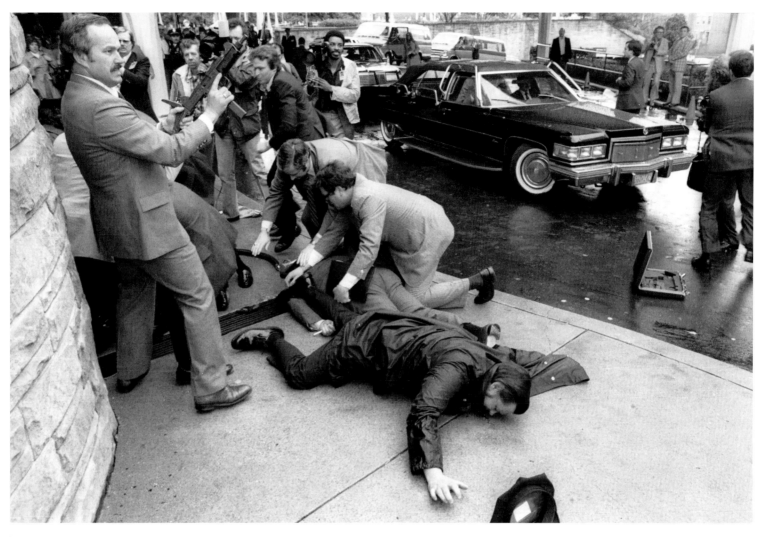

A Secret Service agent brandishes a machine gun while two agents assist Press Secretary James Brady, whose wound was caused by an exploding "devastator" .22-caliber bullet. Officer Delahanty is face down on the pavement. Brady never returned to his post, but he and his wife Sarah spearheaded a push for gun control, which became the "Brady Bill" passed by Congress and signed by President Bill Clinton on November 30, 1993.

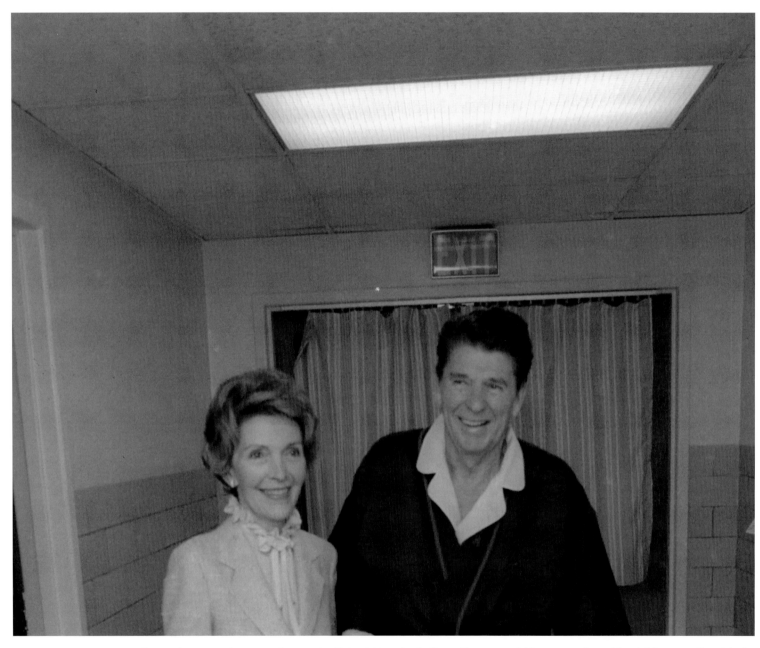

Reassuring an anxious populace on April 3, 1981, a day before a fever caused him to cough up blood, Nancy walks with the President to demonstrate his improving health. Reagan made a rapid recovery from his wounds.

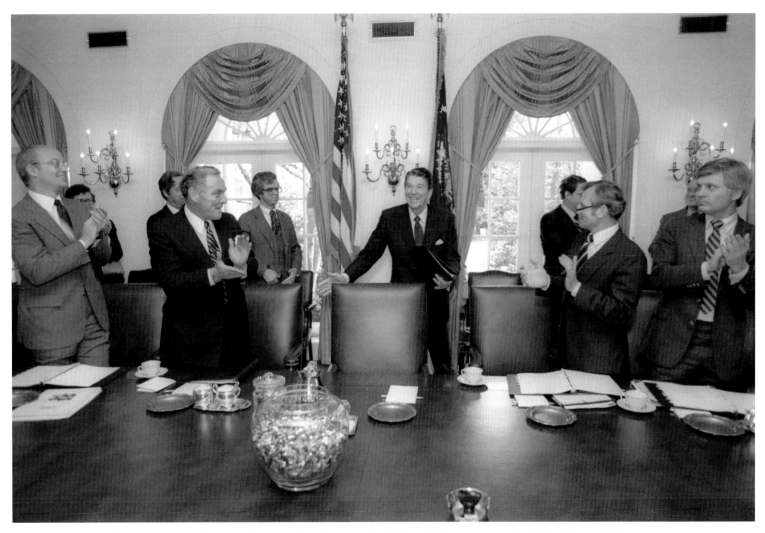

The omnipresent jelly bean jar is a welcome sight as the President is applauded on his first return to the White House Cabinet Room following the attempted assassination. Reagan's habit of distributing his favorite candy at cabinet meetings began on his first day as California governor. Reagan later quipped to candy maker Henry Rowland, "We can hardly start a meeting or make a decision without passing around the jar of jelly beans."

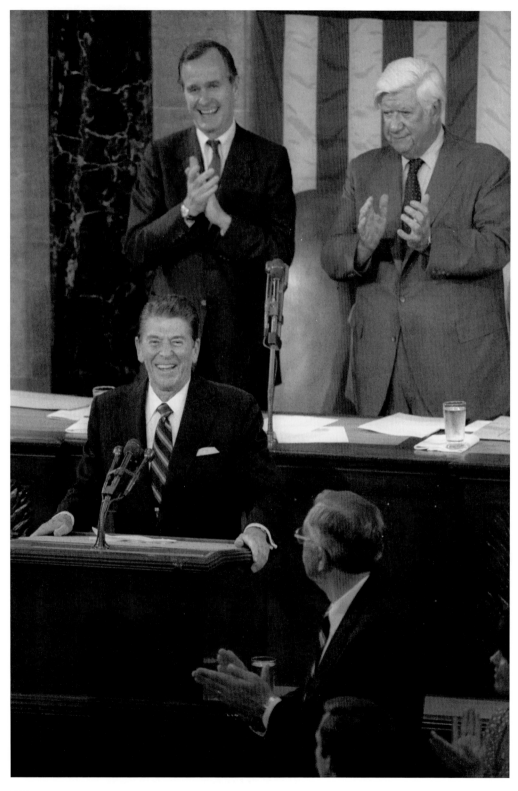

In his first speech after the attempt on his life, Reagan rolled out his program for economic recovery on April 28, 1981. Pictured with Vice-president Bush and House Speaker Tip O'Neill, Reagan was enjoying a burst of popularity on the heels of recovering from gunshot wounds inflicted by Hinckley. Reagan and O'Neill, both of Irish descent, often swapped jokes but clashed when they disagreed.

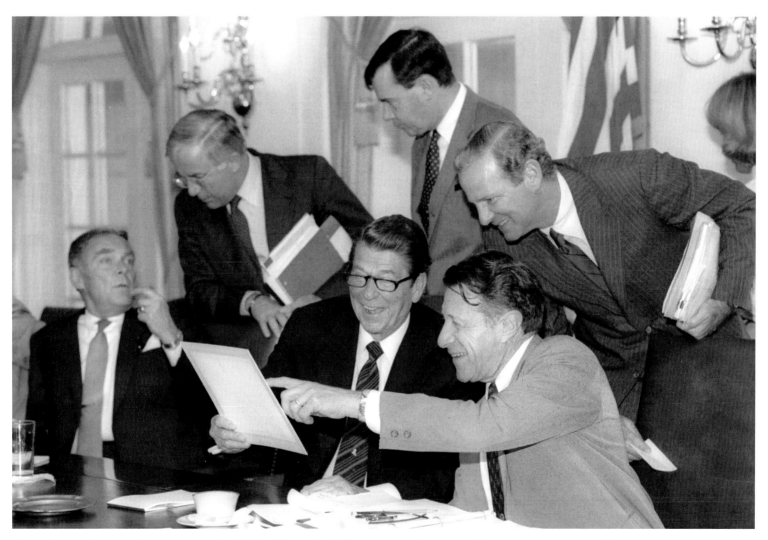

General Alexander Haig, former Nixon Chief of Staff (seated at left), was Reagan's secretary of state for 18 stormy months. Longtime aide, as far back as Reagan's governorship, was Caspar Weinberger (seated right), who served as secretary of defense. James Baker, standing at right, was a good friend of Vice-president Bush, serving as chief of staff in Reagan's first term and secretary of the treasury in the second term. Baker also served as secretary of state for future President George H. W. Bush (1989-1993).

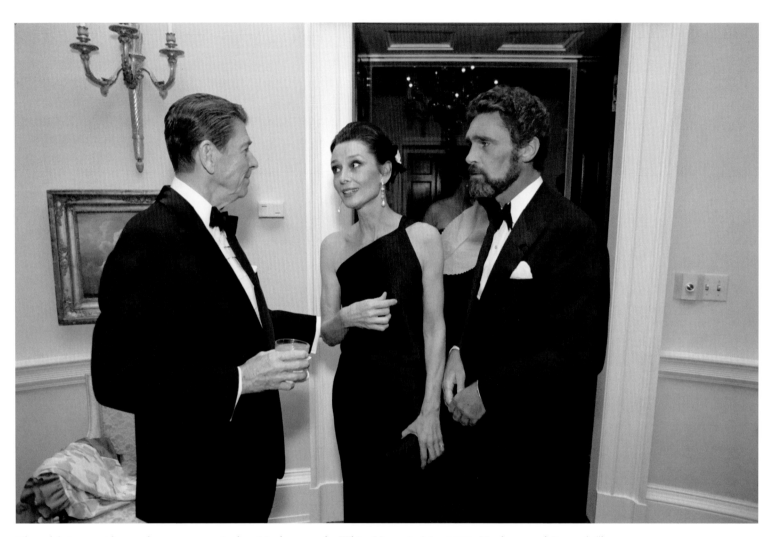

The celebrity president welcomes actress Audrey Hepburn to the White House in May 1981. Hepburn and Reagan's "best man" Bill Holden starred in the 1954 film *Sabrina*. She served as a Goodwill Ambassador for UNICEF, having been the beneficiary of United Nations relief meals in the Netherlands after World War II. Reagan's successor President George H. W. Bush awarded Hepburn the Presidential Medal of Freedom in 1992. In 1999, the American Film Institute ranked her third greatest female star of all time.

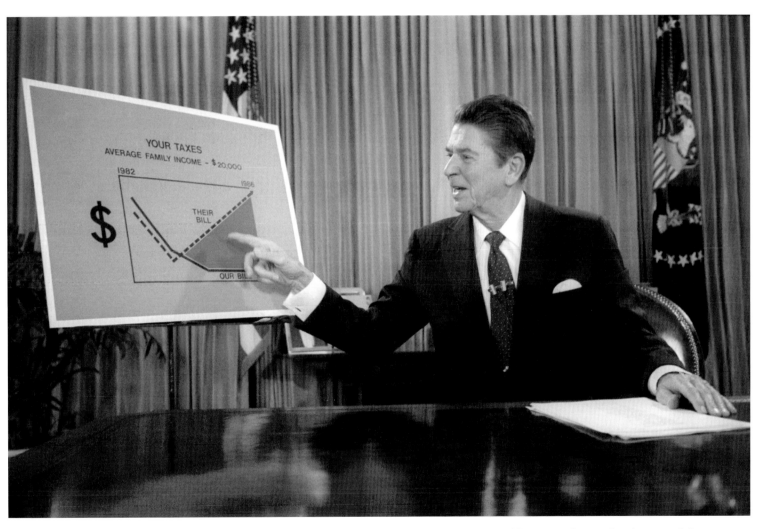

Handed Reagan's high approval ratings, the Congress passed his Tax Reduction legislation on July 29, 1981. The tax bill legislation reduced income taxes by 25 percent over three years and a bipartisan budget bill reduced government spending, jointly earning the name "Reaganomics." By 1987, the national economy was surging forward and Americans on the whole were experiencing what would become the longest period of peacetime prosperity on record.

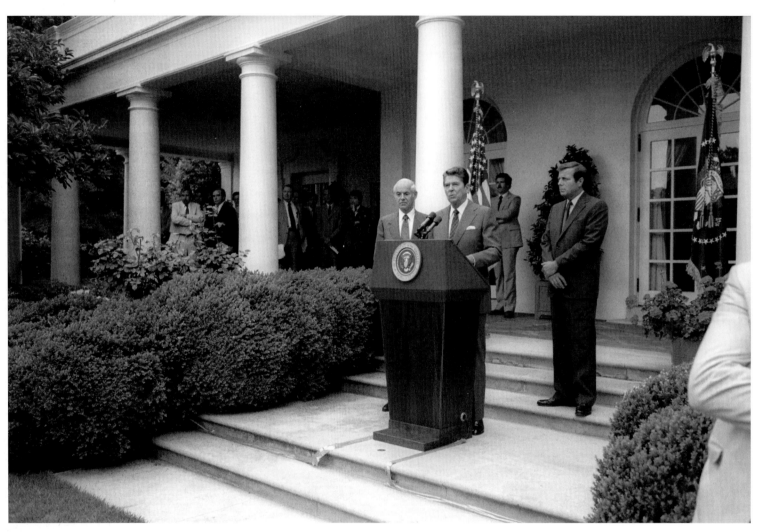

When all U.S. Air Traffic Controllers walked out on strike, Reagan sent a message to the country, and indeed the world, that he meant business. In the Rose Garden on August 3, 1981, Reagan cited a paragraph from the oath each PATCO (union) air traffic controller had signed: "That he or she will not strike against the United States Government or any of its agencies." The president offered the strikers 48 hours to return to service or be separated from employment. As of noon on August 4, 35 percent of the air controllers were back at work and 65 percent of air traffic was normal. The others, having concluded erroneously that Reagan was bluffing, were handed their pink slip.

The president's easy Marlboro man persona, faith in America, and his commitment to a tough American foreign policy helped restore American confidence. Americans gave him the license to just be Reagan, earning him the nickname "Teflon President." No matter what happened in his administration, nothing bad ever stuck to him personally. Liberals tried to paint Reagan with clichés: "the dimwit, the rigid monomaniac, the extremist who owed his success purely to communication skills." In fact he was a realist and pragmatist who proved himself capable of compromise with liberals—when necessary.

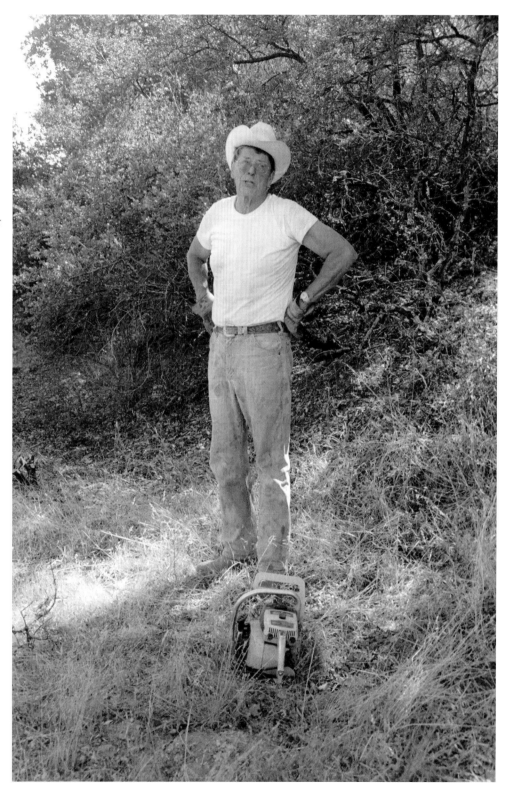

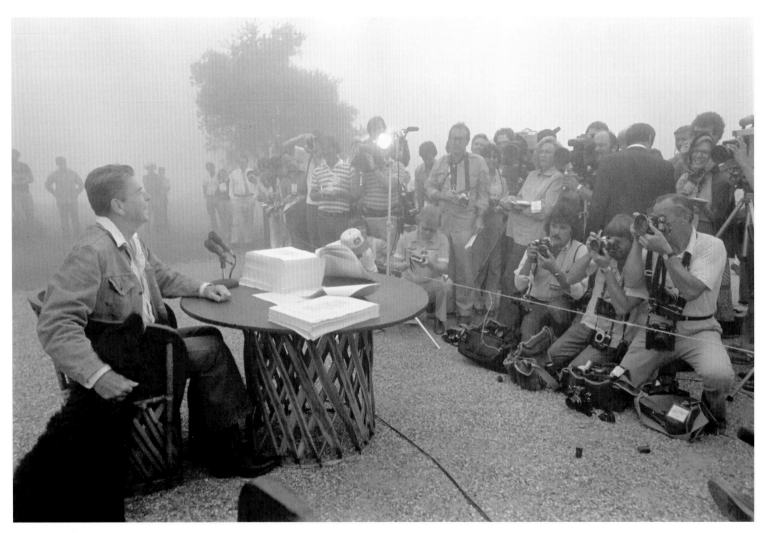

In the "Brigadoon" setting of foggy Rancho del Cielo, Reagan signed the largest tax reduction and spending control bills in history. Federal deficits continued past his terms as president—the defense bills he deemed necessary increased military spending by $26.4 billion, and the spending habits of Congress were already a legend inseparable from truth.

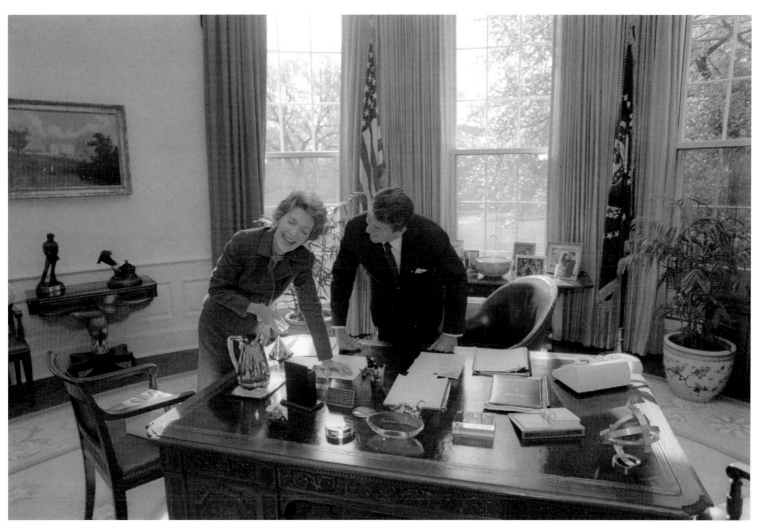

"Nancy with the Laughing Face," a song Frank Sinatra sang to the First Lady at an inaugural event earlier in 1981, was apropos. Here the Reagans share a laugh in the Oval Office that November.

Reagan was a "meat and potatoes" man who enjoyed simple lunches in the family quarters of the White House.

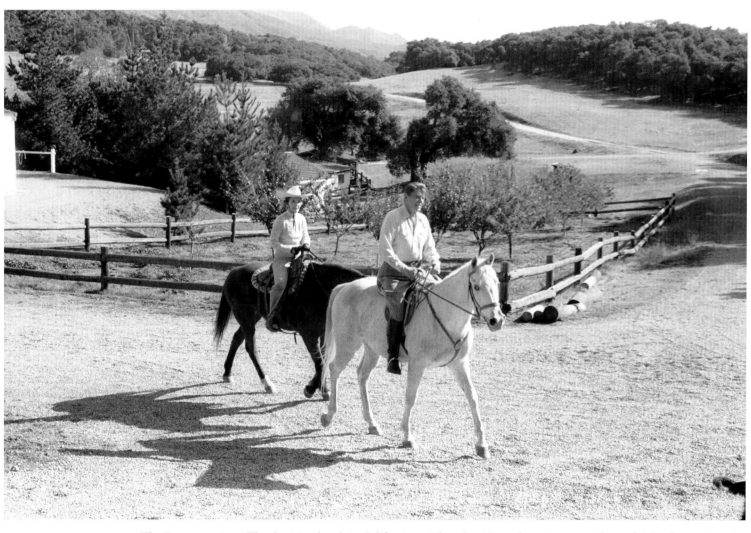

The Reagans enjoy a Thanksgiving break in California on Thursday, November 25, 1981: A beautiful day for a ride in the Santa Barbara countryside, shedding previous days of rain.

Canada's Wayne Gretzky, "the Great One" of professional ice hockey fame, meets
"the Great Communicator" in February 1982.

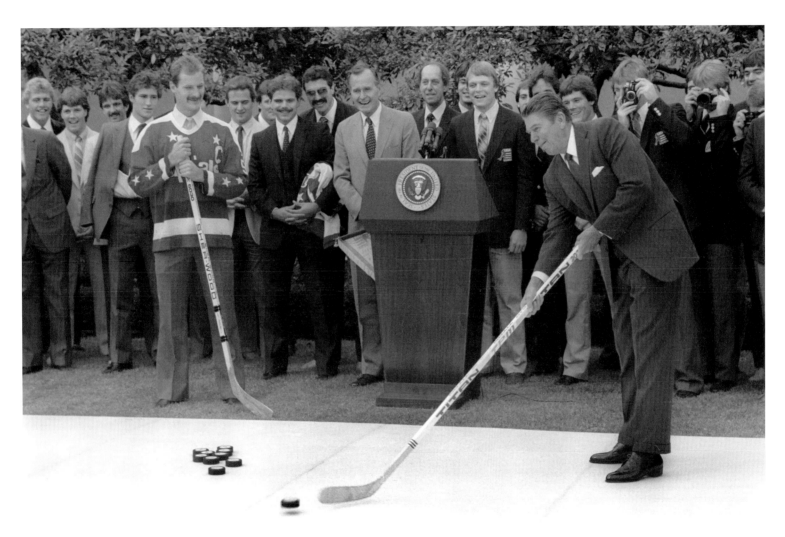

Reagan enjoys the demonstration of a sport that was fast growing in popularity with youth in the 1980s.

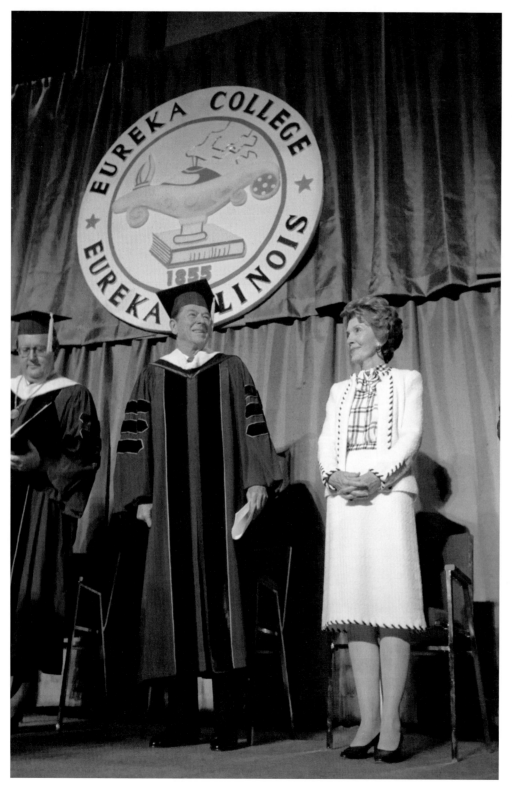

In May 1982, Reagan introduced the START program for nuclear weapons reduction in a commencement address at Eureka College in Illinois. That same weekend the president also attended his 50th class reunion at his alma mater.

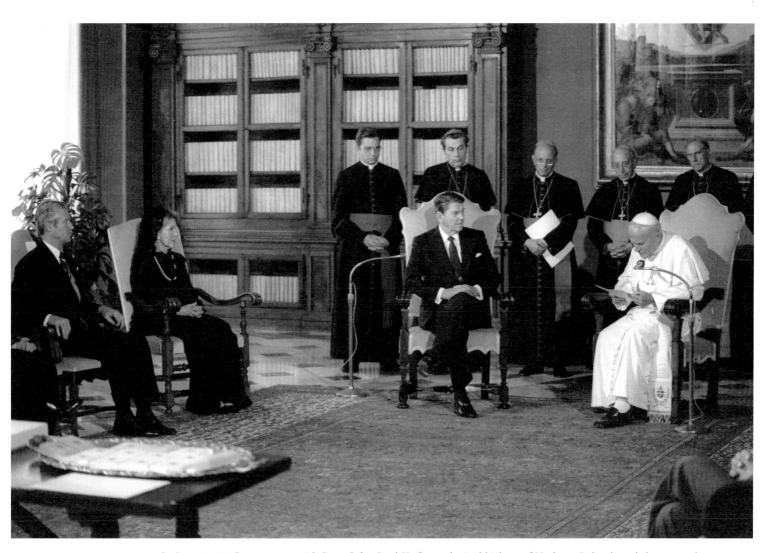

In June 1982, Reagan met with Pope John Paul II, formerly Archbishop of Krakow, Poland, and they agreed to support each other in upending the Soviet Union. Both had survived assassination attempts.

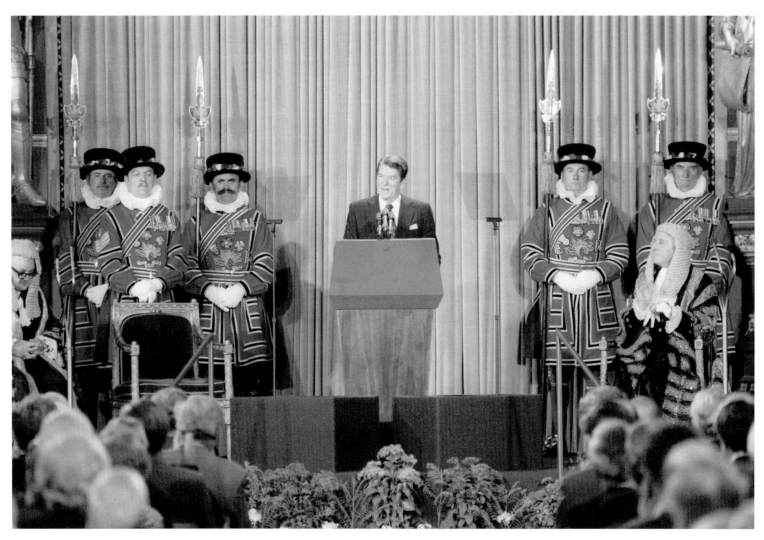

Before Parliament in the Palace of Westminster in London, Beefeaters afford British pageantry to Reagan's speech. On June 8, 1982, President Reagan predicted that the Soviet Union was sowing the seeds of its own downfall. According to speechwriter Peggy Noonan, Reagan considered it one of his most important speeches. Perhaps his most visible speechwriter, Noonan was in good company. Many of the speeches Reagan delivered during his lifetime were written, it turns out, by Reagan.

Reagan's special ally, fellow conservative, and soul mate was British Prime Minister Margaret Thatcher. In June 1982, the United States offered a new proposal to settle an argument over the Falkland Islands that had erupted into war between the United Kingdom and Argentina. The U.S. was concerned that declaring total victory could topple the government of Argentina, but Thatcher believed the loss of life could only be justified if the U.K. won.

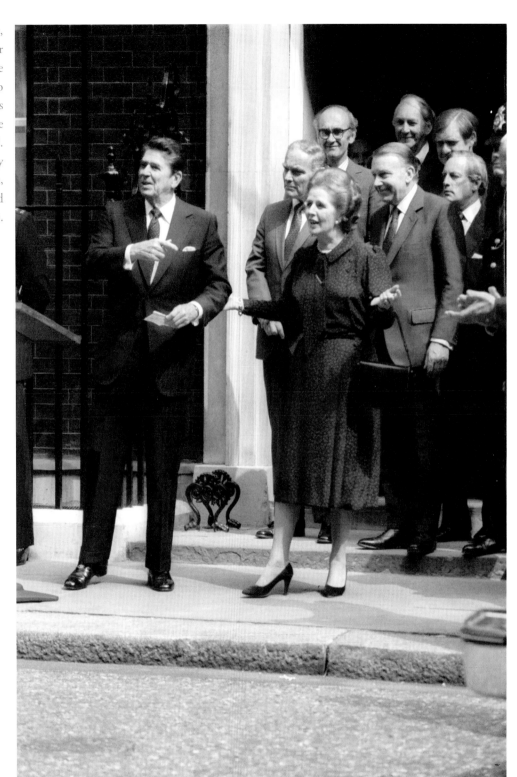

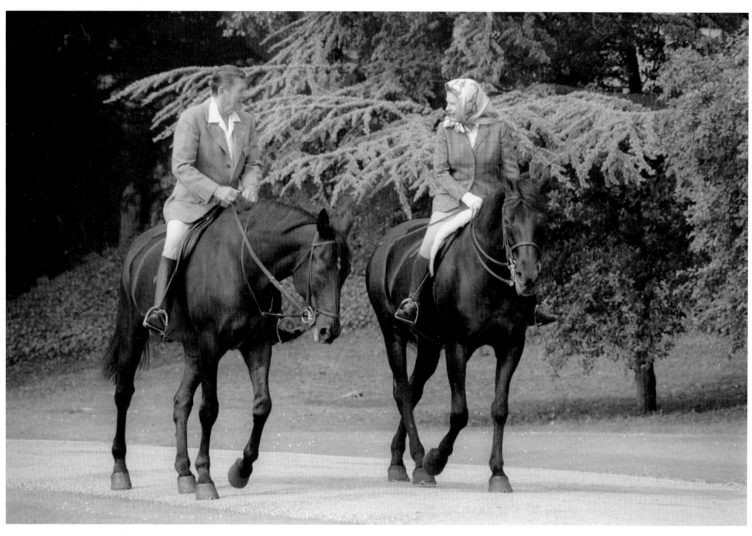

Queen Elizabeth II and Ronald Reagan, both celebrities for most of their lives, shared a passion for all things equestrian. President Truman called her a "fairy princess" when she visited him in 1951, and Reagan agreed that riding with the queen was a fairy tale come true.

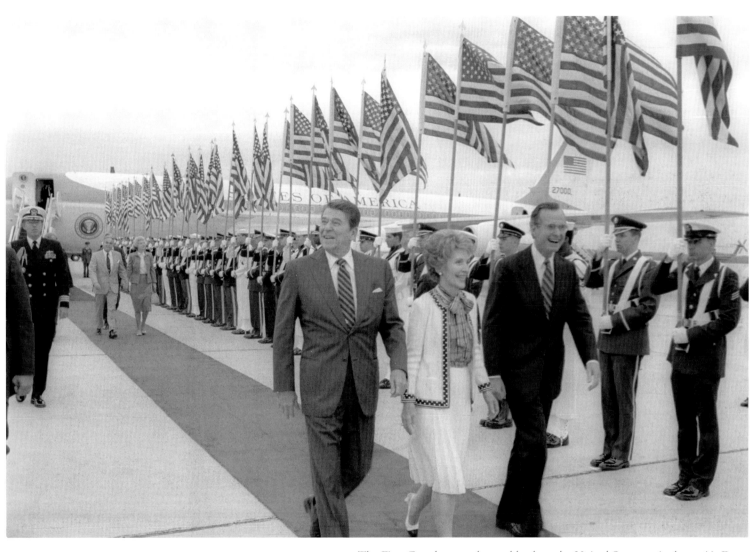

The First Couple are welcomed back to the United States at Andrews Air Force Base by Vice-president George Bush.

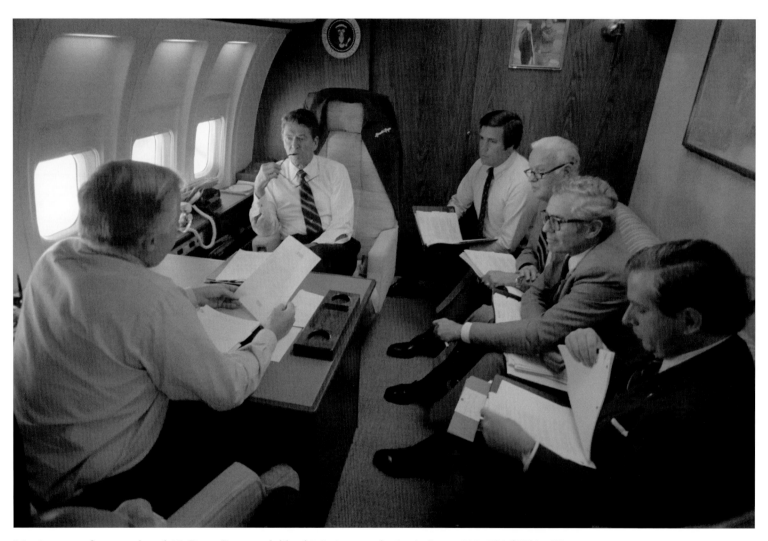

Meetings were frequent aboard Air Force One, much like this intimate gathering in June 1981. Chief White House Spokesman Larry Speakes appears in the foreground. Not fond of flying, Reagan avoided airplanes until he entered politics, preferring to ride the rails as GE spokesman in the 1950s and 1960s. When it was observed that he had apparently overcome the fear, he quipped, "Overcome it, hell. I'm holding this plane up in the air by sheer will power."

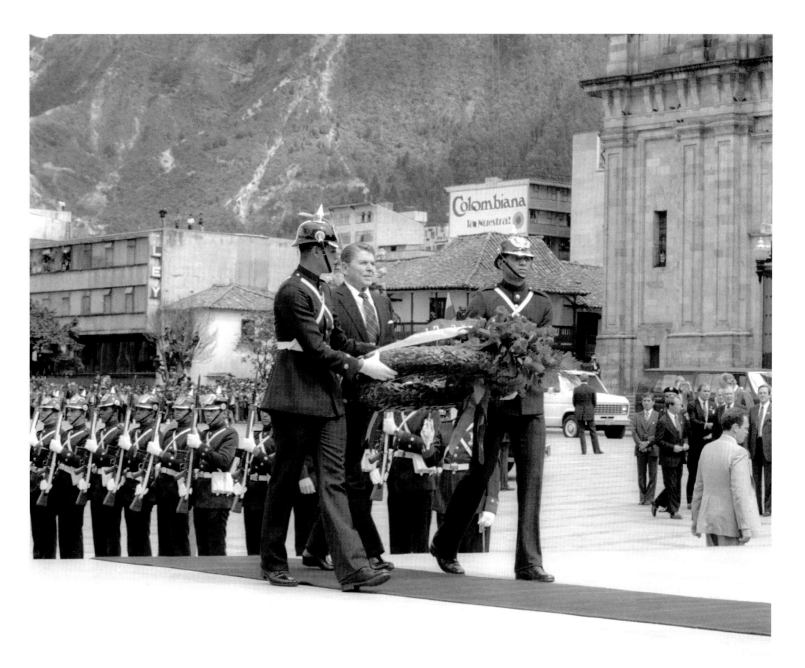

Years of neglect dogged United States foreign policy in South America, yet full military honors were accorded the President during his visit to Bogota, Columbia, in 1982. Still, Reagan detected "a tone of resentment toward the 'Colossus of the North' that was a little harsh," he wrote.

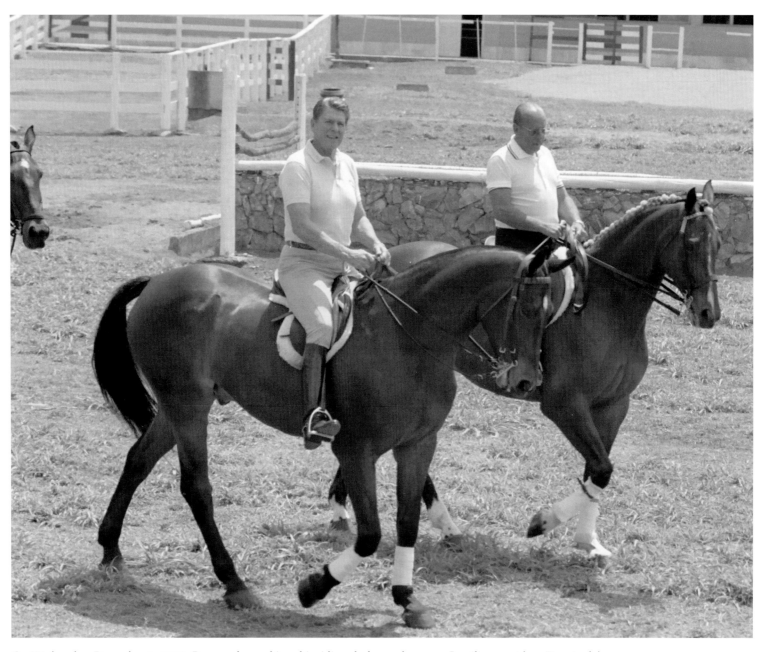

On Wednesday, December 1, 1982, Reagan changed into his riding clothes and went to Brazilian president Figueiredo's ranch, whose stables and horses were admirable. Reagan is shown riding a horse that was twice National Champion in Brazil, a cross between a thoroughbred and a German Hanover.

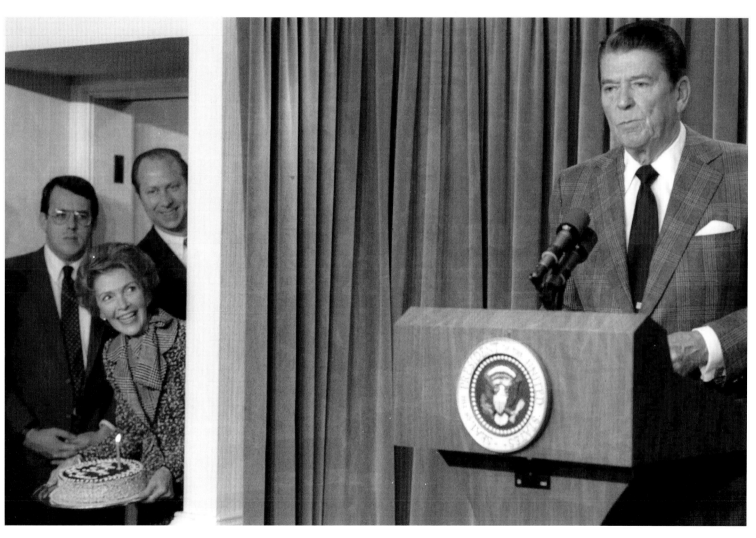

Nancy surprises the president after this press conference on February 4, 1983, on the occasion of Reagan's 72nd birthday, or as he would have joked: the 33rd anniversary of his 39th birthday.

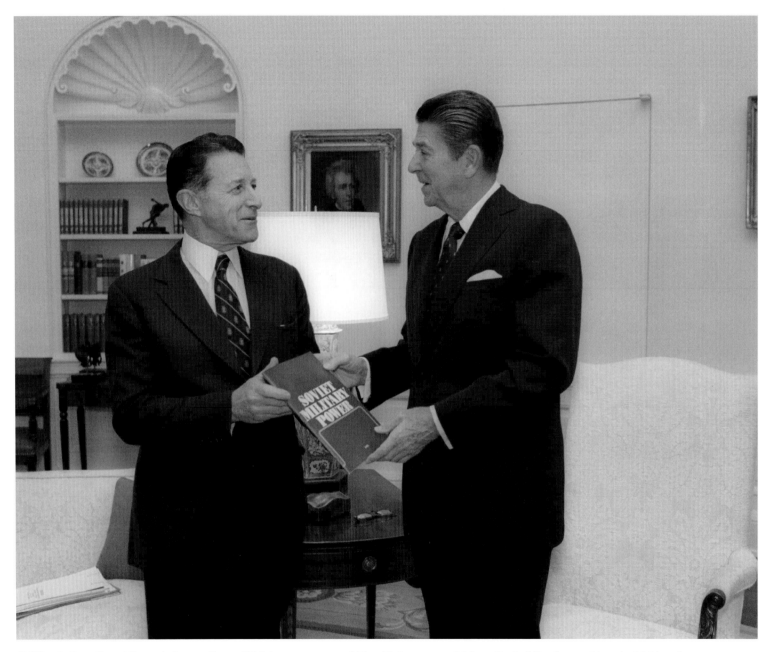

California State Republican chairman Caspar Weinberger supported New York governor Nelson Rockefeller for president in 1964 and that fact made him anathema to Reagan's "Kitchen Cabinet" led by Holmes P. Tuttle. However, after a tax increase was required to solve California's fiscal crisis that almost ruined Reagan's first year as governor in 1967, Weinberger became state finance director. He was known as "Cap the Knife" for effectively managing the budget process until 1970, when he became Nixon's director of the Federal Trade Commission. Pictured meeting with the president in the Oval Office in March 1983, Defense Secretary Caspar Weinberger presided over an immense peacetime build-up in the U.S. military.

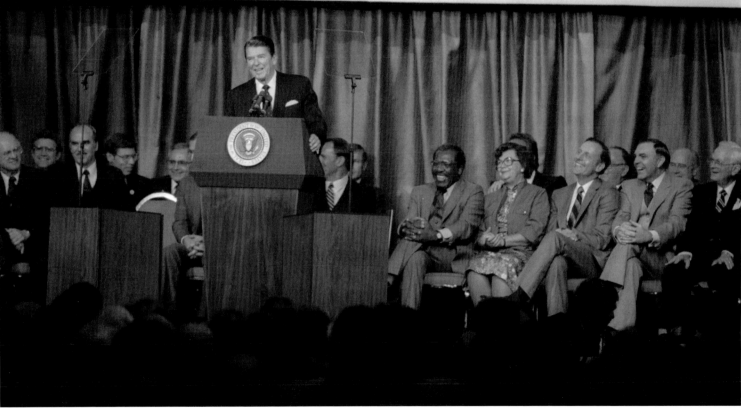

Christian evangelicals were so important to Reagan's political coalition of voters that he chose their convention to deliver what became known as his "Evil Empire" speech. Named the "Reagan Doctrine," it was his commitment to "those fighting freedom and against Communism wherever we found them." The President said, "Of the nuclear freeze proposals I urge you to beware the temptation of pride—the temptation of blithely declaring yourselves above it all and label both sides equally at fault, to ignore the facts of history and the aggressive impulses of an evil empire."

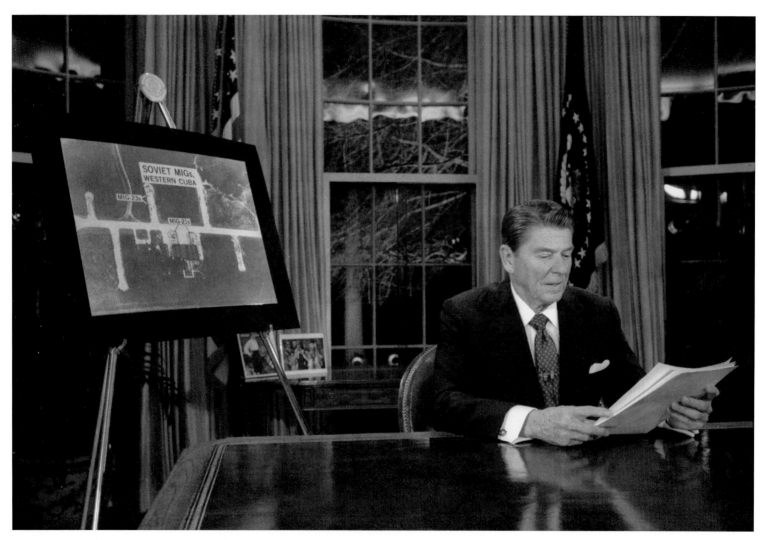

When Reagan announced his Strategic Defense Initiative (SDI), the media derided it "Star Wars," an allusion to the George Lucas movie of recent acclaim. The idea surprised and intrigued the nation, while many scientists and others were skeptical. One believer was Anatoly Shcharansky, formerly of the Russian gulag and once Israeli deputy prime minister, who said, "Then came Reagan, and Star Wars-Star Wars was a way of talking to the Soviet Union!"

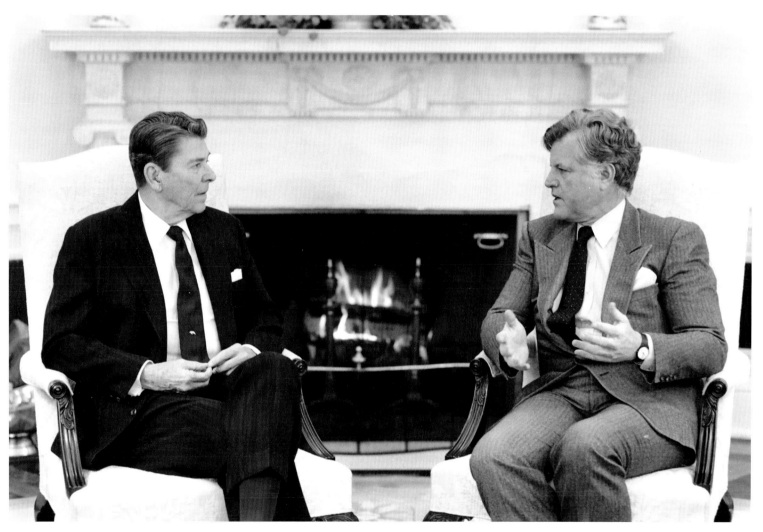

Reagan's strife with the Kennedys dated back to the 1960 presidential campaign. Reagan, still a registered Democrat, rebuffed the request of family patriarch Joseph P. Kennedy to campaign for his son, John F. Kennedy. Pictured is President Reagan with JFK's brother, Senator Edward Kennedy of Massachusetts. Kennedy, a liberal lion of the U.S. Senate, with Republican Mark Hatfield of Oregon, cosponsored nuclear freeze resolutions in the Senate to stop "an impending era of first strike temptations" when it became known that the new administration was rethinking nuclear strategy. Secretary of Defense Caspar Weinberger countered accusations of warmongering, stating that he was "increasingly concerned with news accounts that portray this Administration as planning to wage a protracted nuclear war, or seeking to acquire a 'warfighting' capability."

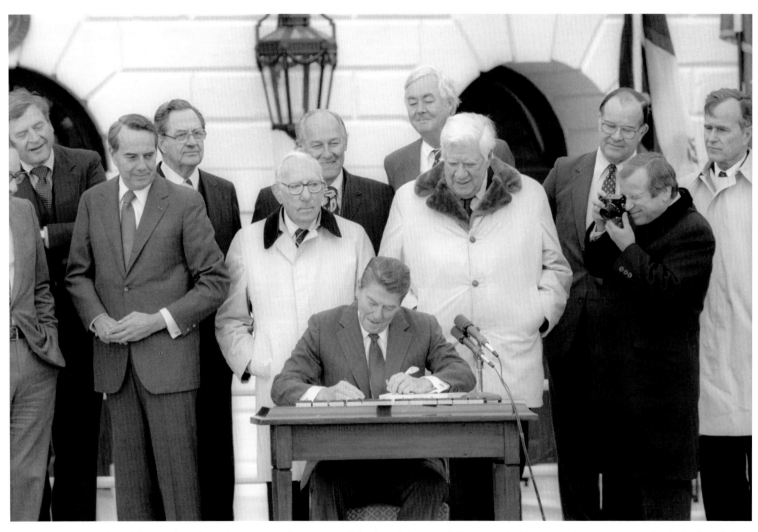

On the cold, gray day of April 20, 1983, the signing of the Social Security bill is attended by more than 1,000 people, including (left to right) the future 1996 Republican presidential nominee Senator Bob Dole, Representative Claude Pepper, Speaker Tip O'Neill, Howard Baker (with camera), and Vice-president Bush. New York senator Patrick Moynihan peeks over O'Neill's shoulder. Two aging Americans of Irish descent, Reagan and O'Neill, "saved" Social Security until a future day of reckoning.

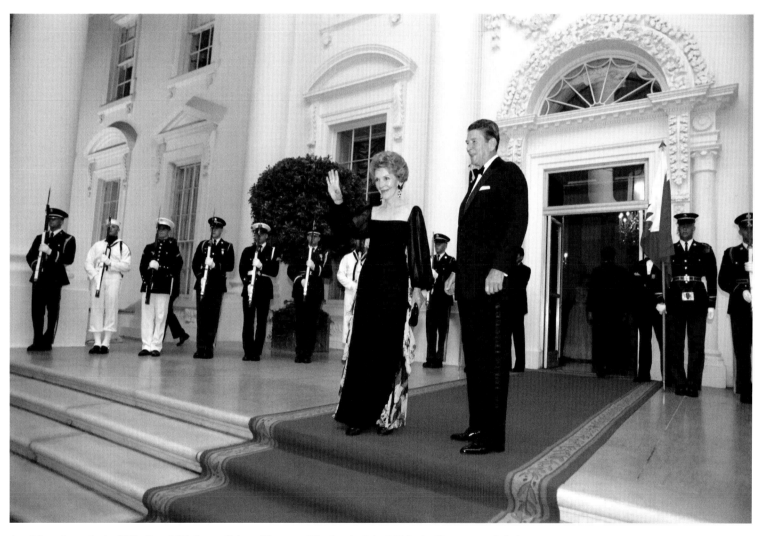

Awaiting the arrival of His Royal Highness Prince Hassan of Jordan in July 1983, the Reagans and their military guard are prepared to greet royalty.

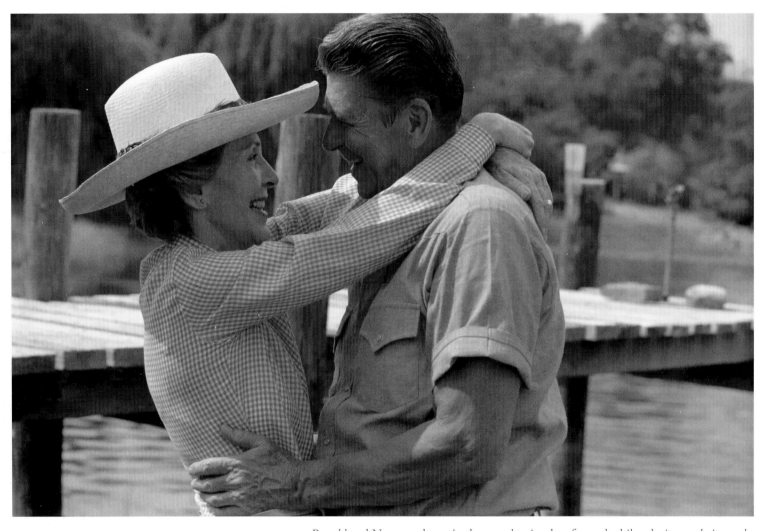

Ronald and Nancy embrace in the casual attire they favored while relaxing at their ranch.

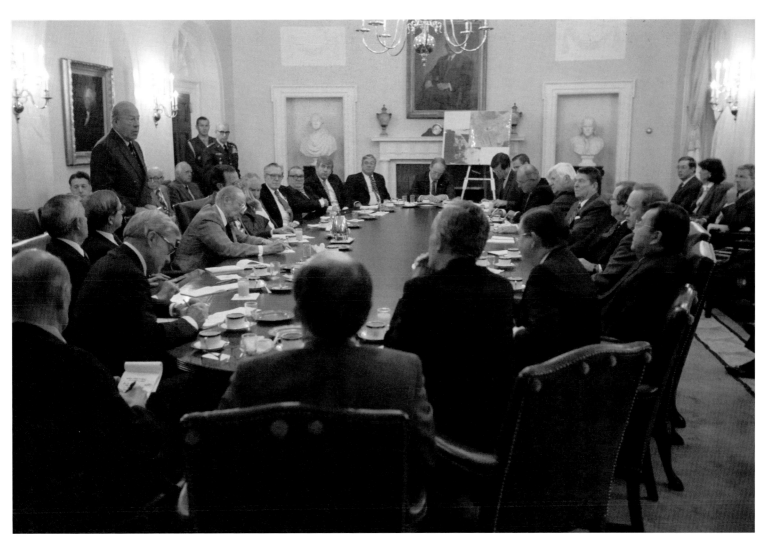

Following a meeting of the Joint Chiefs of Staff on October 24, 1983, Reagan said of the planned invasion of Grenada: "This was one secret we really managed to keep." The next day, George Schultz (standing at left) addressed the Cabinet room full of congressmen and told them U.S. forces had landed at two points and had secured both airports, rescuing American medical students from the Cuban-influenced island.

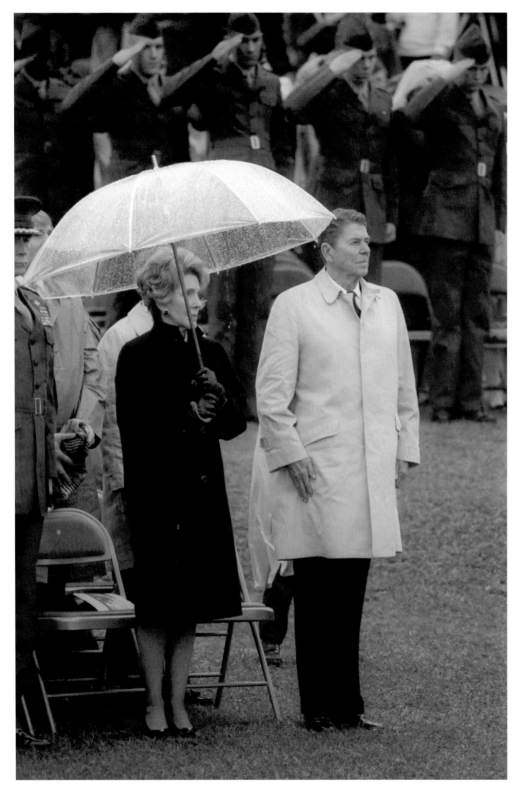

More than 100 U.S. Marines were wounded and 241 killed by a terrorist car bombing of their barracks in Beirut, Lebanon, on October 23, 1983. Reagan's military response to the attack was aborted by Secretary Weinberger, reportedly owing to concerns involving other Arab nations. On November 4, the Reagans arrived early at Camp Lejeune, North Carolina, for the memorial service honoring those Marines. The service was moving, the weather was dark and rainy, and the day was one of the most depressing the President had had, amplified by the haunting sounds of "Taps." Reagan was comforter-in-chief to widows and mothers after the service honoring their husbands and sons.

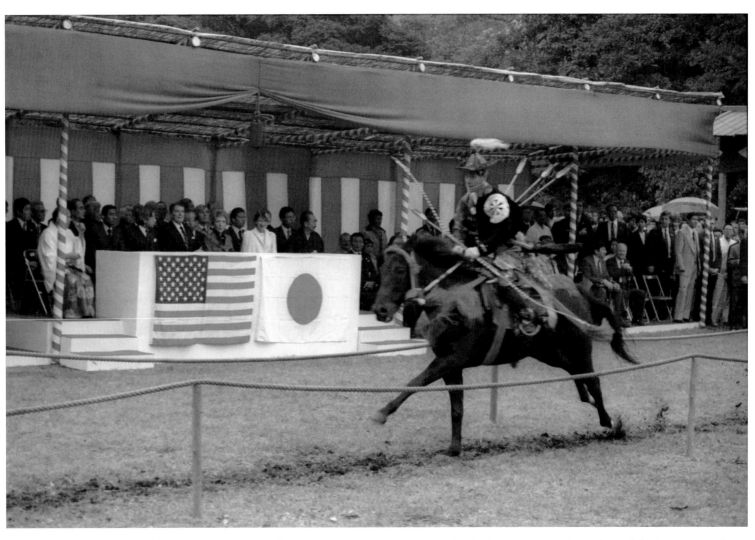

Before the State dinner in Japan on Thursday, November 10, 1983, the Reagans watch a riding exhibition at Meiji Shrine with Crown Prince Naruhito and Princess Nori. The next day Reagan became the first United States president to address the Diet, Japan's legislature. The underlying strife that led to the visit regarded American imports.

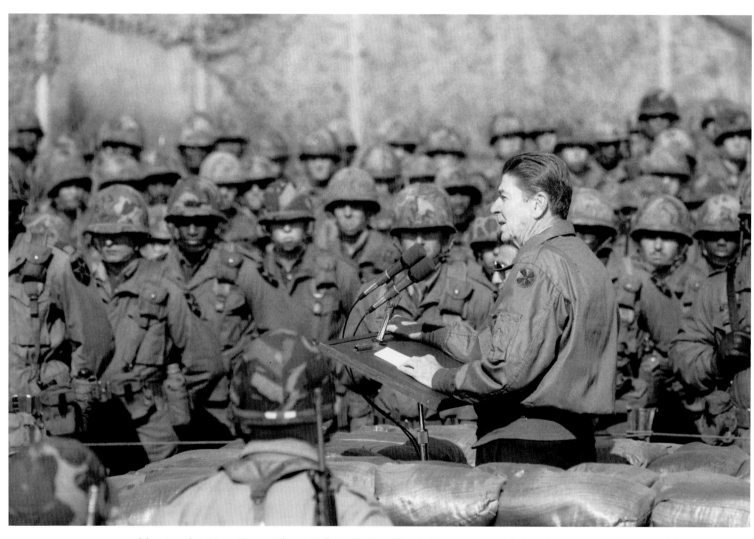

Addressing the GIs at Camp Liberty Bell, in the Demilitarized Zone, Reagan is less than one mile from North Korean troops. Reagan said if North Korea wanted better relations, digging tunnels under the demilitarized zone must end. Ironically, in 1954, Reagan played a POW held by North Korea in the MGM Film *Prisoner of War,* as an officer dropped behind enemy lines to learn about brainwashing and torturing of captured soldiers.

The Charles Wicks, dear friends of the Reagan family, hosted an annual Christmas party where it was a tradition for guests to switch off playing St. Nick. The president's turn came in December 1983 and the photographer "saw mommy kissing Santa Claus." One of Reagan's nicknames for Nancy actually was "mommie." Wick was director of the United States Information Agency from 1981 to 1989 and launched the first live global satellite television network, broadcasting the Voice of America to Cuba and the world.

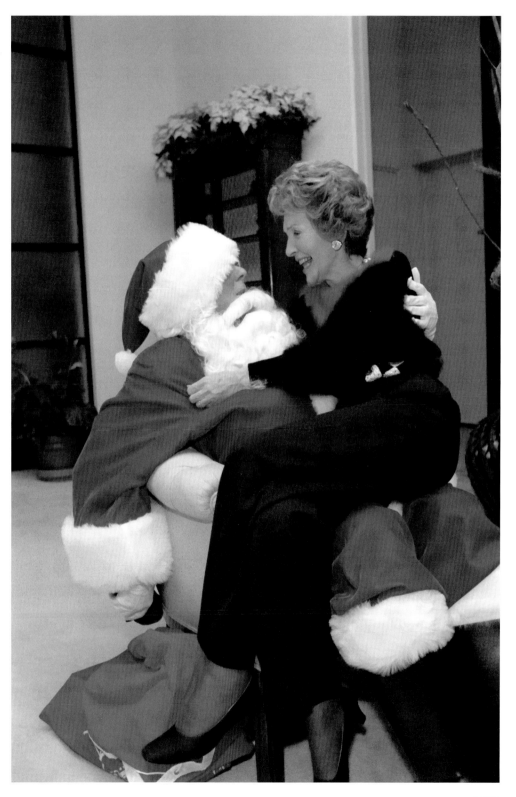

After being shot, Reagan began seeing and speaking to crowds of people from an armored limousine and surrounded by Secret Service agents.

First built in the Seventh Century B.C., the
Great Wall of China was rebuilt, modified,
and extended throughout Chinese history. The
President and First Lady are shown here visiting
the Great Wall on Saturday, April 28, 1984.

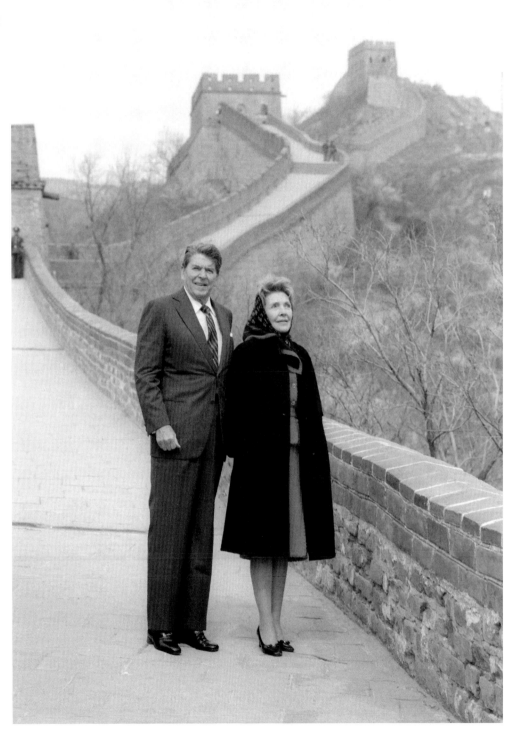

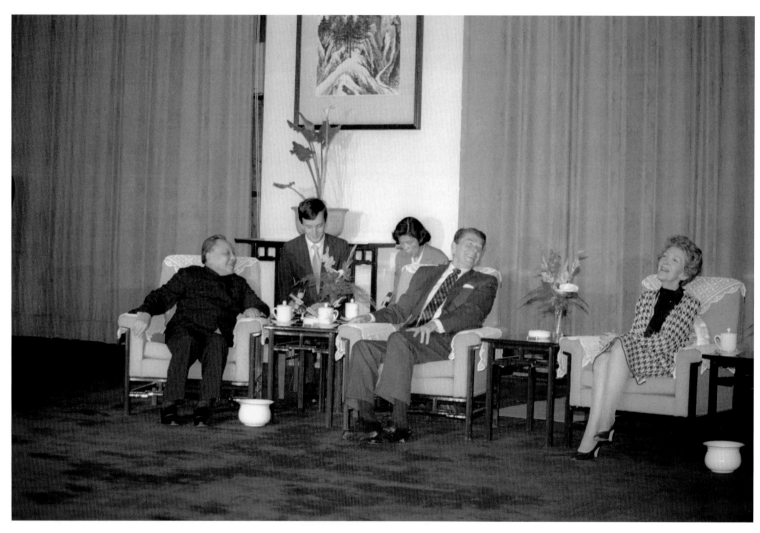

In meeting with Chairman Deng Xiaoping of China, Nancy accompanied the President to the informal opening. Deng would go on to level criticism at the United States over Middle East policy, United States treatment of developing nations, Reagan's disarmament failure, and his policy of supporting Taiwan. When Reagan spoke he corrected the chairman on certain facts, who seemed to enjoy the frank exchange.

On April 29, 1984, the Reagans visited the tomb of the first Emperor from 2,000 years ago, near Xian, the ancient capitol of China. On display were 800 life-size terra cotta army figures standing in ranks complete with horse head chariots guarding the emperor's tomb. Contained in three vaults, the figures differ from one another in facial features, expression, and uniform. Discovered in 1974, the tomb holds more than 7,000 others yet to be excavated and the site is considered the eighth wonder of the ancient world.

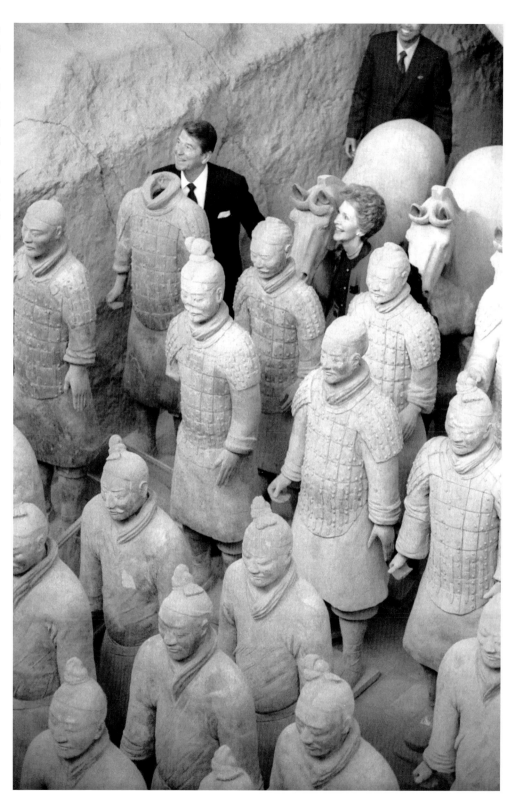

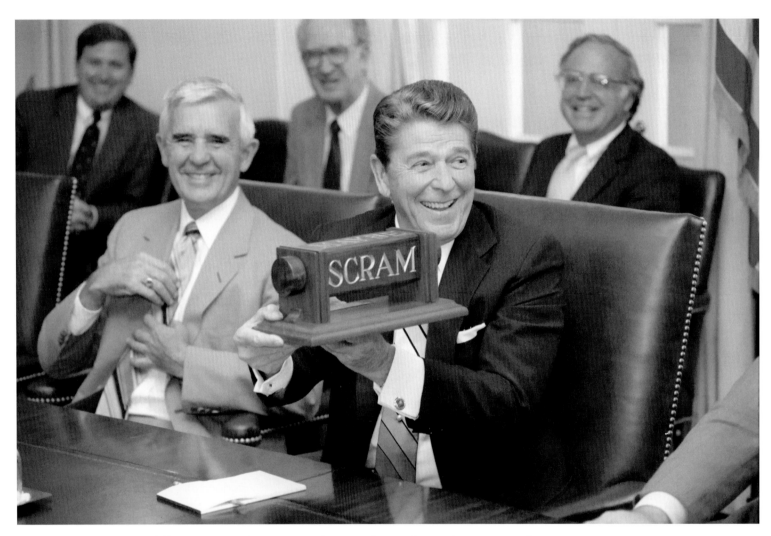

A revolving desk sign with different messages (scram, yes, etc.) amuses the President in this meeting with Congress, including close friend Senator Paul Laxalt of Nevada. At least two books have been published documenting Reagan's humor and wit.

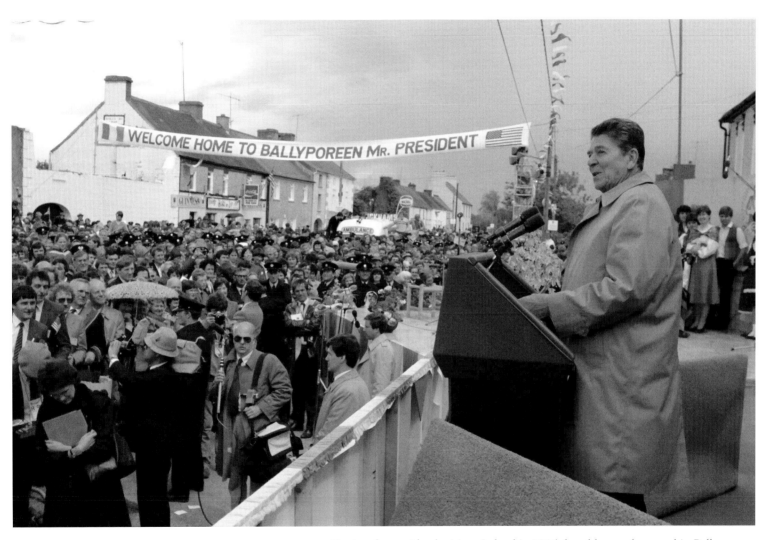

During the president's visit to Ireland in 1984, he addresses the crowd in Ballyporeen, County Tipperary—home of Reagan's great grandfather who immigrated to America. Reagan visited the church where his ancestors were baptized before attending a state dinner at Dublin Castle as the guest of Irish President and Mrs. Hillery.

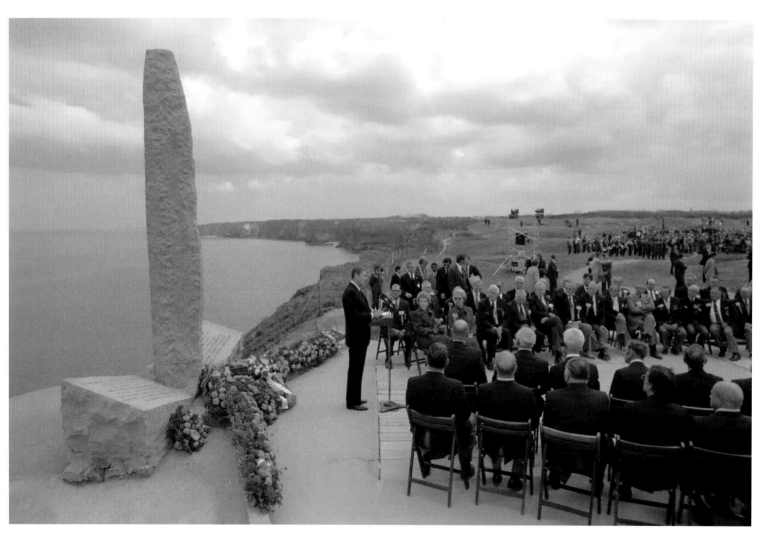

On June 6, 1984, President Reagan and President Francois Mitterrand speak at a U.S.-French ceremony commemorating the 40th anniversary of the D-Day landing at Omaha Beach. Reagan read aloud a letter from a woman whose father participated in the invasion. Reagan, overcome with emotion, had difficulty completing his speech. Five thousand ships had participated in the 1944 invasion fleet and rangers had scaled a 100-foot sheer cliff to establish their position. At Pointe du Hoc, the Reagans met 62 rangers who had returned for the event and visited a massive concrete pillbox where Nazis first witnessed the Allied invasion.

The President and Mrs. Reagan visit the military cemetery at Normandy, where row on row of white marble crosses and stars of David mark the more than 9,000 graves of fallen soldiers.

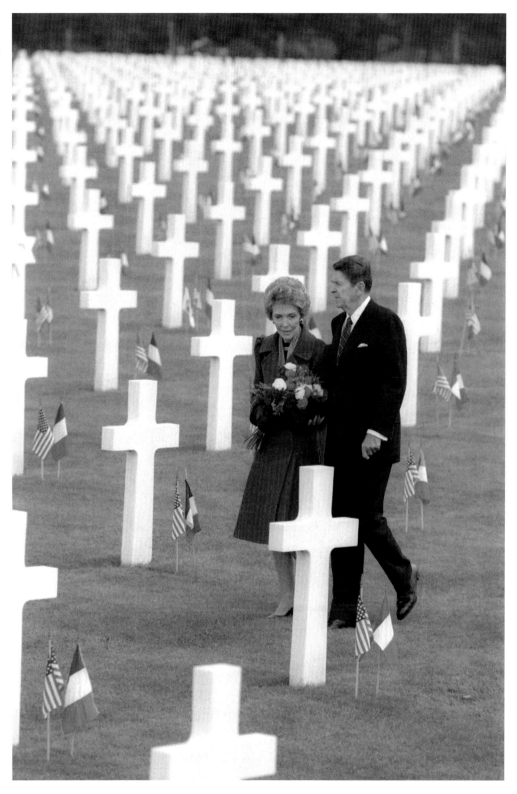

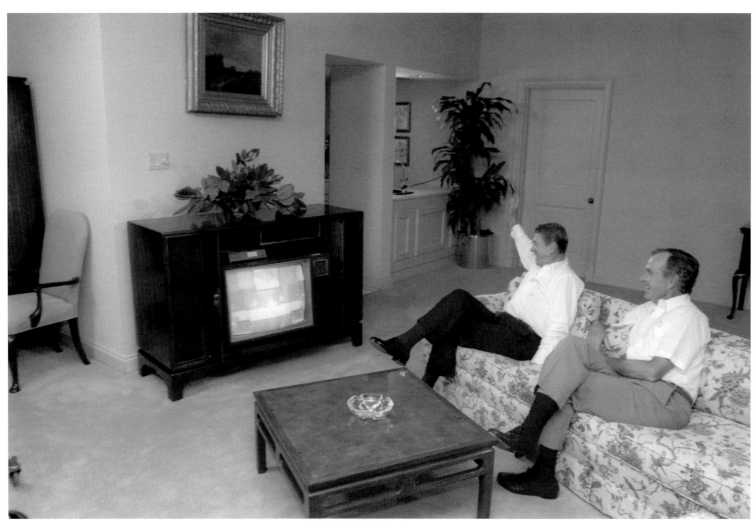

On August 22, 1984, Reagan and Bush watch the televised proceedings of the Republican National Convention in Dallas, the night that featured a tribute to Nancy. At the end of her speech, she looked up at the jumbo screen behind her and this picture of Reagan and Bush appeared. She waved and the President waved back at her.

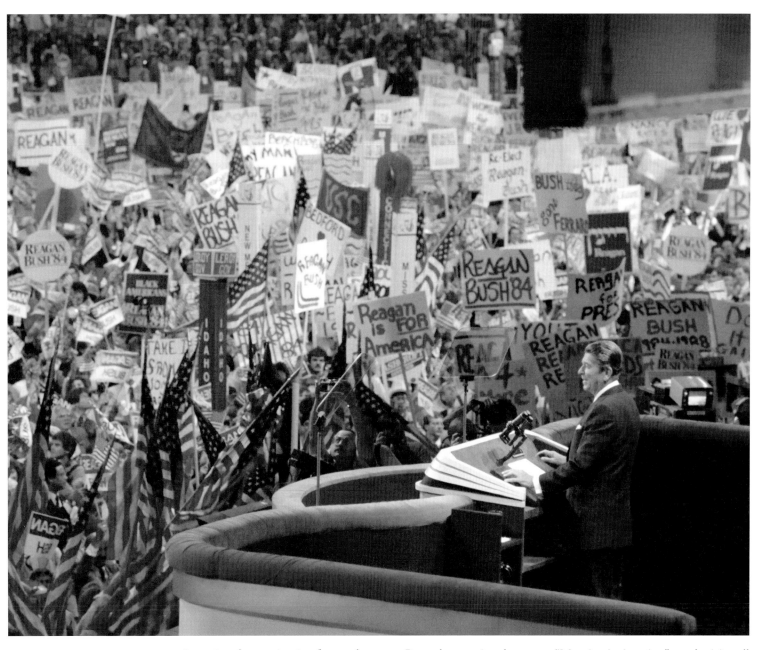

Accepting the nomination for another term, Reagan's campaign theme was "Morning in America," emphasizing all that was good with America in 1984. Pundits observed that the lack of a substantive campaign deprived Reagan of a real mandate in his second term, but the landslide victory to come would yield a mandate of its own.

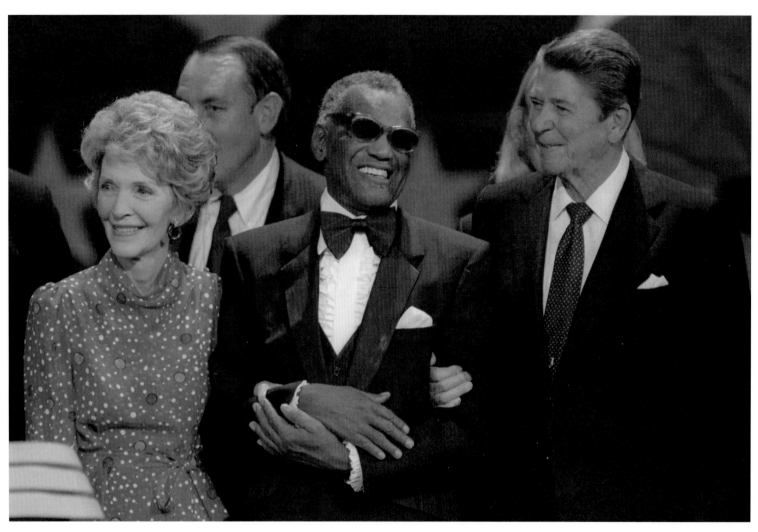

Grammy award winner Ray Charles sang his rousing rendition of "America the Beautiful" after
Reagan's acceptance speech at the Republican Convention.

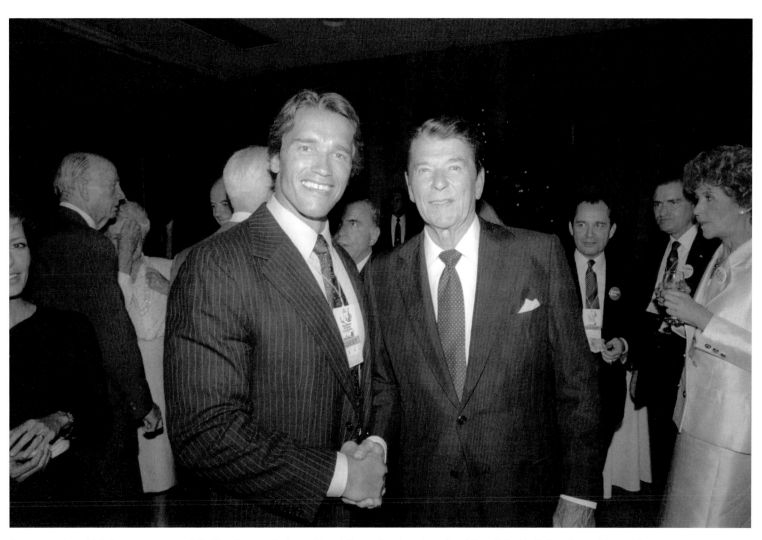

Governor Arnold Schwarzenegger of California enrolled as a Republican after learning that his political beliefs mirrored Ronald Reagan's conservative philosophy. "The Governator," aptly named after his movie fame in *Terminator* films, and "the Great Communicator" are shown here at the 1984 Republican Convention. Each was a beneficiary of an early career in sports (body builder and sportscaster) that led to movie stardom and elections to the California governor's office in Sacramento.

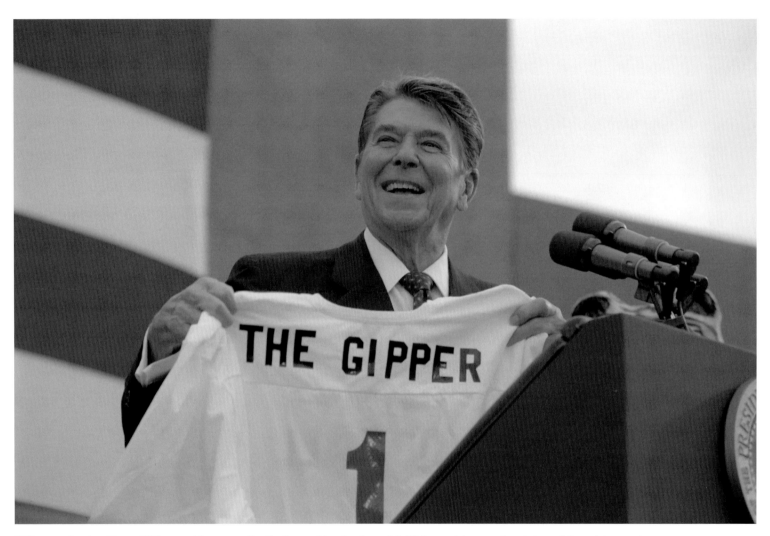

"Win one for the Gipper!" The president proudly displays a shirt that bears his lifelong nickname. It originated from his popular film *Knute Rockne—All American,* in which he played halfback George Gipp.

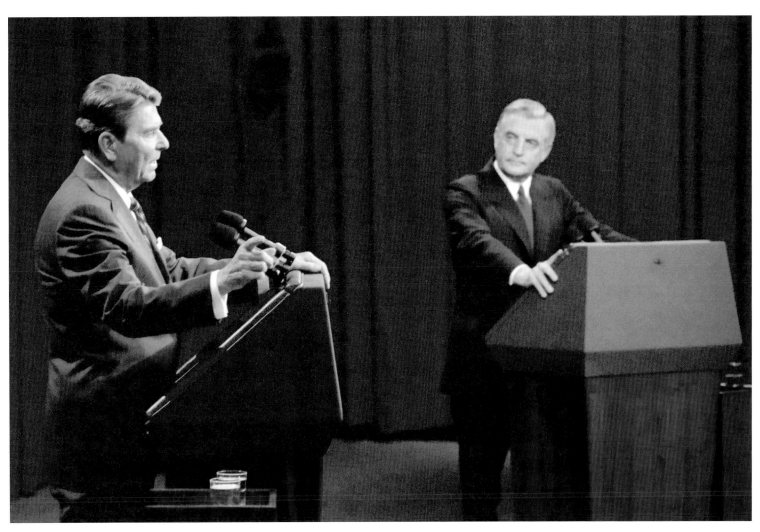

Off his stride in the first debate with former Vice-president Mondale, Reagan dispensed with the issue of his advancing age in the second debate with his quip, "I will not make age an issue of this campaign. I am not going to exploit for political purposes my opponent's youth and inexperience." Mondale nailed his own coffin in the campaign when he said, "Let's tell the truth. Mr. Reagan will raise taxes, and so will I. He won't tell you. I just did." By 1986, Reagan's tax reform plan left Americans with a top rate of 28 percent and a bottom rate of 15 percent, in contrast to the 70 percent top rate bequeathed by the Carter administration.

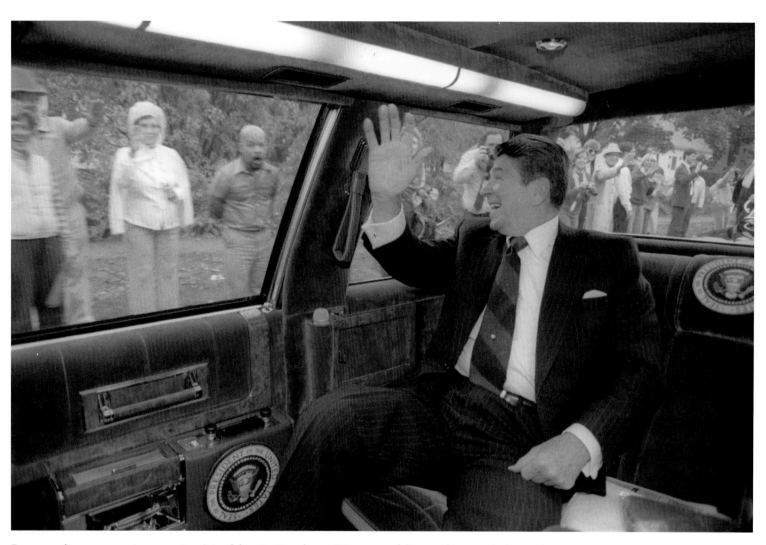

Reagan rode to an easy victory against Mondale, winning almost 59 percent of the popular vote, 525 votes in
the electoral college (the greatest number of electoral votes ever garnered by a presidential candidate), and all the
states except Mondale's home state of Minnesota. Republicans held the Senate and gained 16 seats in the House,
not enough to win control of Congress.

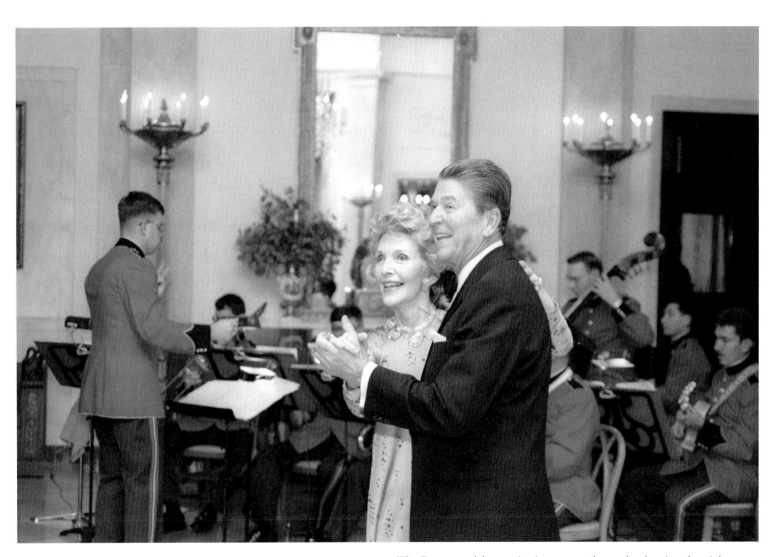

The Reagans celebrate winning a second term by dancing the night away.

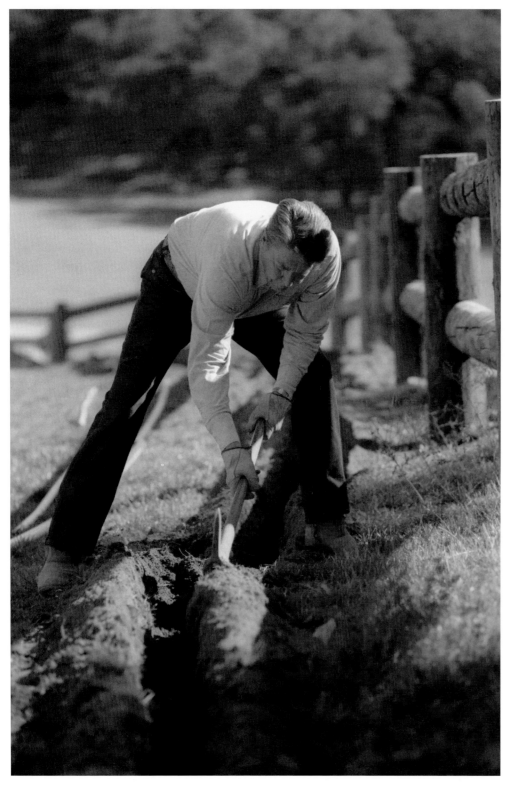

After the momentous victory, Reagan loved being back at his California ranch for Thanksgiving vacation, where he indulged in morning rides and chores like laying pipes.

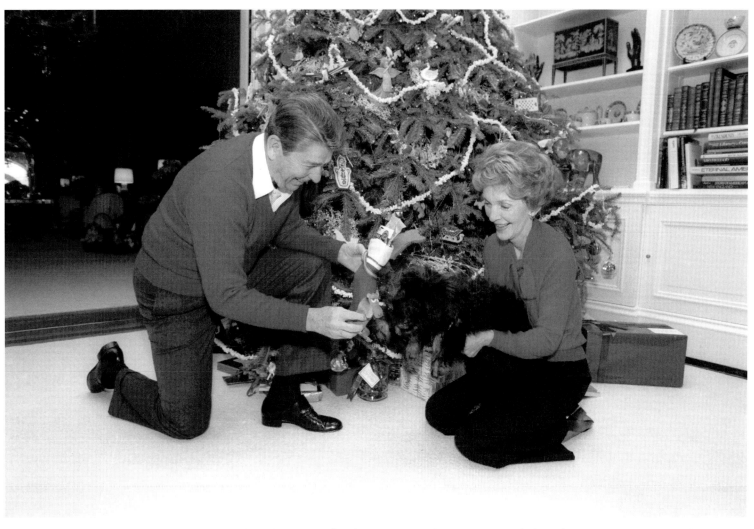

In the White House family quarters on Christmas Eve 1984, the only creatures stirring were the Reagans' dog Lucky and Senator Orrin Hatch of Utah. He had asked Reagan to grant clemency to Sun Myung Moon, who had been convicted on charges of filing false income tax returns. The President refused but allowed Moon a furlough from prison over New Years, the holiest period in Moon's Unification Church.

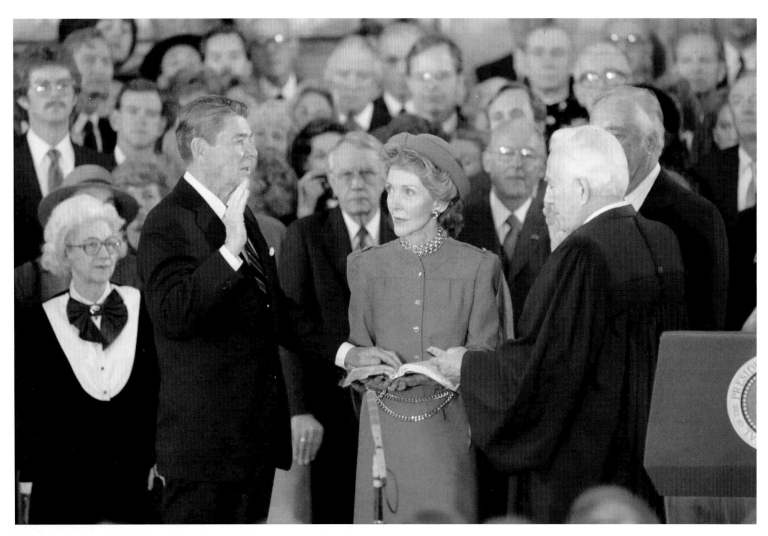

More than 1,000 people crowded into the Capitol rotunda to escape the subzero weather for the
second inauguration of President Reagan on January 21, 1985. For Reagan, the highlight of the
day was Speaker O'Neill conceding to the president that his huge electoral mandate translated into
considerable political capital on the Hill.

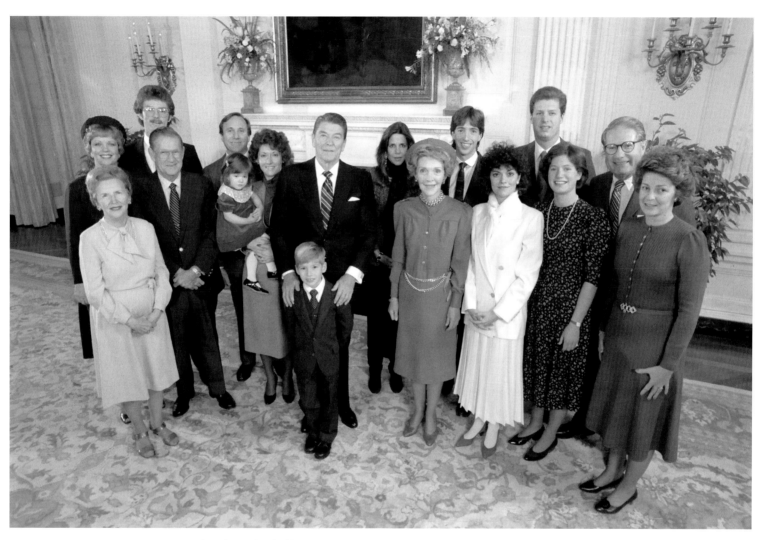

After the oath of office was administered at the Capitol, the family returned to the White House for an Inaugural photograph. Back row: Maureen and Dennis Revell, Michael, Patti Davis, Ron, Geoffrey Davis and Dick Davis. Front row: Bess and Neil (Moon) Reagan, Colleen with Ashley Marie Reagan, the President with Cameron Reagan, Nancy, Doria Reagan, Anne Davis and Patricia Davis.

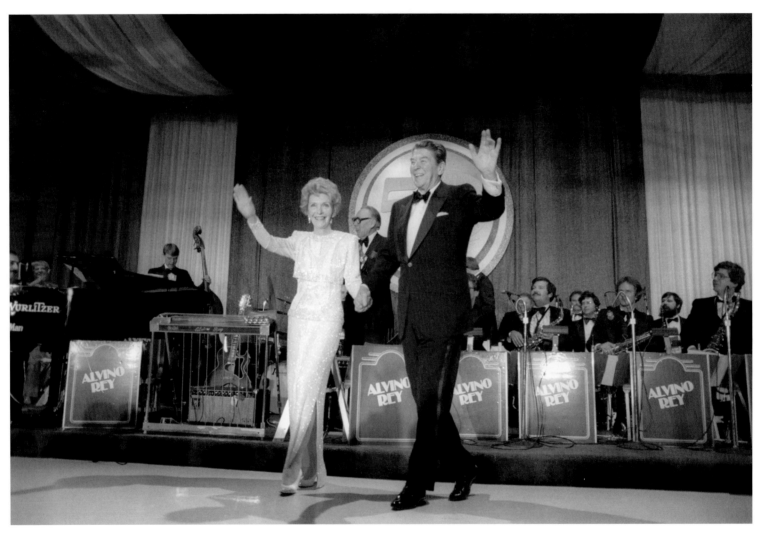

The presidential couple wowed the crowd during one inaugural ball at the Hilton Hotel in Washington. Of the 11 inaugural balls attended by the Reagans, they danced at all of them for at least one minute.

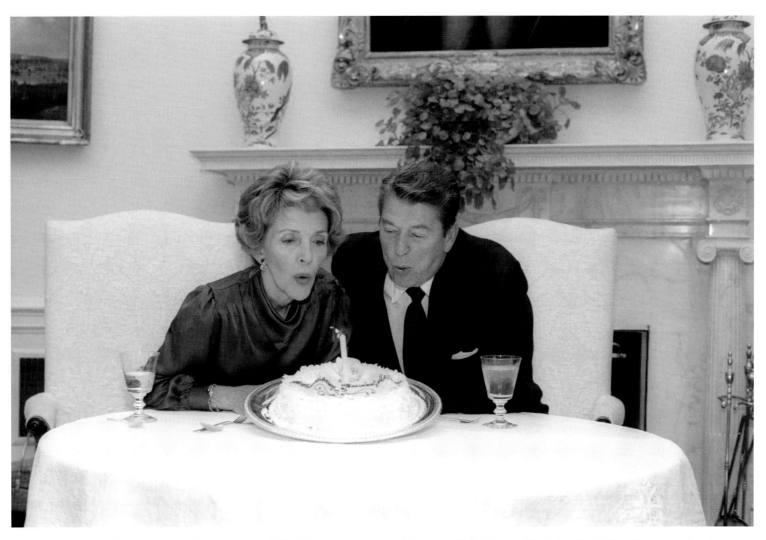

The Reagans celebrate their 33rd Wedding Anniversary on March 4, 1985. Nancy visited the Oval Office for a quiet lunch and an anniversary cake that was shared with a few of the immediate staff. This was the extent of their celebration, until dinner when they split a bottle of Chateau Margaux 1911, in honor of the year Reagan was born.

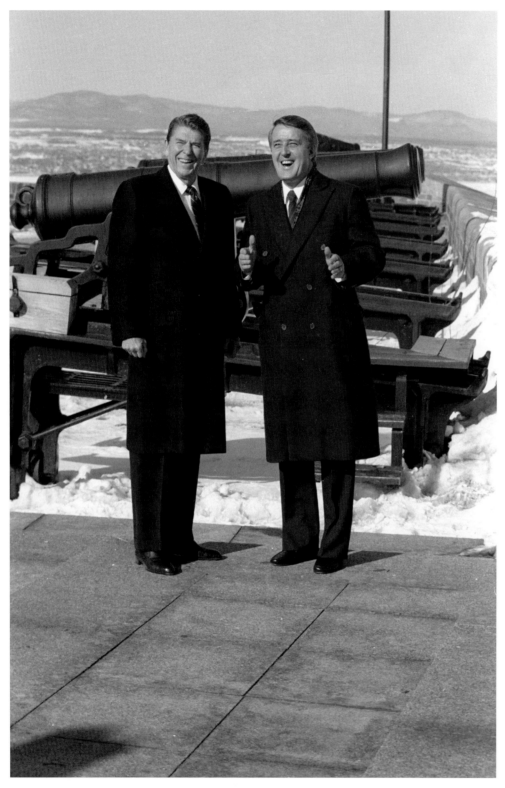

Among Reagan's most enjoyable trips were the short ones made to Canada. Prime Minister Brian Mulroney was a valued ally, and the Reagans became good friends with him and his wife, Mila. At the Shamrock Summit in Canada, Mulroney suggested that they could do business with Soviet leader Gorbachev. Reagan must have agreed. In his memoirs he said, "As we shook hands I had to admit . . . there was something likeable about Gorbachev. There was warmth in his face and his style."

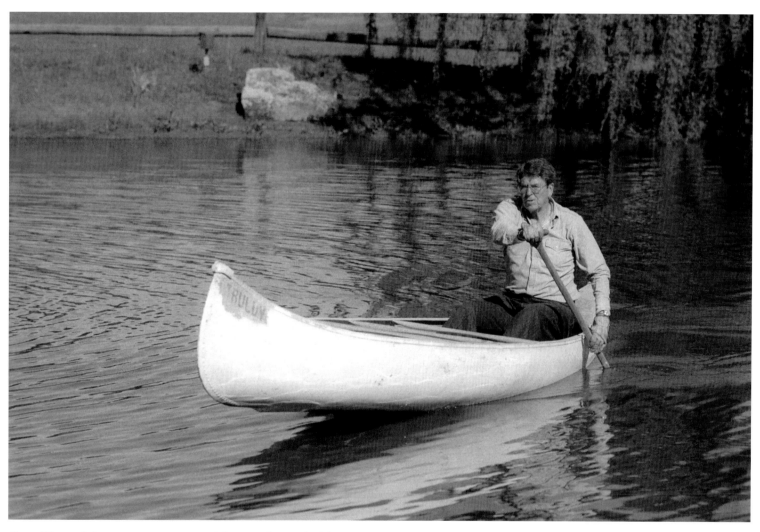

One of Reagan's favorite pastimes was paddling *Truluv* on the lake at Rancho del Cielo, California, which seems to belie the image frequently painted by the media of a president aging and feeble-minded.

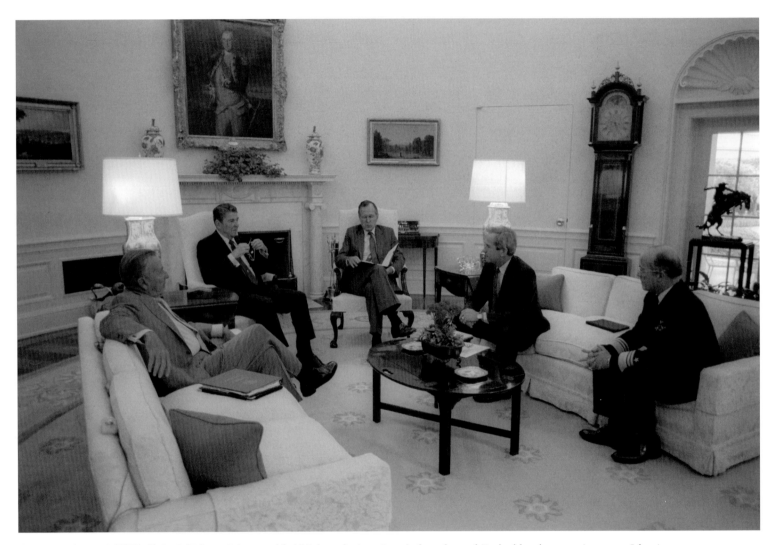

On June 14, 1985, TWA flight 847 from Athens, with 153 (mostly Americans) aboard, was hijacked by the terrorist group Islamic Jihad. Despite being awakened early, Reagan maintained his usual schedule, as well as the standard policy of not negotiating with terrorists. The hijackers demanded the release of 760 Shiite prisoners taken from Lebanon by Israel. Many Shiites were freed along with all the surviving airline hostages through back-door Iranian efforts. One American, serviceman Robert Stethem, had been brutally beaten and then executed before the ordeal ended.

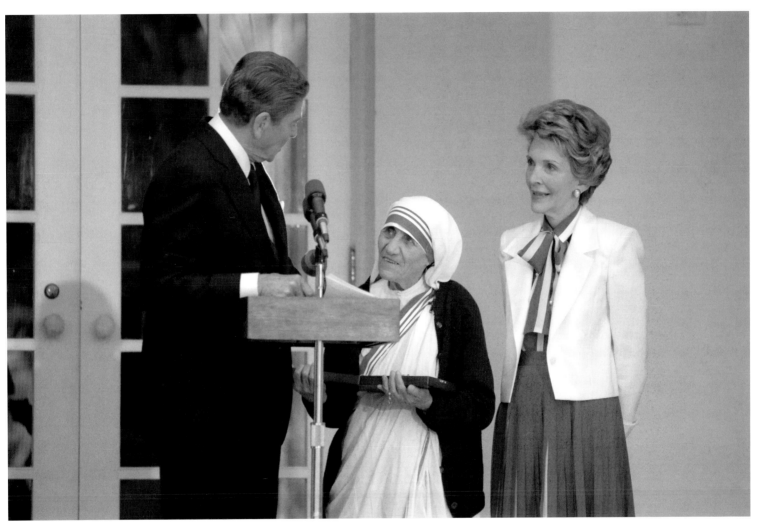

Calling her a "living saint," Reagan presents the Presidential Medal of Freedom to Mother Teresa on June 20, 1985, at a White House Rose Garden ceremony.

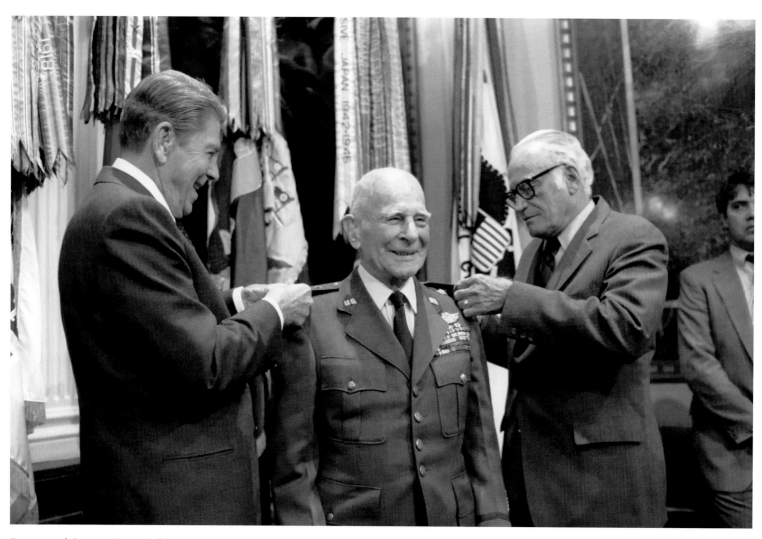

Reagan and Senator Barry Goldwater present his 4th Star to General Jimmy Doolittle on June 12, 1985.
Doolittle's successful raid over Tokyo, scant months after the Japanese bombed Pearl Harbor, made him one
of the first American heroes of World War II.

On June 10, 1985, President Reagan, ever the California booster, honors the Hall of Fame center Kareem Abdul-Jabbar after the Los Angeles Lakers' first championship win over the Boston Celtics. Abdul-Jabbar became the biggest media star of the NBA when he made his famous sky hook with a minute to play in game 6 of the 1985 finals.

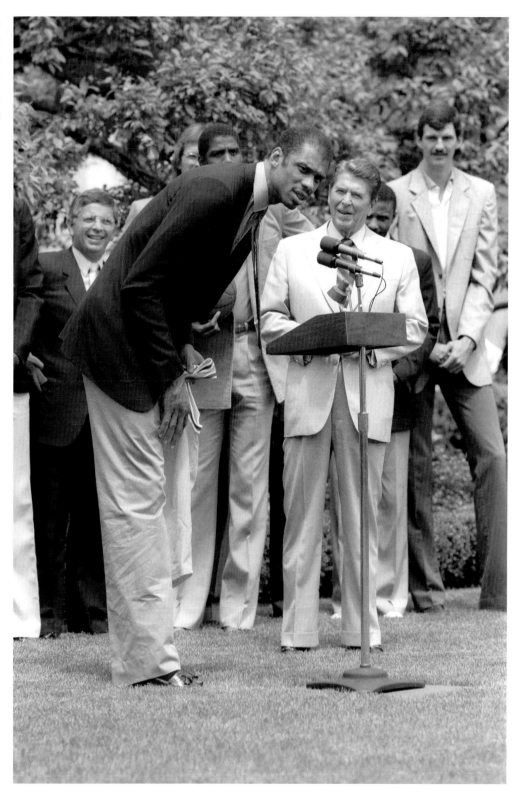

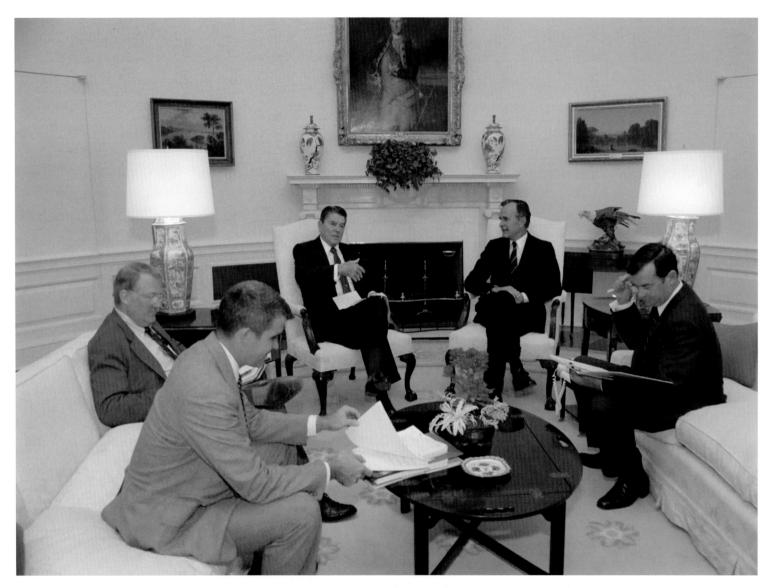

Colonel Oliver North, Ed Meese, the President, Vice-president Bush, and John McFarland converse in the Oval Office. The Iran-Contra affair would soon envelop the administration, with Oliver North in the spotlight.

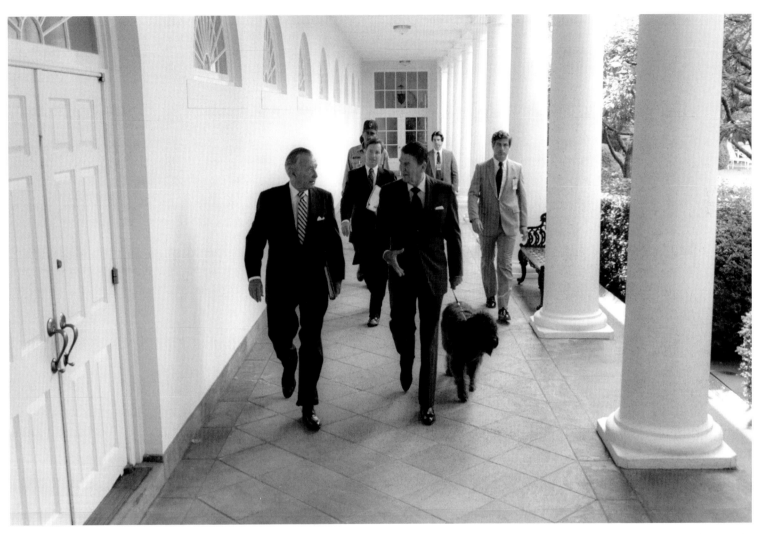

Reagan walks with his chief of staff Donald Regan and lap dog Lucky. By 1987 Republican leaders would agree with Nancy Reagan that, in the aftermath of the Iran-Contra scandal, Regan was a liability to the president. Reagan, loath to dismiss anyone, allowed Vice-president George Bush to negotiate Regan's resignation. Before the chosen day, Regan heard of his ouster on CNN and stormed out, only to vent his wrath in a bitter tell-all book, claiming that Nancy Reagan consulted an astrologer before scheduling the president's days. Reagan had said in his 1965 autobiography, "One of our good friends is Carroll Righter, who has a syndicated column on astrology. Every morning Nancy and I turn to see what he has to say about people of our respective birth signs." In matters of the presidency twenty-two years later, his position was that Regan's claims were nonsense. Whether or not Reagan read the astrology column, what is clear is that the president, by contrast, was informed by the concepts of Christianity: he believed he had been chosen by a higher power for his role.

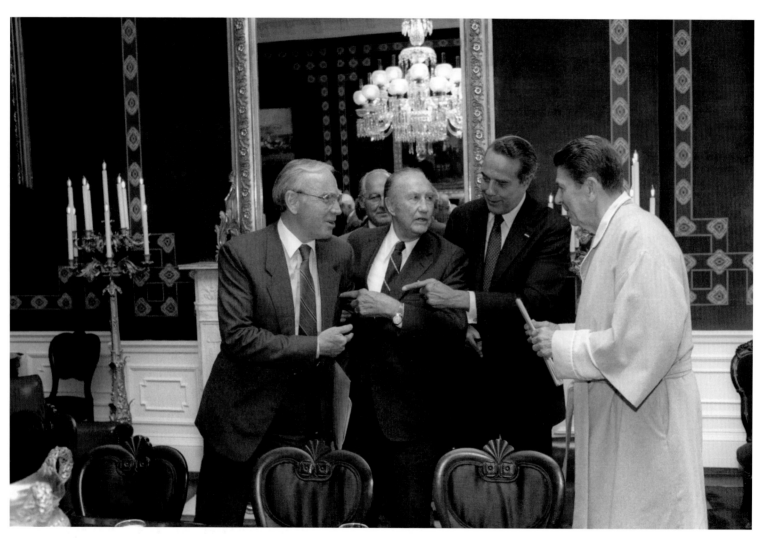

In 1985 Republican Senate leaders visit the recuperating Reagan upon his return to the White House from Bethesda Naval Hospital. Doctors had found a large flat polyp that was potentially cancerous, with cancer cells in the tissue. On a televised special report regarding the hospitalization, the President heard White House correspondent Helen Thomas say, "The President has cancer." Reagan's doctor quickly interjected that the cancerous tissue had been removed.

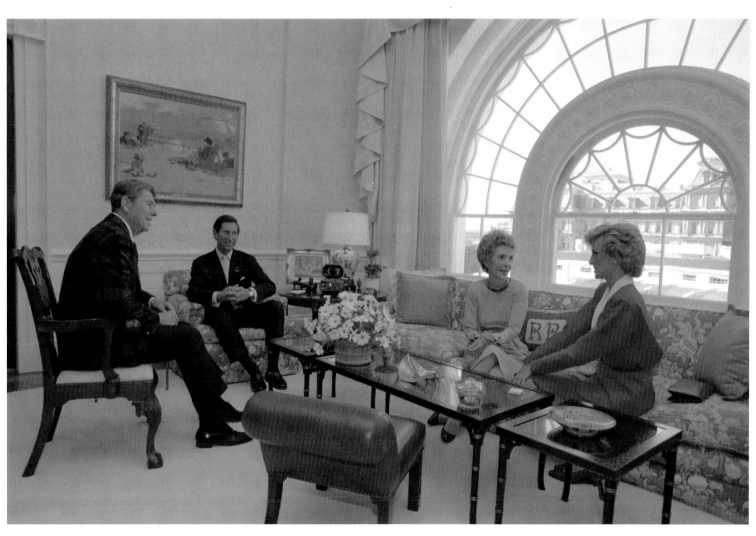

On November 9, 1985, a state dinner and dancing for visiting royalty was held at the White House. Earlier that day the ill-fated Princess and Prince of Wales shared coffee with the Reagans in the upstairs family quarters. Following their divorce, Diana died in a Paris automobile crash in 1997 and Charles married his longtime paramour, Camilla Parker Bowles, in 2005.

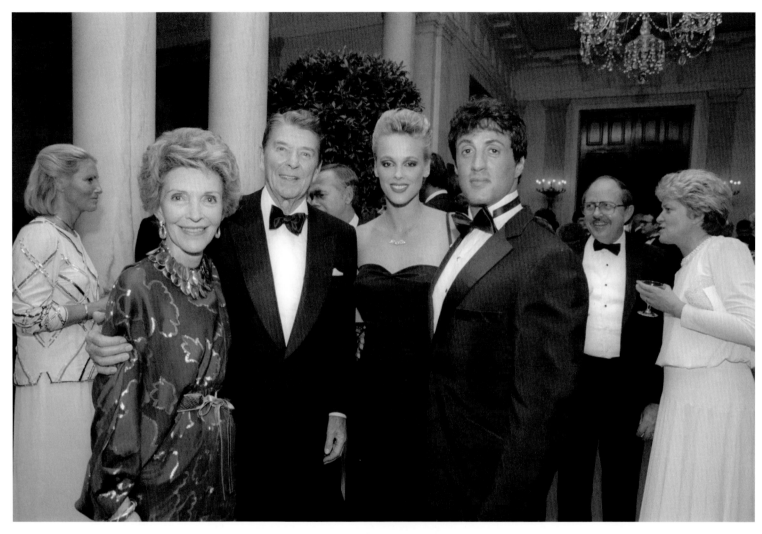

The Reagans welcome Sylvester Stallone to the White House, where Ronbo (opposite page) meets Rambo. In America's popular culture, extremes always sell movies, newspapers, television, magazines, and now downloads. Sylvester Stallone's 1980s macho Vietnam veteran John Rambo became the protagonist for the wounded United States psyche, cinematically revising the history of the Vietnam War and giving political cartoonists the grist they needed to make life imitate art. "Ronbo," on the highest frontier, was depicted confronting the Soviet Union using "Star Wars" weaponry.

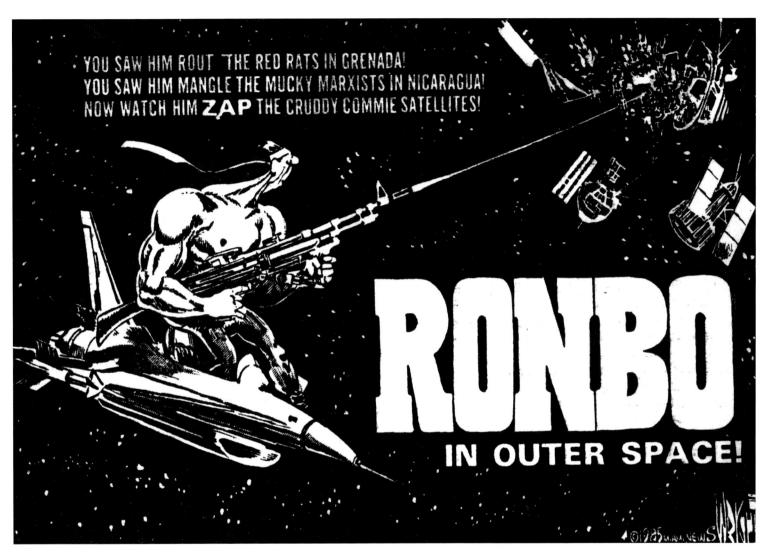

According to Bill Bennett, former Reagan education secretary, the president loved political cartoons. Speaking at a June 7, 2008, luncheon sponsored by the Ronald Reagan Presidential Foundation and recorded by C-SPAN, Bennett said the president was a great storyteller and enjoyed humor in all forms. Jenny Mandel, an archivist at the Reagan Library, revealed the "Friday Follies" to Turner Publishing in May 2008. Boxes of carefully stored files for almost every week of the Reagan presidency contained political cartoons from leading newspapers that skewered the high and the mighty. The cover sheet that appears in every file is marked: White House News Summary Special Edition, with volume and issue numbers and the date—always a Friday. A quotation also appears: "I don't care a straw for your newspaper articles. My constituents don't know how to read. But they can't help seeing them damn pictures" (William Marcy Tweed speaking of Thomas Nast, 1871). Nast cartoons were credited with exposing the corruption of Boss Tweed's Tammany Hall in New York City. *Ronbo in Outer Space* is the work of Pulitzer Prize–winning cartoonist Don Wright.

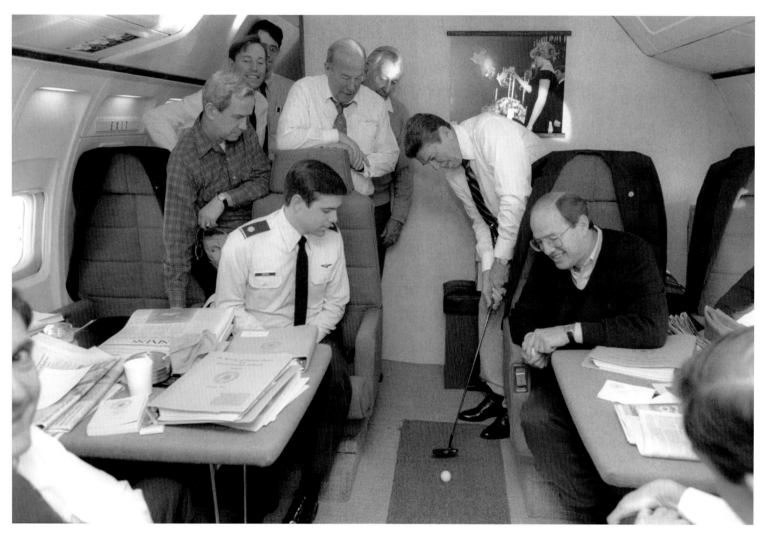

Before this flight to Geneva on Air Force One, the president received a letter of support for his Strategic Defense Initiative from 39 senators. With that backing, Reagan relaxes with his golf putter before a staff briefing in preparation for the summit with Mikhail Gorbachev on November 19, 1985.

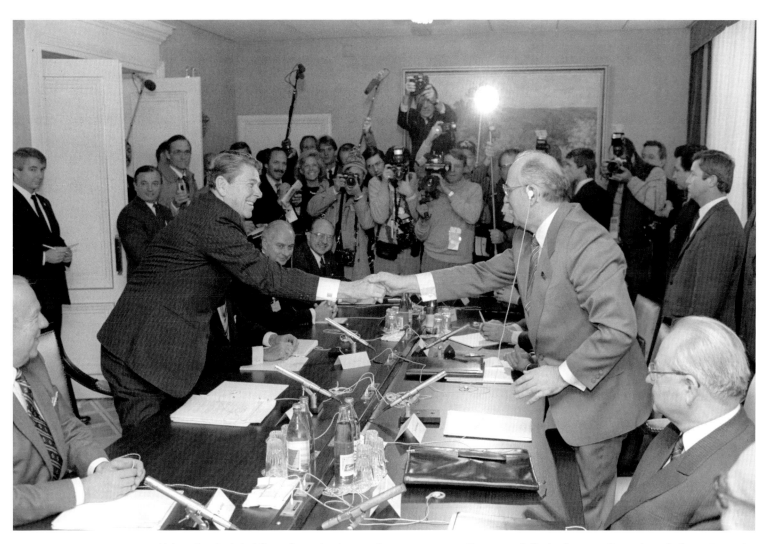

Although scheduled for only a 15-minute private one-on-one, Reagan and Gorbachev met for an hour before joining the plenary meeting pictured. Both sides exchanged views during morning and afternoon meetings. Later, the two leaders retreated to a pool house on Lake Geneva's shore for two more hours of discussion on SDI. They agreed to disagree and scheduled more meetings in 1986 and 1987.

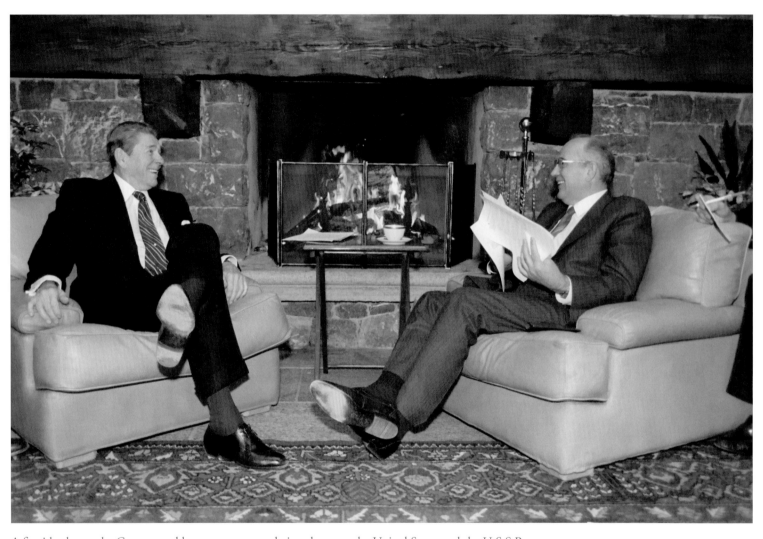

A fireside chat at the Geneva pool house warms up relations between the United States and the U.S.S.R.

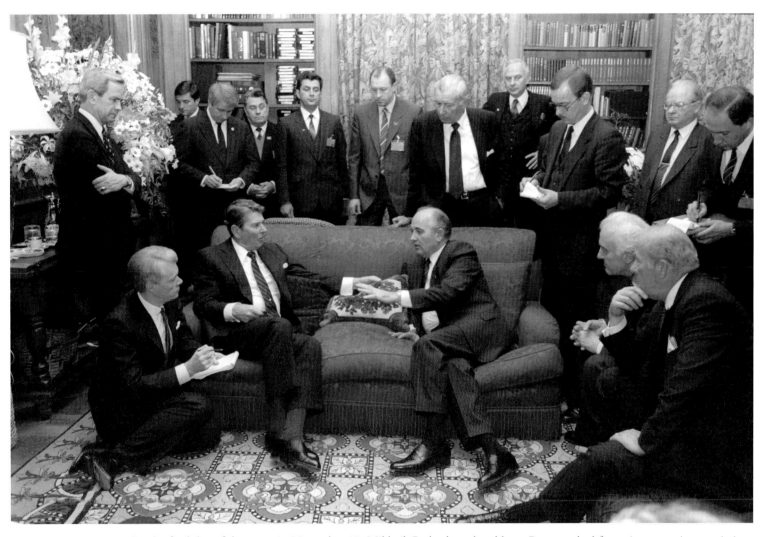

On the final day of the summit, November 20, Mikhail Gorbachev played host. Reagan asked for action on easing restrictions on emigration and other human rights issues, in exchange for more trade concessions by the United States. Later, in the plenary session, Reagan pressed for arms control and Gorbachev accused the United States of creating an arms race in space.

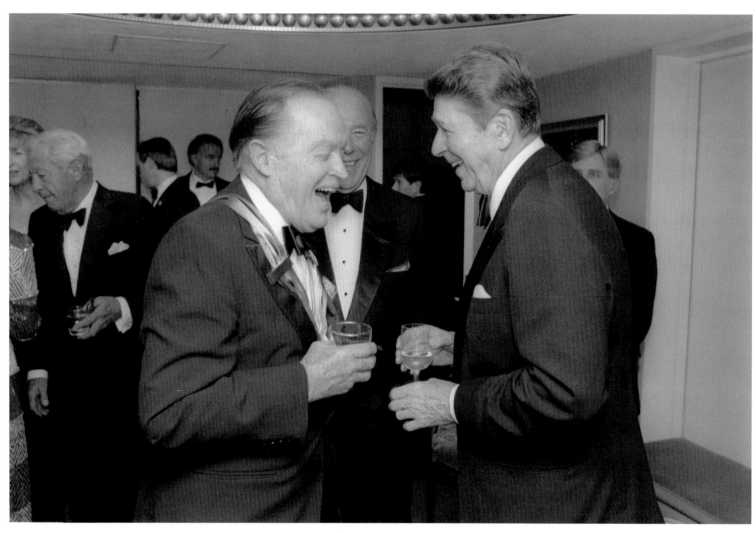

Secretary of State George Schultz and Reagan congratulate old friend Bob Hope on December 8, 1985, at the Kennedy Center Honors. Other honorees that year were Irene Dunne, Mercer Cunningham, Alan Jay Lerner, Frederick Lowe, and Beverly Sills. Bob Hope would live to the age of 100, dying less than a year before the president, on July 23, 2003.

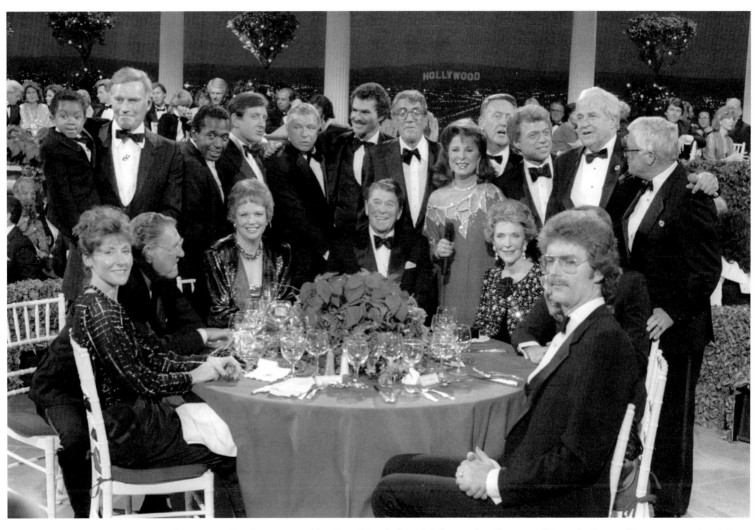

The Reagan family are joined by their friends from Hollywood at the 1985 Kennedy Center Honors reception. Those standing include Emmanuel Lewis, Charlton Heston, Ben Vereen, Monty Hall, Frank Sinatra, Dean Martin, Burt Reynolds, Eydie Gorme, Steve Lawrence, and Merv Griffin.

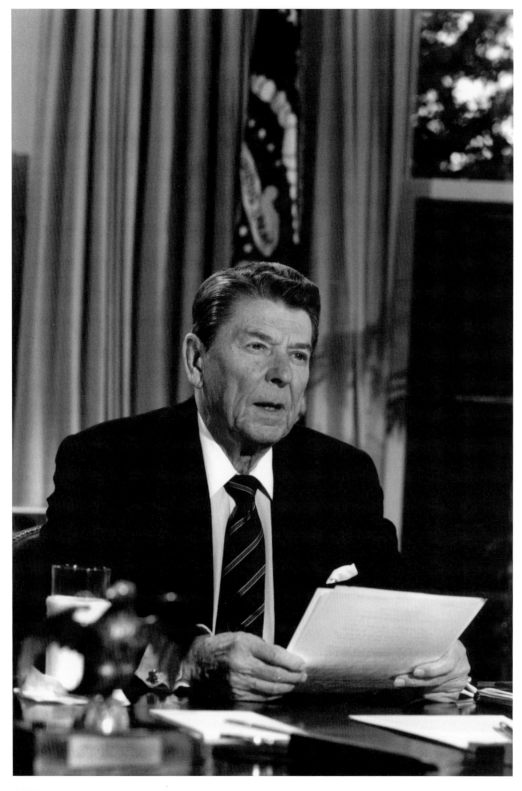

Without warning, on January 28, 1986, the Space Shuttle *Challenger* exploded, killing all seven crew members the second minute into launch. A faulty O-ring seal on one of the solid rocket boosters was shown to be the cause. The State of the Union address was canceled for that evening, and Reagan addressed the nation, especially the nation's youth. Many children had watched the launch in their classrooms, because "the first teacher in space," Christa McAuliffe, was aboard the doomed flight.

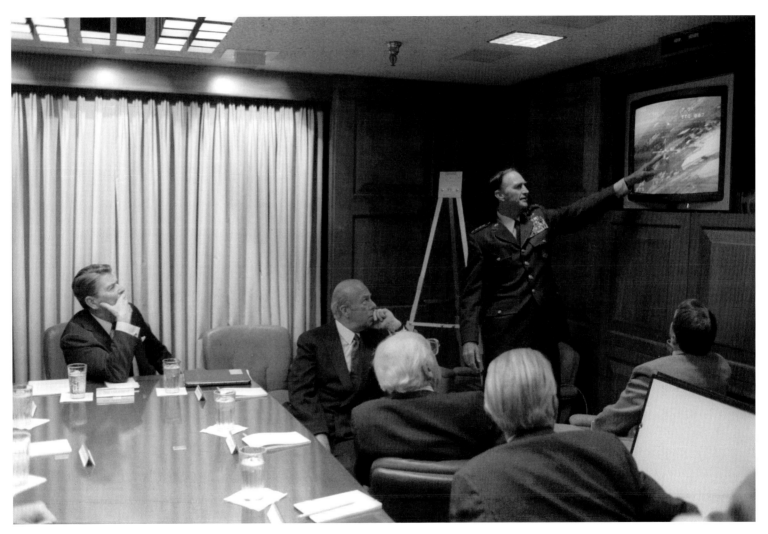

Reagan and Secretary of State George Schultz attend a study and analysis session on April 14, 1986, following the attack on five military targets in Libya. The preliminary report deemed Operation El Dorado Canyon, involving 200 aircraft and more than 60 tons of bombs, a success. One United States F-111 aircraft with a crew of two was missing. The attack was aimed at Libya's sponsorship of terrorism, in particular the April 5 terrorist bombing in West Berlin that killed and wounded American servicemen. The Reagan administration would respond in varying ways to other attacks—among them the bombings of U.S. embassies and hijacking of planes and the cruise ship *Achille Lauro*—in its effort to grapple with nascent terrorism in the Middle East.

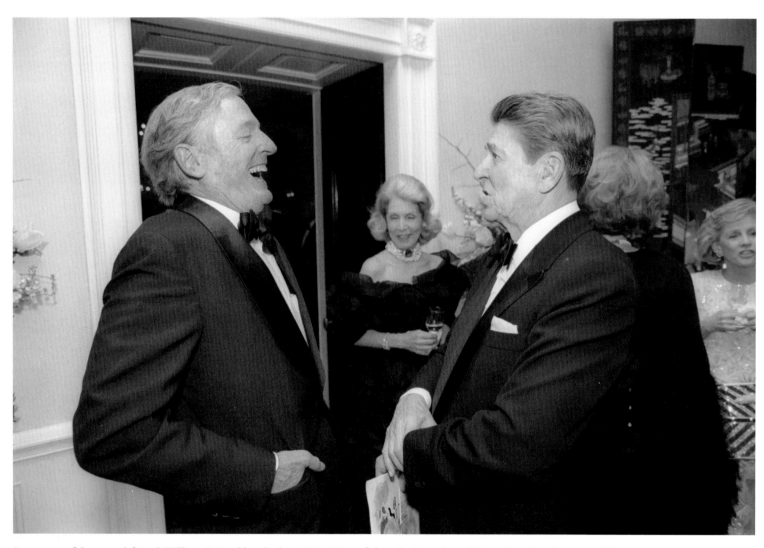

Reagan confidante and friend William F. Buckley died in 2008. Host of the television show "Firing Line" and Editor of the *National Review* magazine (the bible of the conservative movement he founded in 1955 and to which Reagan subscribed), "Bill" himself was a conservative icon. Prior to passage of the INF Treaty in Congress, Buckley told Reagan that he was concerned that the Soviets could violate the treaty by substituting one class of missiles for another.

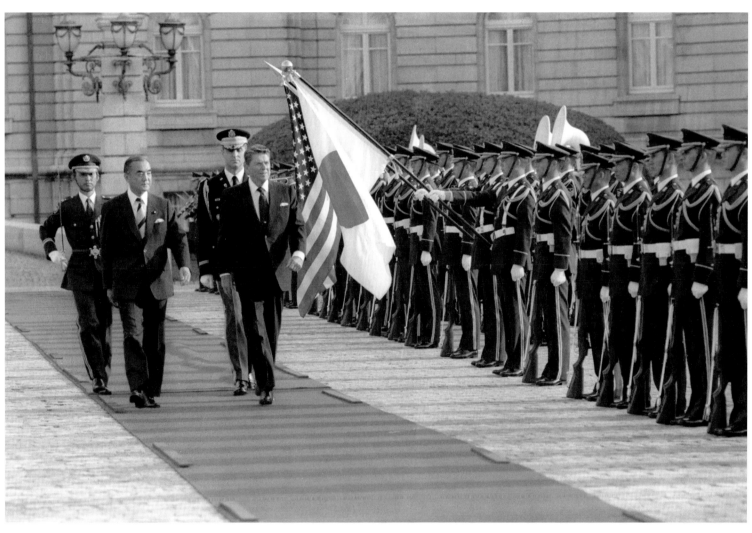

On Sunday March 4, 1986, at the Group of Five meeting in Japan, Reagan inspects the troops at Akasaka Palace with Prime Minister Yasuhiro Nakasone. Terrorists launched five homemade missiles at the palace that day, all missing their targets.

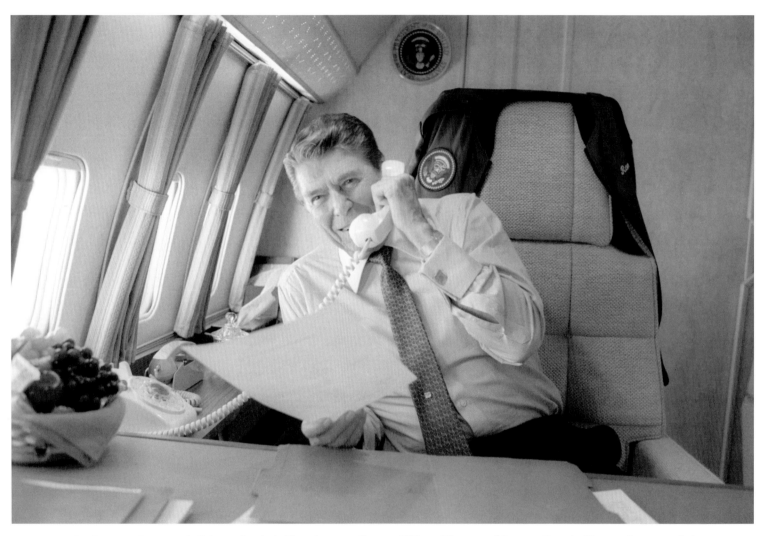

In the 2008 Democratic Primary battle in Texas between Senator Hillary Clinton and Senator Barack Obama, the issue of who was most qualified to handle a national emergency telephone call at 3:00 A.M. harked back to the Reagan White House. In the early morning hours of August 19, 1981, Libya fired on two U.S. F-14s over international waters in the Gulf of Sidra; in response, the F-14s shot down the two attacking Libyan jet fighters. Presidential counselor Ed Meese conveyed the news to Vice-president Bush without waking Reagan. The next day questions were asked about how national security was being conducted. Meese stated that "the President was in charge, and if there had been any action he needed to take, he would have been awakened."

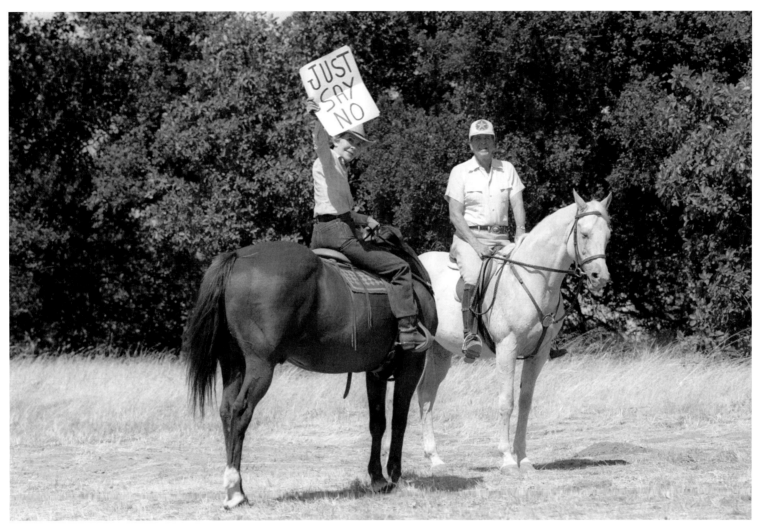

A First Lady's work is never done. Ever keen to push her "Just Say No" campaign against drugs on behalf of the
nation's youth, Nancy interrupts a horse ride to publicize her mantra with a homemade sign at their Rancho del Cielo
in Santa Barbara County.

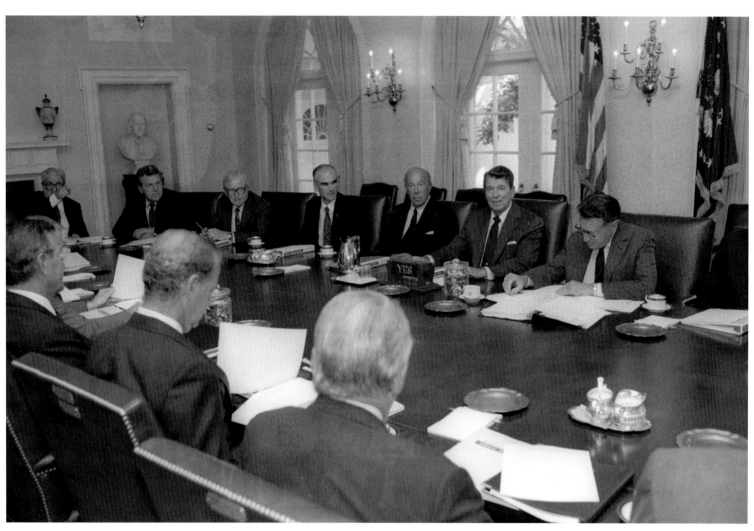

At this 1986 meeting it was agreed to turn Soviet spymaster Gennadi Zakharov over to the U.S.S.R. ambassador pending trial. Nicholas Daniloff, *U.S. News and World Report* journalist, was being held as a "spy" and was later delivered to the United States Embassy in Moscow. For the fourth time in Reagan's presidency, the Soviets arrested a private United States citizen in hopes of arranging a prisoner exchange for an arrested KGB agent. This time, Reagan insisted that Zakharov be tried for spying.

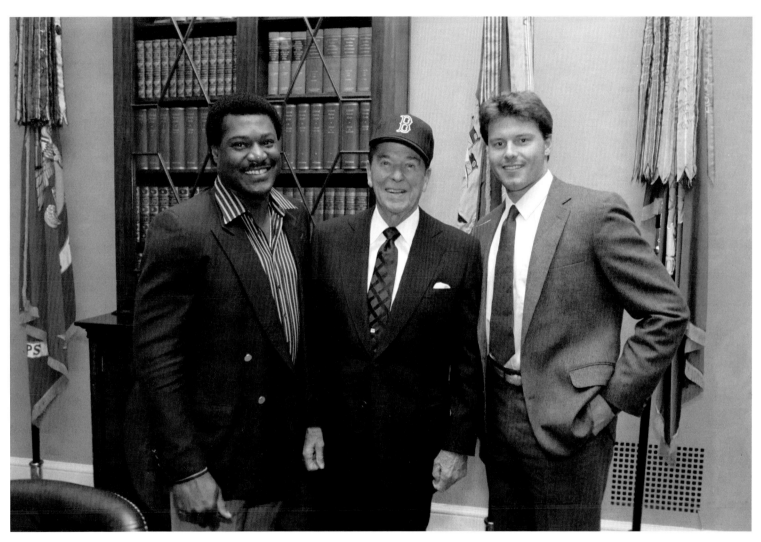

Boston baseball players Don Baylor and Roger Clemens present a Red Sox cap to President Reagan in December 1986. Baylor played in three consecutive World Series with three different teams, the third with the Red Sox in 1986. Clemens, one of only four pitchers to pitch 4,000 strike-outs, would court controversy in 2007. He was one of 89 players implicated in "The Report to the Commissioner of Baseball of an Independent Investigation into Illegal Use of Steroids and Other Performance Enhancing Substances by Players in Major League Baseball," or the Mitchell Report. Clemens denied all allegations against him.

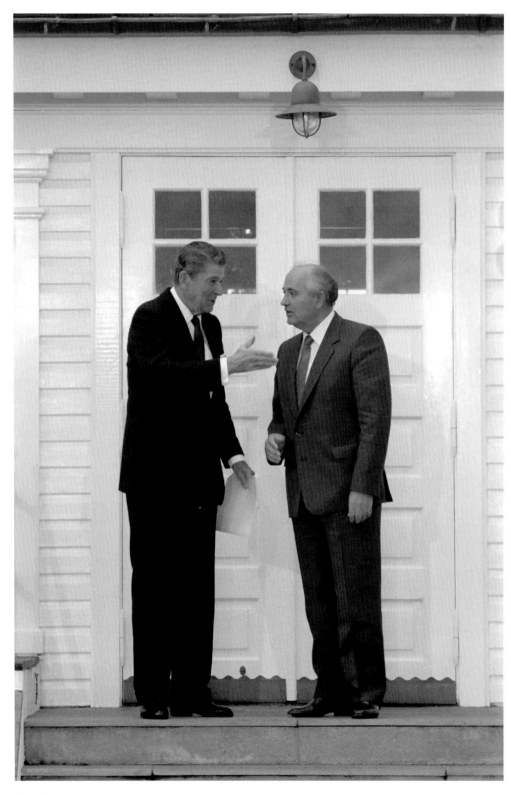

At the Hofdi House in Reykjavik, Iceland, on October 11, 1986, Reagan hosted the first meeting of a two-day summit between the United States and the U.S.S.R. The president and Soviet leader Gorbachev discussed human rights and bipartisan agreements before turning to the subject of arms control. They debated the issue, each indicating a willingness to reduce the number of nuclear weapons held by each nation. Secretary of State George Schultz and his Soviet counterpart, Eduard A. Shevardnadze, attended the meeting and took notes of the agreements and disagreements.

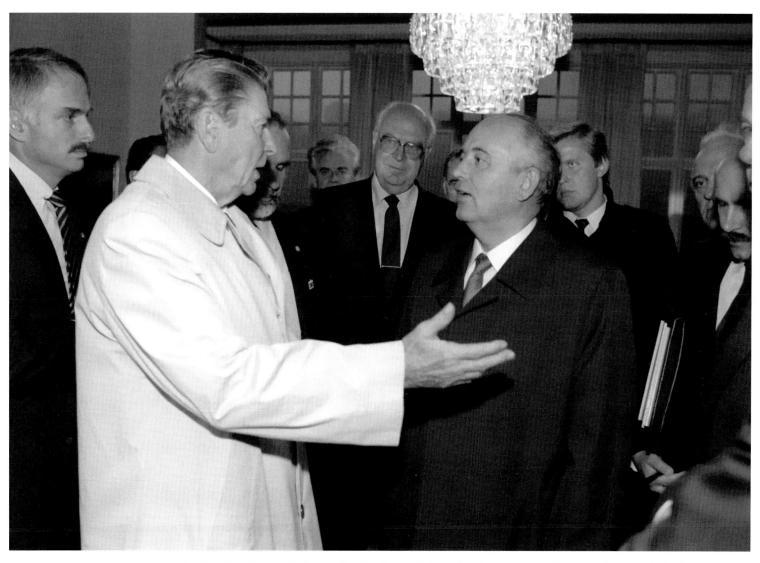

On October 12, negotiations at Reykjavik ended abruptly when it became clear that the Soviets' chief objective was to eliminate Reagan's SDI program. Reagan was incensed. The press reported the summit as a failure; in hindsight it seems to have been key to facilitating the treaty that was eventually implemented. The INF Treaty, which made sweeping cuts to both nations' arsenal of intermediate-range nuclear weapons, was signed in 1987.

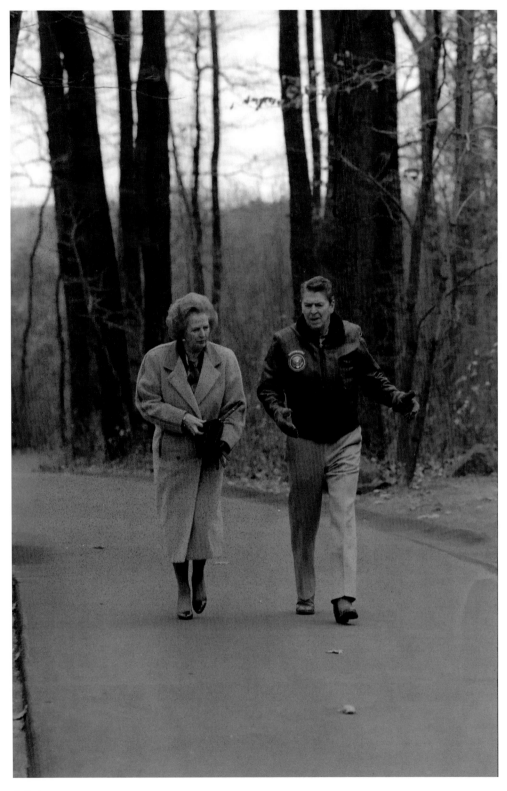

British prime minister Margaret Thatcher and President Reagan meet at Camp David where he addresses her concerns regarding the Iceland summit and arms reductions. Reagan gave reassurances to Thatcher before her scheduled meeting with her ambassador and advisors. Thatcher supported Reagan's initiatives at a Washington, D.C., press conference held later.

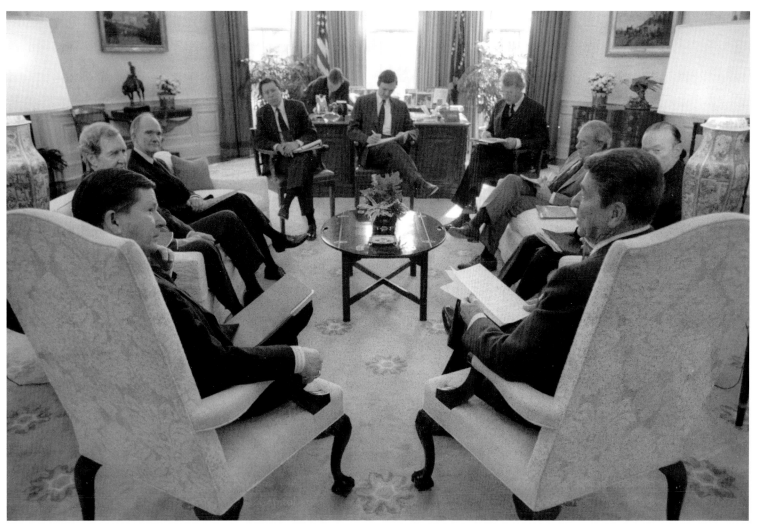

Senator John Tower and President Reagan discuss Iran-Contra on February 11, 1987. In yet another meeting with the Tower Commission, the president declared a newly surfaced tape recording to be a "complete fabrication." It purported to reveal Colonel Oliver North informing the Iranians that Reagan would guarantee arms deliveries in exchange for United States hostages. The tape also said that Reagan authorized providing Iran with strategies and the intelligence to defeat Iraq in their ongoing war.

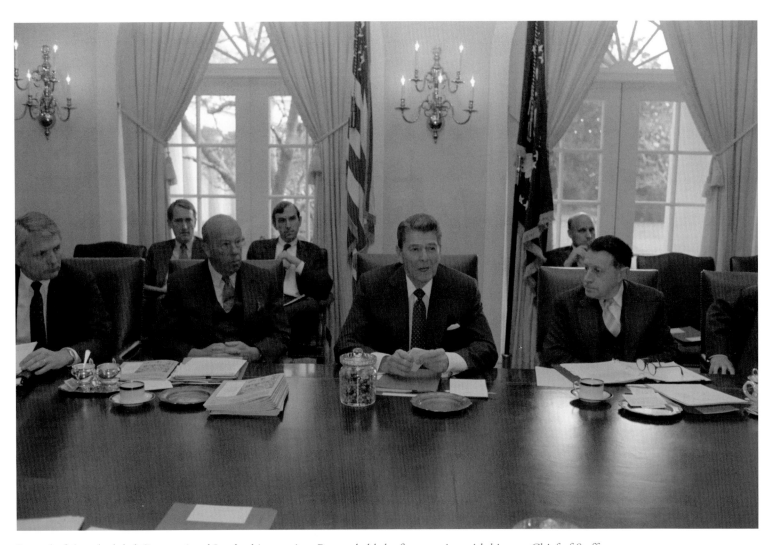

Instead of the scheduled Congressional Leadership meeting, Reagan held the first meeting with his new Chief of Staff Howard Baker at the helm. Defense Secretary Caspar Weinberger attended as well because Bob Gates removed his name from nomination as new C.I.A. director. They were trying to attract John Tower to the job, or William Webster after Gates could not win enough Senate support for confirmation. Webster was sworn in as the director on May 26, 1987, after insisting that it not be a cabinet-level position.

Off to Camp David for the weekend aboard Marine One, the Reagans wave to staff and reporters on March 13, 1987.

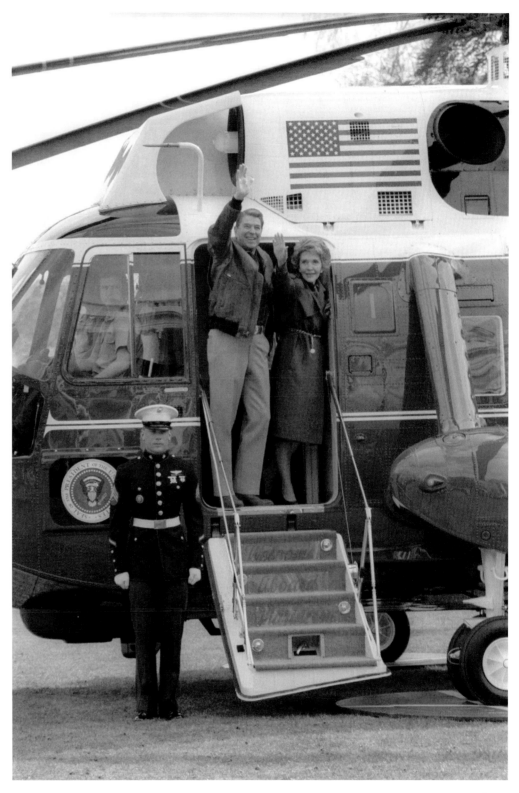

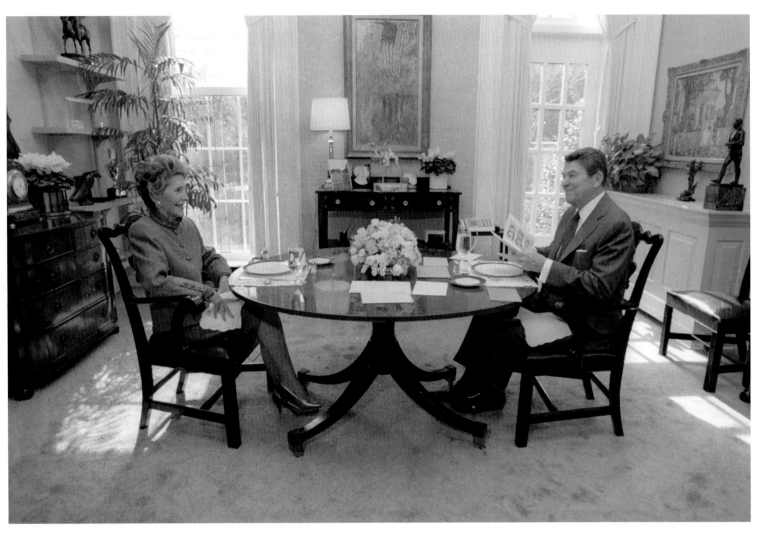

The Reagans celebrated their 35th wedding anniversary, the last one as residents of 1600 Pennsylvania Avenue, on March 4, 1987. Nancy joins the president for lunch in the White House Study. The couple's deep devotion to each other has been widely noted and admired.

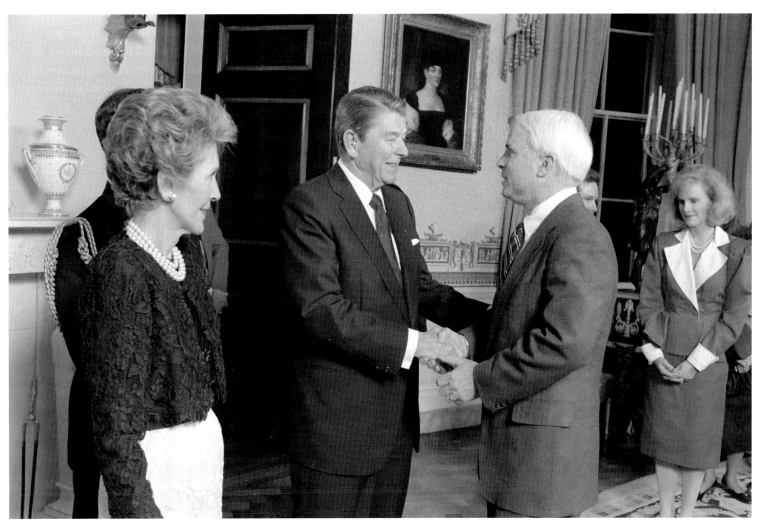

Senator John McCain, Republican of Arizona, became the Republican nominee for president in 2008, more than two decades after he and second wife Cindy greeted the Reagans at a White House reception on March 22, 1987. In 2008, Nancy Reagan endorsed McCain for president during his visit to her home at Bel Air, California. "Ronnie and I always waited until everything was decided, and then we endorsed," she said. "Well, obviously this is the nominee of the party."

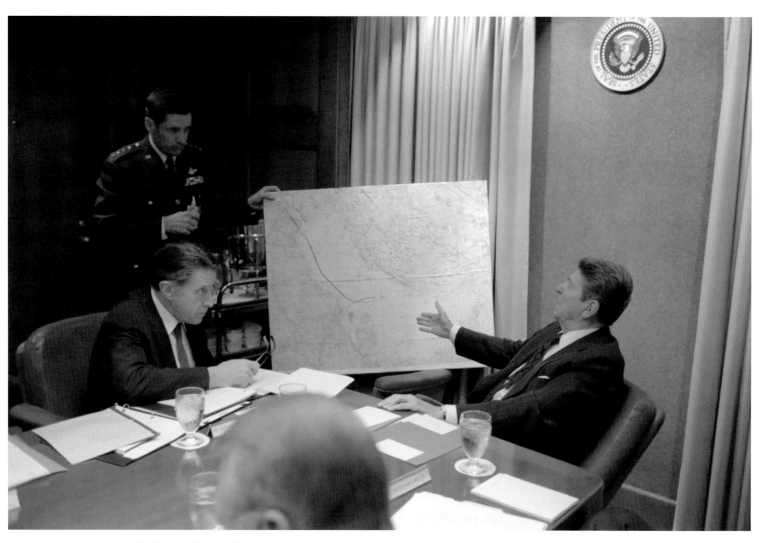

On May 17, 1987, the USS *Stark,* a frigate off the coast of Bahrain in the Persian Gulf, was struck by two missiles fired from a Russian-built Iraqi F-1 fighter, killing 37 seamen. In the Situation Room, Reagan ordered United States naval vessels to open fire on any craft positioning itself to attack. The Iraqi foreign minister apologized and their ambassador offered compensation to families of the injured on the USS *Stark*. President Reagan sent condolences to the injured in the weeks to follow.

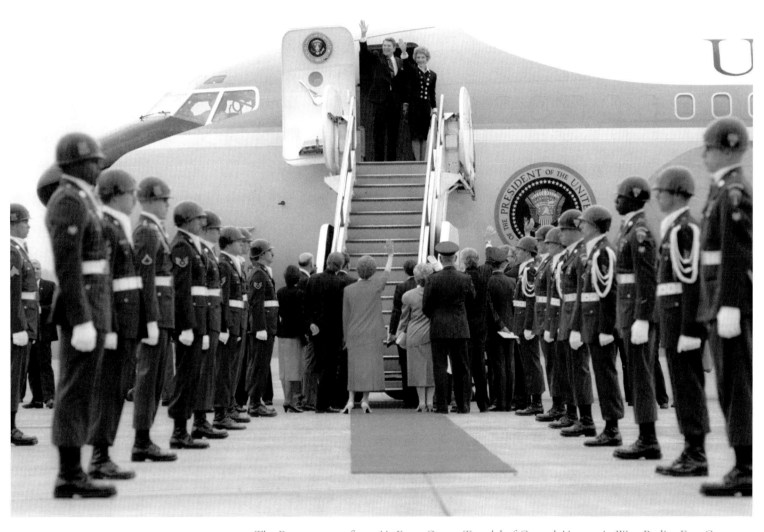

The Reagans wave from Air Force One at Templehof Central Airport, in West Berlin, East Germany.

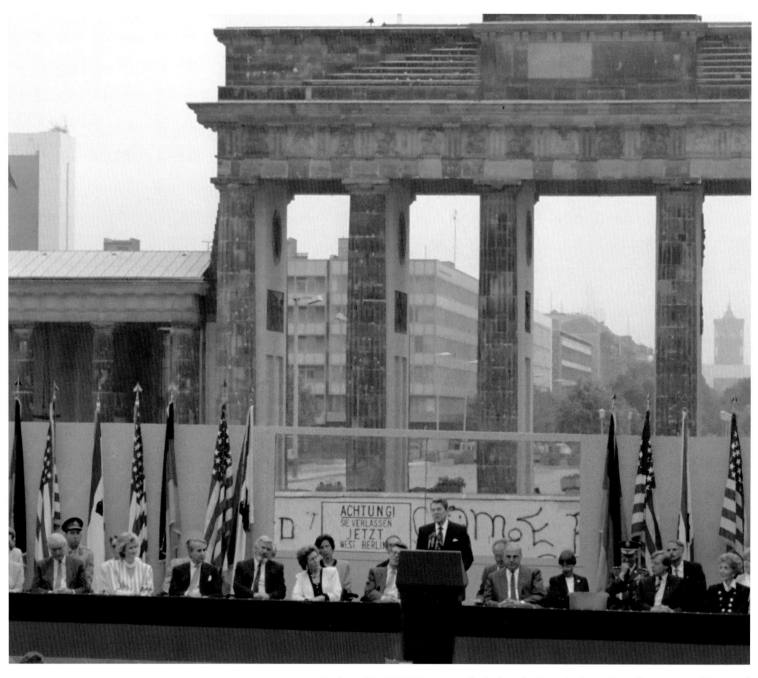

On June 12, 1987, Reagan spoke before the Brandenburg Gate that separated East and West Berlin, addressing tens of thousands of Berliners. The crowd interrupted him 28 times with applause and cheers, especially when he demanded, "Mr. Gorbachev, open this gate! Mr. Gorbachev, tear down this wall!"

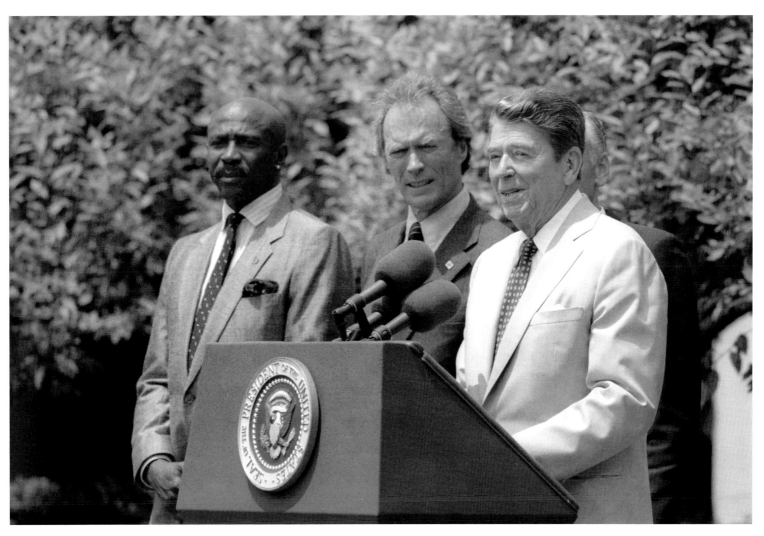

Clint Eastwood, one of Reagan's favorite actors, visits the White House in this July 1987 photo. Reagan was impressed with Eastwood's work in films, especially *Fire Fox* and *Honkey Tonk Man*. In November 1982, Eastwood had visited Reagan at Rancho del Cielo where he discussed a group he supported that aimed to find POWs in Laos and bring them home. Reagan was skeptical of such efforts made by private citizens.

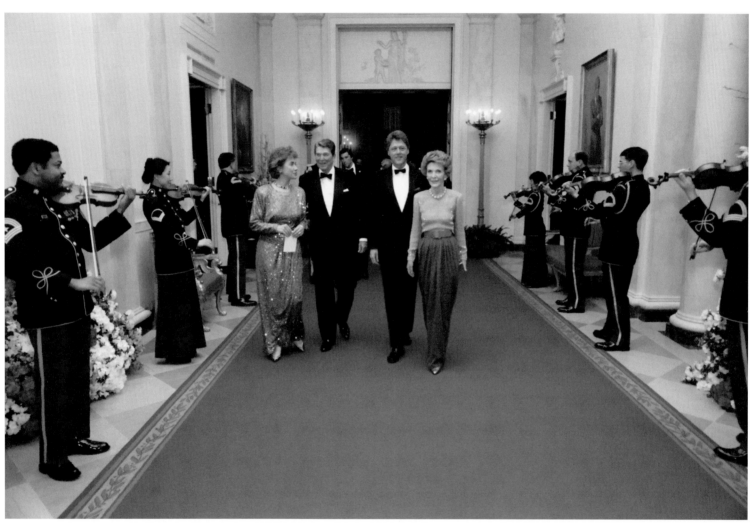

The Reagans escort Hillary and Governor Bill Clinton of Arkansas past a military band's musical interlude at a White House reception for governors. In 1992 and 1996, Bill Clinton would win two terms as president, becoming only the second president in U.S. history (after Andrew Johnson in 1868) to be impeached, on convictions of perjury and obstruction of justice. Ironically, Reagan and Hillary Clinton both worked for the presidential campaign of Arizona Senator Barry Goldwater in 1964. Reagan appeared in a televised election appeal for Goldwater, while Hillary volunteered as a teenage "Goldwater Girl." Senator Hillary Clinton of New York was narrowly defeated by Illinois Senator Barack Obama for the 2008 Democratic presidential nomination.

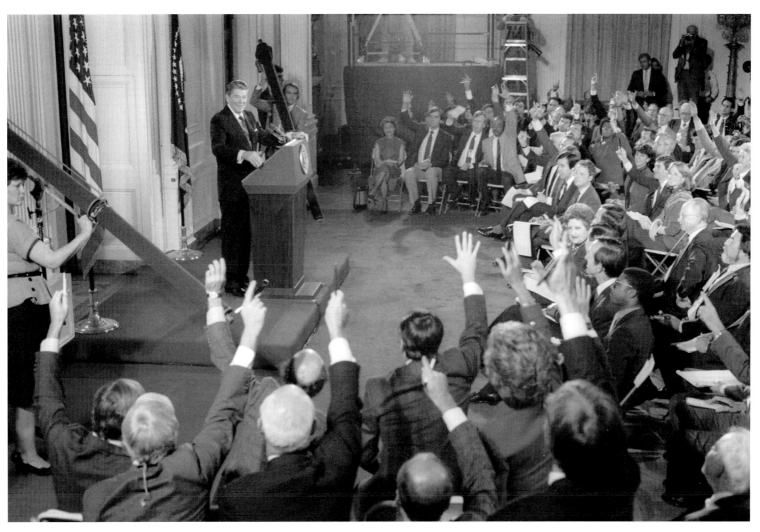

The Dow Jones Industrial Average had plunged 800 points in a week by Monday, October 21, 1987, and 508 points on that day alone, to become known as "Black Monday." At the press conference, the questions centered on the stock market panic, the upcoming meeting with Congress to reduce the deficit, and a replacement to be named to the Supreme Court. Helen Thomas, a particularly strong questioner of the president and fixture at his many press conferences, has question at the ready. The president was always careful to give the veteran reporter her chance.

Robert Bork was anathema to liberals ever since his role in Nixon's "Saturday Night Massacre" in 1973. After the attorney general and deputy attorney general resigned rather than fire Watergate Prosecutor Archibald Cox, Bork acted on Nixon's order to do so. When Reagan nominated then Judge Bork to the Supreme Court in 1987, Senator Edward Kennedy's "Robert Bork's America" speech outraged the Reagan White House. Kennedy's ideological accusations, considered slanderous by conservatives, went unanswered for weeks, and the otherwise well-qualified nominee was rejected by the Senate 58-42. Instead, a different Kennedy—Anthony Kennedy—was sworn in as Reagan's last Supreme Court appointee on February 18, 1988.

Reagan's chief of staff Howard Baker discusses General Colin Powell's becoming national security advisor on November 6, 1987. Powell was named chairman of the joint chiefs of staff under President George H. W. Bush in 1989 and secretary of state in the first term of President George W. Bush in 2001.

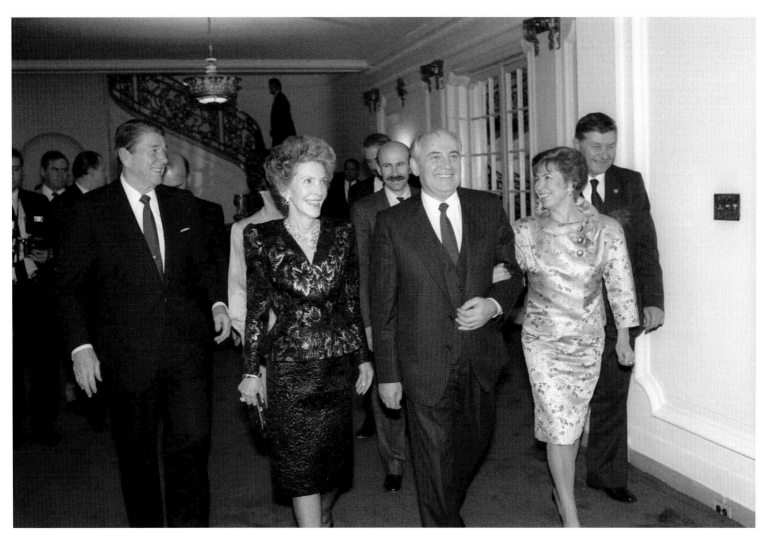

On December 8, 1987, little more than a year after the Reykjavik summit, the Gorbachevs visit
the White House. After lunch, Reagan, Nancy, Gorbachev, and his wife Raisa would stroll to the
East Room for the signing of the Intermediate Range Nuclear Forces (INF) Treaty between the
United States and the U.S.S.R.

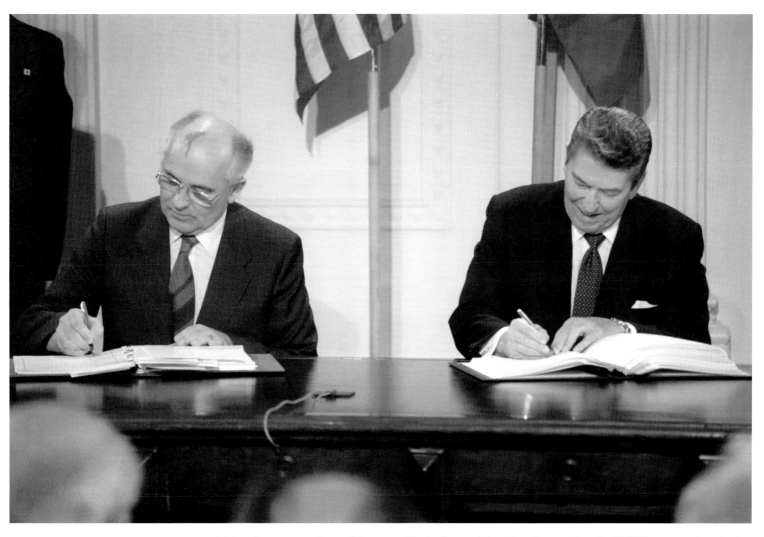

A historic moment, General Secretary Gorbachev and President Reagan sign the INF Treaty greatly reducing the number of intermediate-range nuclear weapons. Reagan invoked an old Russian maxim: "Dororey no prororey": Trust but verify. In fact this treaty included more verification rules than had heretofore been negotiated with the Soviet Union in any treaty.

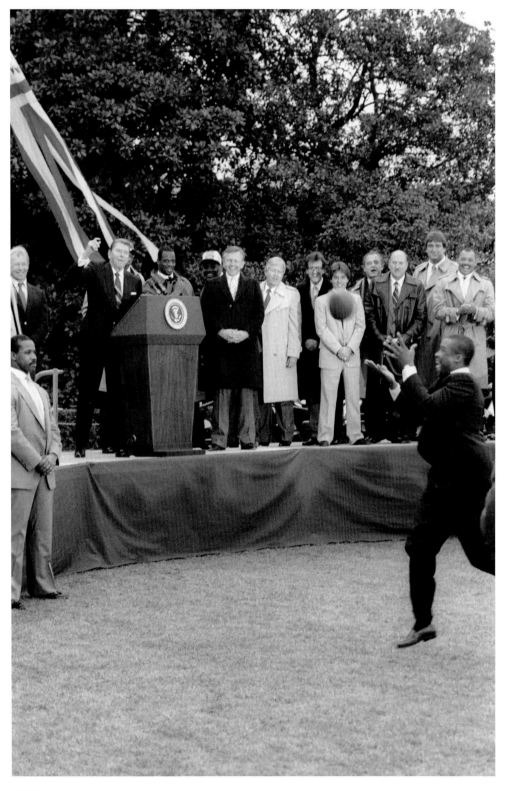

"The Gipper" passes to Ricky Sanders while greeting the 1988 Super Bowl champions the Washington Redskins on February 3, 1988. Under Coach Joe Gibbs, the Redskins defeated the Denver Broncos 42-10 in Super Bowl XXII.

Reagan celebrates on March 17, 1988, with Irish officials at the White House and at House Speaker Jim Wright's St. Patrick's Day party. But there was no luck of the Irish for Colonel Oliver North, Admiral John Poindexter, General Richard Secord, and Albert Hakim with the announcement of 23 indictments against them in the Iran-Contra affair. In his congressional testimony, North said he was authorized to pursue various covert operations without constitutional constraint.

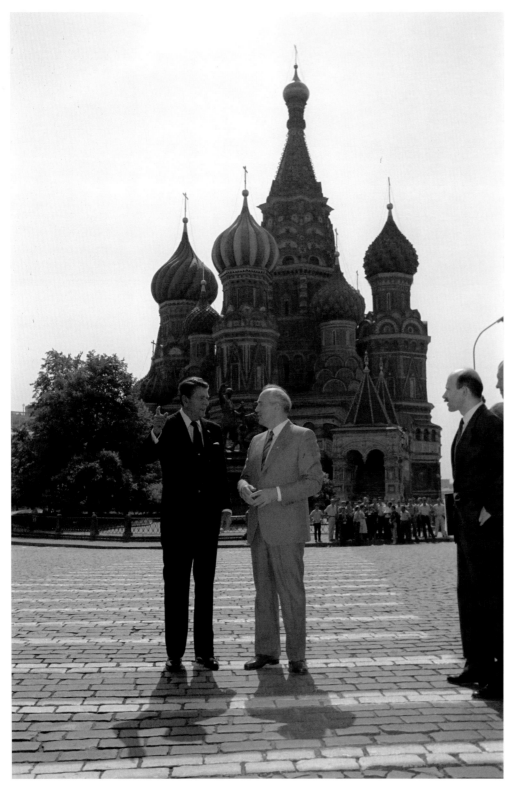

St. Basil's Cathedral on brick-paved Red
Square was the expansive scene as leaders
Reagan and Gorbachev visited in Moscow on
May 31, 1988.

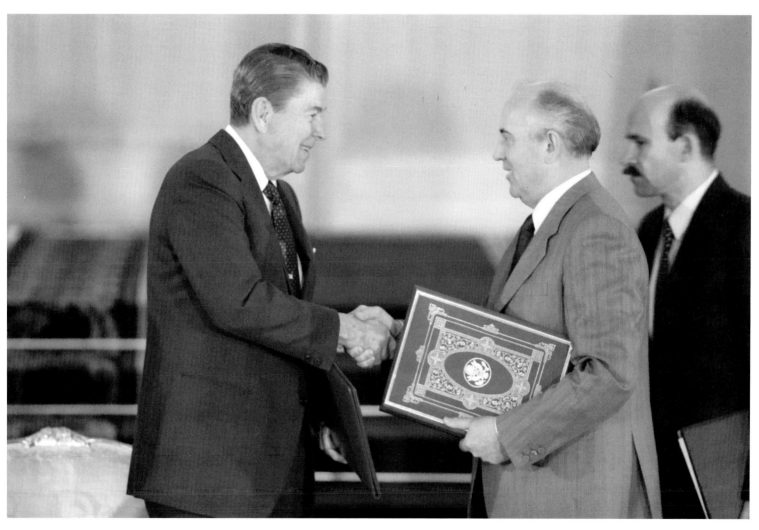

Congratulatory handshakes follow the formal signing ceremony of INF Treaty ratifications on June 1, 1988, in the Kremlin.

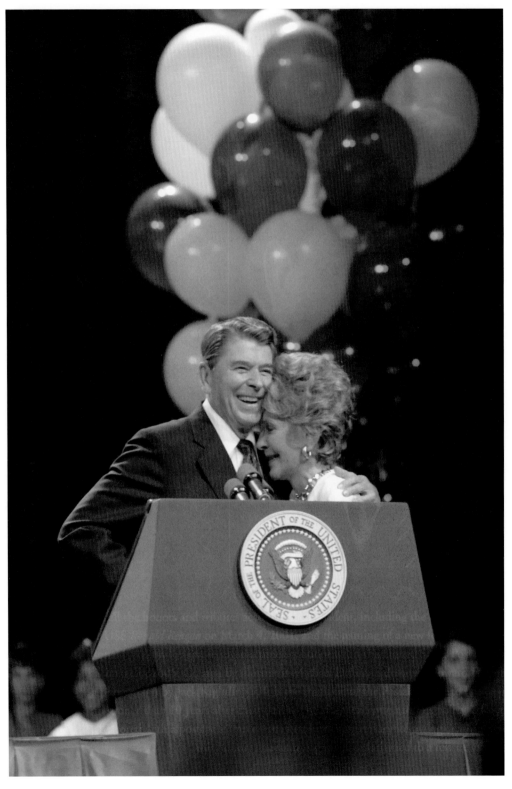

Win one more for the Gipper! Ronald Reagan makes an appearance at the Republican National Convention in New Orleans on August 15, 1988. Reagan's vice-president, George H. W. Bush, would be nominated for president at the convention.

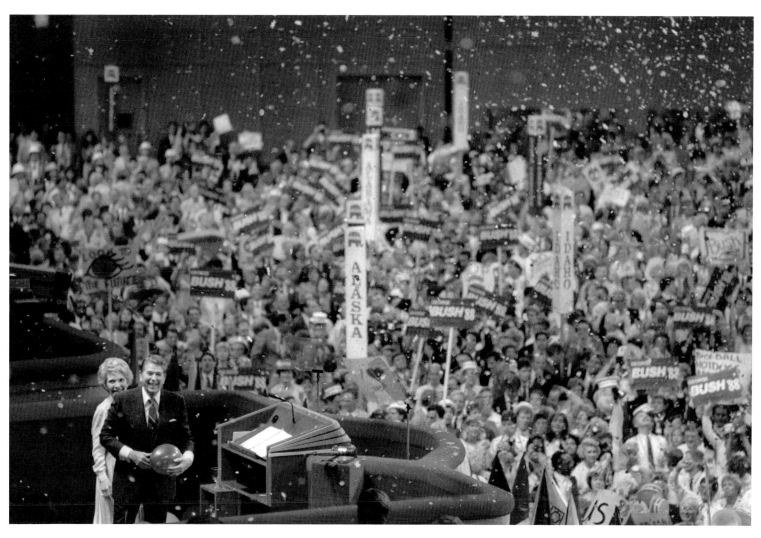

The Reagans receive one more confetti shower while Lee Greenwood delivers his tribute song "God Bless the USA."

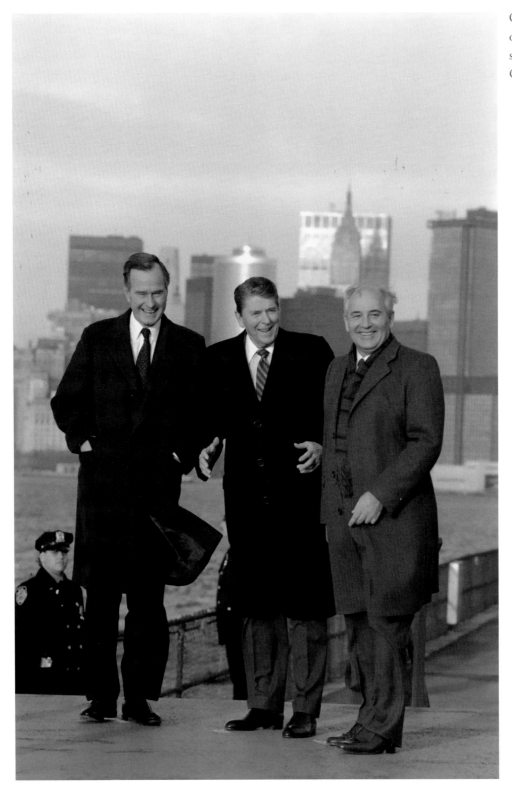

On December 3, 1988, in the twilight of his presidency, Reagan hosted a summit with Mikhail Gorbachev on Governor's Island in New York.

LEGACY

(1989–)

To appreciate how far the Reagan legacy extends, consider the following. None other than Barack Obama, arguably the most liberal candidate ever to seek the presidency, invoked the name of Ronald Reagan during the 2008 Democratic primaries. He received criticism from all manner of Democrats for praising Reagan's oratorical successes. Although 2008 marked the first year in 28 years not to have a Reagan, Bush, or Clinton on the general election ballot, the long legacy of President Ronald Wilson Reagan is still a benchmark by which all presidents are judged. In a 2007 Gallup poll, respondents ranked Reagan the second greatest president in United States history after Abraham Lincoln. Ronald Reagan would have said, "Not bad, not bad at all."

"Underestimated" is perhaps the best word to describe Ronald Reagan. He was underestimated by many key figures in his life. Warner Bros.' chief Jack Warner observed the work ethic that made Reagan a reliable "B" movie actor who always arrived fully prepared for his character's parts. Why was such performance not rewarded with better roles and films? Warner underestimated Reagan. Wife Jane Wyman won an academy award and divorced Reagan as his film career was declining in the face of his Screen Actors Guild duties. Wyman underestimated Reagan. Herb Sorrell was a communist who ran powerful Hollywood labor unions and bullied Reagan while he was president of the SAG. Sorrel underestimated Reagan. Employer General Electric fired Reagan from the popular GE Theater to curry favor with the more liberal Kennedy Democrats. GE underestimated Reagan. Former Governor Pat Brown of California said, "Really nothing much has happened in the years that he's been governor and that will plague the next governor with tremendous problems." Brown underestimated Reagan. Reagan's second-term opponent Jesse M. Unruh, former speaker of California's state assembly, said, "I do not like Ronald Reagan. I find him cold, withdrawn, shallow, sanctimonious and with very little personal warmth in spite of his appeal to people from the platform and the television tube." Unruh underestimated Ronald Reagan. President Gerald R. Ford said in his memoirs, "I didn't take Ronald Reagan seriously." In 1974 Ford failed to select Reagan as vice-president in favor of Governor Nelson Rockefeller. Ford narrowly won the 1976 Republican nomination over Reagan and was defeated by Jimmy Carter in the general election. Ford underestimated Reagan. President Jimmy Carter's support was not concentrated in

many states, winning only 41 percent of the popular vote and 49 electoral votes in his race against Reagan. Ronald Reagan became president with 51 percent of the popular vote and a lopsided 489 electoral vote total in 1980. Carter underestimated Reagan. Former Vice-president Walter Mondale, as a candidate for president in 1984, tried to make Reagan's 73 years an issue of age in the campaign. Mondale suffered the greatest electoral defeat for any Democratic candidate in history, winning only 13 electoral votes and the popular votes of Minnesota and the District of Columbia. Mondale underestimated Reagan.

President Reagan changed the national conversation to include his conservative ideas, among them optimism about America's future, not looking to government for the solutions to all problems, allowing more free trade and markets, and reducing government regulation. The Reagan administration presided over an economic boom that included a rising stock market, lower taxes, the curbing of inflation, lower unemployment, and lower interest rates. Despite these efforts, deficit spending continued in earnest, 1970s style, with the Congress refusing his repeated requests for the line item veto to control deficits. Reagan attempted to reconfigure the Supreme Court, elevating William Rehnquist to chief justice and naming three new justices during his two terms: Sandra Day O'Connor, Antonin Scalia, and Anthony Kennedy. Part of Reagan's greatest achievement came to fruition less than two years after he left office: the fall of the Berlin Wall. In subsequent years, that symbolism was amplified by the fall of the Soviet Union and its iron grip on Eastern Europe, as well as the reunification of Germany. Reagan's insistence on reducing the proliferation of nuclear weapons, which he feared would lead to a man-made Armageddon, is arguably his most lasting legacy.

Never underestimating Reagan were wife Nancy, Reagan's mother Nelle, Mikhail Gorbachev, and the American people. Holmes Tuttle was another. One of the original group of kingmakers who backed Reagan, Tuttle summarized the consensus of all loyal supporters: "He's a man of integrity and principle . . . A great governor . . . A man of determination . . . A man who is not afraid to make a decision regardless of the political consequences." On May 10, 2008, the late Tim Russert asked ABC's Barbara Walters for her assessment of Ronald Reagan, and she replied, "You couldn't help but be charmed by Ronald Reagan. He was the great communicator." Conservatives and liberals, with a majority in between, continue to be influenced by the Reagan legacy.

No longer the President of the United States of America after the inauguration of George H. W. Bush at
the Capitol, Ronald Reagan salutes before boarding the helicopter for a ride to Andrews Air Force Base
and then home to California to begin a new life in retirement.

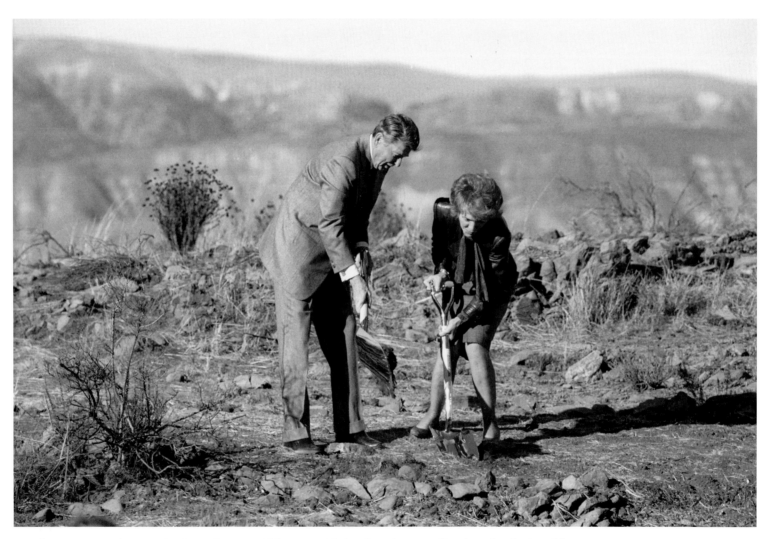

President Reagan and First Lady Nancy Reagan wield ceremonial shovels at the groundbreaking for the Ronald Reagan Library and Museum at Simi Valley, California, on November 21, 1988. The 100-acre site is a hilltop of the Santa Monica Mountains in Ventura County, near the border with Los Angeles County and the Pacific Ocean. The library and museum have been open to visitors since 1991 as the largest of all presidential libraries in the nation.

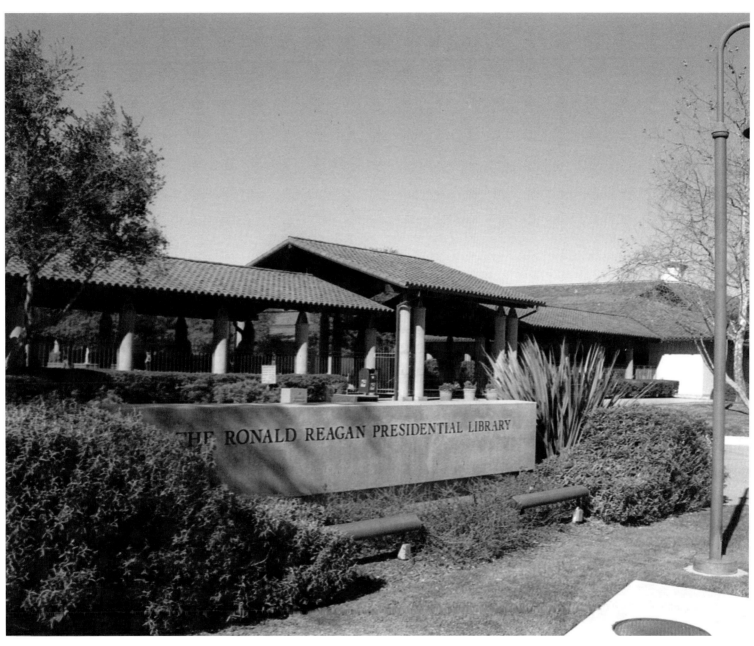

The Ronald Reagan Presidential Foundation, housed at the Reagan Library and Museum, provides operational support for the presidential library and museum including educational programming and exhibits. Visitors may view the Gubernatorial Gallery, First Term Gallery, Spirit of America Gallery, Flights of Freedom Gallery, Cold War Gallery, Oval Office replica, Camp David and the Ranch displays, the Nancy Reagan Gallery, Legacy Gallery, Berlin Wall and South Lawn, White House Rose Garden replica (3/4 scale), and F-14 Tomcat. Other special exhibits appear from time to time.

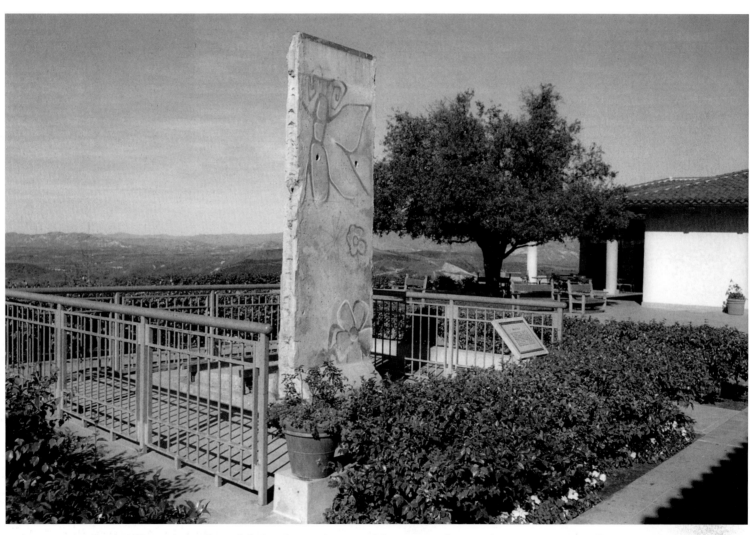

A chunk of the Berlin Wall stands before the South Lawn of the Reagan Library and Museum. With graffiti on the side that once faced West Berlin and a reverse side showing bare concrete, which faced the "no man's land" corridor by East Berlin, the wall effectively split the city into two sections. Built in 1961, the wall was a concrete example of Winston Churchill's rhetorical reference to an "iron curtain" that the Soviet Union forced on Eastern Europe following World War II. When Berlin's Brandenburg Gate reopened on December 22, 1989, Reagan's paramount achievement was realized.

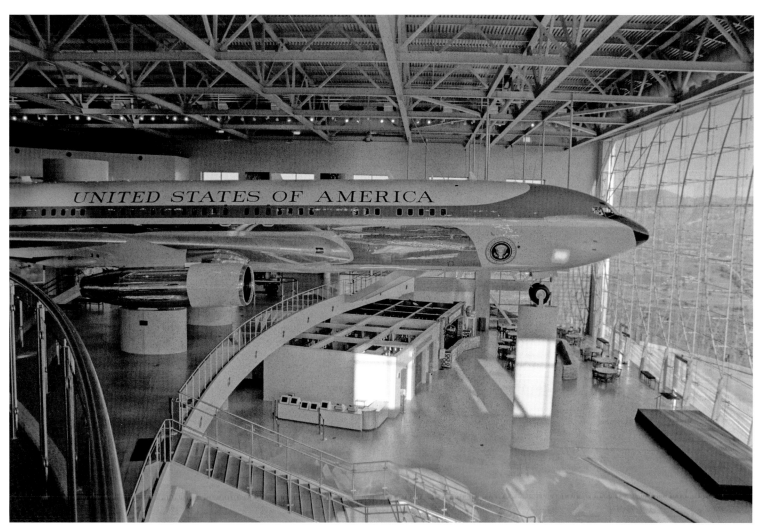

Air Force One, the Boeing 707 jet aircraft that served seven presidents from Richard Nixon to George W. Bush, flew more than one million miles during its 28 years of service. At the Reagan Library's Air Force One Pavilion, visitors may walk through and view each cabin in detail as it appeared during the Reagan administration. America's "Flying White House" arrived at the Reagan Library by truck from the San Bernardino International Airport on June 21, 2003, traveling 104 miles over four freeways. The plane was unveiled on September 23, 2005, and opened to the public on October 24, 2005. Also on view is Marine Helicopter Squadron One (HMX-1), from the Lyndon Johnson era, as well as vintage vehicles forming a motorcade of secret service and local law enforcement, complete with a specially built presidential limousine.

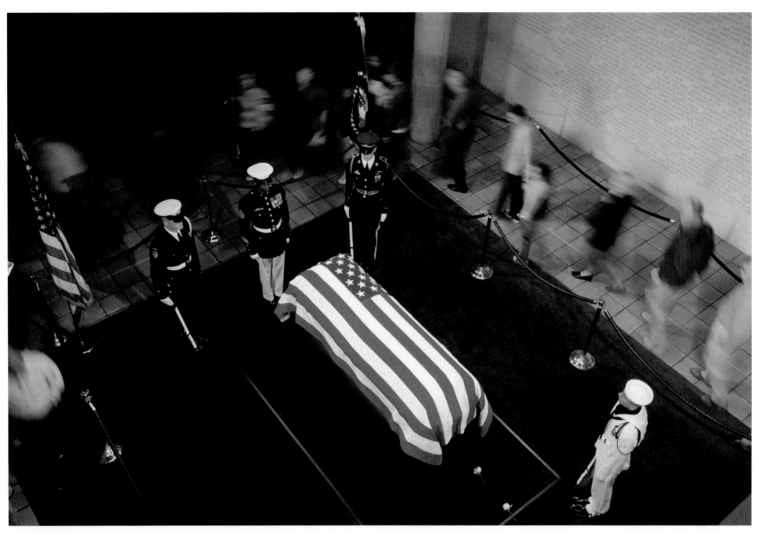

On November 4, 1994, Reagan revealed that he was beginning "a journey that will lead me into the sunset of my life." He was referring to Alzheimer's, the disease that gradually destroys a person's memory and the ability to carry out daily activities unassisted. On June 5, 2004, Ronald Wilson Reagan, surrounded by his family, died at his home in Bel Air, California, at age 93. The journey from a Santa Monica funeral home to the Reagan Library included travel via the Ronald Reagan Highway on June 7. At 11:00 A.M. the Reagan motorcade arrived to the strains of a Marine Corps band playing "Hail to the Chief" under spring clouds. Eight military pallbearers carried the casket to the library's rotunda where a brief family service was conducted by Michael Wenning of Bel Air Presbyterian Church. One hundred thousand mourners had passed quietly through before the mourning period ended on June 9. Some traveled 10 hours for their two-minute tribute to the 40th President. At 8:00 A.M. the same day, the former first family escorted the body to Point Magu Naval Air Station in Ventura County, where a 21-gun salute honored Reagan before departure to Andrews Air Force Base near Washington, D.C. Inside of 34 hours another 100,000 people filed past the casket beneath the Capitol rotunda, where Reagan became the tenth United States president to lie in state.

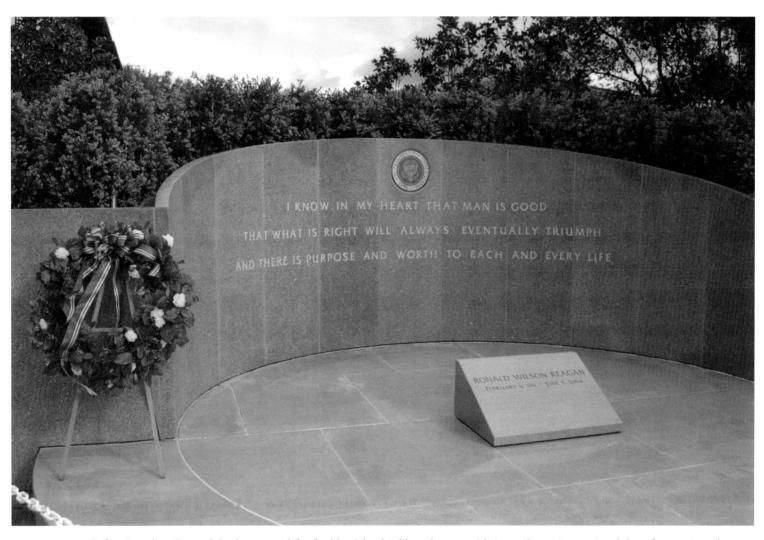

I KNOW IN MY HEART THAT MAN IS GOOD

THAT WHAT IS RIGHT WILL ALWAYS EVENTUALLY TRIUMPH

AND THERE IS PURPOSE AND WORTH TO EACH AND EVERY LIFE

RONALD WILSON REAGAN
FEBRUARY 6, 1911 – JUNE 5, 2004

Before President Reagan's body returned for final burial at his library's memorial site on June 11, a national day of mourning, the state funeral was conducted at the National Cathedral. Presided over by President George W. Bush, eulogies were given by both presidents Bush, former British Prime Minister Margaret Thatcher, and former Canadian Prime Minister Brian Mulroney. Among the foreign dignitaries attending the services included British Prime Minister Tony Blair, German Chancellor Gerhard Schroder, Italian Prime Minister Silvio Berlusconi, and interim presidents Hamid Karzai of Afghanistan, and Iraq's Ghazi al-Yawer.

Ronald Reagan

39 USA

2006

Of all the honors and tributes accorded the President, including the renaming of National Airport, the Christening of the USS *Ronald Reagan* on March 4, 2001, and the naming of a new federal building in Washington, the late President Ronald Wilson Reagan received a timeless honor when the United States Postal Service issued a postage stamp bearing his image in 2005. Created by illustrator Michael Deas and designer Howard E. Paine, the stamp's image was based on a photograph by Jack Kightlinger. It is the tradition of the Postal Service to honor prominent Americans with a stamp no sooner than 10 years after their death. The single exception to this policy is for a United States President, who may be honored with a postage stamp on the first birth anniversary following death. Ronald Reagan became the recipient of this honor. The stamp's great popularity led to a reissue when postage rates increased to 39 cents.

THAT'S A WRAP

NOTES ON THE PHOTOGRAPHS

These notes, listed by page number, attempt to include all aspects known of the photographs. Each of the photographs is identified by the page number, photograph's title or description, collection, archive, and call or box number when applicable. Although every attempt was made to collect all available data, in some cases data may be incomplete.

REFERENCES

Bennett, W. (2008, June 7). *Speech at Ronald Reagan Presidential Library and Museum.* Simi Valley, Calif.

Cannon, Lou (2003). *Governor Reagan: His Rise to Power.* New York: Public Affairs.

——— (2001). *The Presidential Portfolio: History as Told Through the Collection of Ronald Reagan Library and Museum.* New York: Public Affairs.

CBS News (2004). *Ronald Reagan Remembered.* New York: Simon & Shuster.

Diggins, John Patrick (2008). *Ronald Reagan: Fate, Freedom and the Making of History.* New York: W. W. Norton.

Edwards, Anne (1987). *Early Reagan—The Rise to Power.* New York: William Morrow & Co.

Evans, Thomas (2006). *The Education of Ronald Reagan: The General Electric Years and the Untold Story of His Conversion to Conservatism.* New York: Columbia University Press.

Gelb, Leslie H. (2008, May 11). *A Political Insider Describes That 3 A.M. Phone Call.* Parade Publications (New York), p. 7.

Greenberg, Carl. (1974, September 29). "Reagan's Quixotic Legacy." *Los Angeles Times* (Los Angeles, Calif.), part V, pp. 1-6.

Greenberg, David. (2008, May 18). "Dividing Lines: Morning in America." *Los Angeles Times* (Los Angeles, Calif.), part R, p. 5.

Hartmann, Robert T. (1980). *Palace Politics: An Inside Account of the Ford Years.* New York: McGraw Hill.

Helfer, Andrew (2007). *Ronald Reagan: A Graphic Biography.* New York: Hill and Wang.

Leffler, Melvyn P. (2008, April 6). "Keep Your Enemies Closer." *Los Angeles Times* (Los Angeles, Calif.), part M, p. 4.

Reagan, Maureen (1989). *First Father, First Daughter: A Memoir.* New York: Little, Brown & Co.

Reagan, Michael (1988). *On the Outside Looking In.* New York: Zebra.

Reagan, Ronald (2001). *Reagan: In His Own Hand.* Kiron K. Skinner, Annelise Anderson, Martin Anderson, eds. New York: Simon and Schuster.

Reagan, Ronald (2007). *The Reagan Diaries.* New York: Harper Collins.

Reagan, Ronald, with Hubler, Richard G. (1965). *Where's the Rest of Me? The Ronald Reagan Story.* New York: Duell, Sloan and Pearce.

Russert, Tim (Host). (2008, May 10). *The Tim Russert Show.* Washington: MSNBC.

Schweizer, Peter (2002). *Reagan's War: The Epic Struggle of His Forty Years and Final Triumph Over Communism.* New York: Doubleday.

Wartzman, Rick. (2008, June 10). "Our Split Utopia." *Los Angeles Times* (Los Angeles, Calif.), part A, p. 19.

The White House (1981-1989). *Friday Follies: News Summary Special Editions.* Washington, D.C.

Wilentz, Sean (2008). *The Age of Reagan: A History 1974-2008.* New York: Harper.

INDEX